Studies In Art

institutions, form, materials, and meaning

Second Edition

Ashley V. Blalock

Kendall Hunt
publishing company

Dedication

For my husband.

Amor non conosce travaglio.

Grazie mille

When the artist becomes
mute and forgotten,
a censored outcast,
unable to express the
anguish and beauty
inside ourselves,
then the passion

in all of us-

will quickly die
in front of our
disconsolate
eyes.

A poem by Lucio H. Cooper

Contents

Preface

ART HAS A STRANGE WAY of sneaking up on you when you least expect it; in a commercial, in the opening credits of your favorite television show, or even a parody in a magazine ad. Being able to recognize these images is an important tool for negotiating your own culture. I can no longer count how many times I have received some kind of contact from a former student after the semester ends, informing me that he or she finally had that "Aha!" moment of recognizing a work of art we studied in class and finally understanding why the image was chosen. What I seek to help students with in this text is the enjoyment of art, necessarily structured in the form of a class. I envisioned this text primarily as an art appreciation textbook, but believe it could be useful as a supplement for art history courses or studio art classes.

In planning to write an art appreciation text I had to think about what it would be that would set this book apart from the other texts I have used in my classes. I thought about the most common complaints I received from students about the texts they used and also reflected on my own complaints about texts I chose for my own classes. One thing all my art texts have in common is that they are getting bigger with every new edition as publishers and writers are trying to cram more and more information between the covers. There is among art historians a desire for completeness, as if any small thing missed by the student would derail further education. I decided that if I ever were to write a textbook, I would make it not only as cost-effective as possible, but also as concise as

possible—in order to present the basics while at the same time allowing the instructor to structure the course in the manner he or she sees fit. No student enjoys a class where a teacher reads directly from the book in lecture, and I enjoy having freedom with a text to focus more on some relevant areas than others. In regards to images, I often even felt at odds with the choice of images used in my texts, preferring to use those I was more familiar with from my area of specialization, or images I felt were better examples because I could relate them to modern day scenarios and living. I felt more comfortable using images I had dealt with in my time working in a museum, or my time working for an art conservator, or even images I had researched while working on my own art or writing about art history. This text limits the illustrated examples to a few so that these select images can be looked at from a variety of perspectives and so that the instructors are free to choose images that they feel better relate to the text. With the convenience of accessibility to the Internet today, it is easy for teachers and students to locate images for discussion that best suit their needs.

Unfortunately, while the amount of material in textbooks is increasing, the length of semester and quarter classes remains the same. There is no getting away from the fact that art historians love information, and I am also not immune, but keeping time limitations and that I was teaching introductory level classes in mind, I had to do some serious editing to most of my texts in order to present a course that focused on depth of understanding instead of breadth. I am a pragmatic person, and I realize that at this level in your, the student's, academic career in art, you will not need to know every obscure art technique in existence, or every possible facet of the art world. What you do need to know, though, are the most useful tools for appreciating and understanding art that you will commonly encounter the rest of your life. As for the text itself, you will notice a variation in the writing of some of the sections of the text. Some sections of the text are a little more theoretical than others, and it is important to have some sections like this in order to introduce you, the student, to the professional side of art, art history, and art appreciation. The other sections, however, are written in the most direct manner possible to provide you with what you need to know without having to do too much searching for the information. Art is experiential, and I believe the bulk of learning in an art appreciation class should come during class time through lecture, in-class

discussion, and observation of artworks, not solely through the text, which should serve as a supplement.

In this second edition of my book, I have rearranged and updated many chapters of the book as well as consolidated the material into three sections. Part One begins where most art texts begin, with an attempt to define art. We must at least try to define the subject in order to study it; unfortunately, you cannot give one definition for all the art in the world. This was the first thing I learned in graduate school when I read text after text that tried to define art, but none of them seemed to get it right. I learned to distrust any text or person that boasts to have conclusively defined art. Artistic expression is so specific to time and place that blanket definitions do not work. I can attempt to define art for a specific place at a specific time, but once time or place changes, the possible definition changes. Part One also explains how the study of art is structured by professionals in the field and then looks at how artists are trained, and the way art is presented to the public in a structured setting, the museum. Last is an unfortunately brief section on art conservation and restoration, a subject on which I would love to write volumes, most of which would be anecdotal evidence from my brief time working with conservators and information I have collected along the way.

In Part Two, we will delve deeper into art by examining the formal elements and principles of design that go into constructing the work of art. There is a special chapter on color because color is very expressive in art and is the most complex of the formal elements. Coming from a painting background, I used to chafe at the thought of describing art in terms of formal elements—I felt it killed the spirit of creating art, but I now see the relevance and rationale for this approach as a common way for people to talk about an artwork without having to know anything of its background. These formal elements and principles of design can be used effectively for describing works of art from around the world as well as from many different time periods. They provide a relatively objective view of a work of art and a starting point for discussion.

Part Three covers the various materials that art can be made of, because the materials of art often influence the form of art. Many sections of Part Three come from personal experience working with the different art methods, and even teaching some of them. At one time or another, I tried my hand in almost all of those materials and mediums, and I remember the processes

well. In fact, as a preemptive explanation, the terms I sometimes use are a compromise between the formal, or academic, terms for the processes and practices, and the ones I know because I learned them from people who work in these forms of art. As further clarification, Part Three is really a section written from the perspective of an artist, not an academic.

Throughout the book, at the end of each chapter, is a list of artists and artworks that relate to the chapter. Some of these artworks will be shown during class, and the specific artists and artworks were chosen because they relate to the material in the chapter. These artworks also provide a jumping-off point for you to investigate art on your own and the list includes artists and works most art historians are familiar with. In addition, I chose many works that can be found in collections in the United States, and have tried, wherever possible, to include the location of the work of art. I hope you will remember these places as you travel one day and perhaps even make it a point to see some of them firsthand, which I truly feel is the only way to experience art.

Even though I teach art and art history, I am a pragmatist and I accept that the majority of my students are approaching this subject matter as a means of fulfilling a general education requirement. This set the level for the depth and tone of the information I wanted to provide; if I only have a short amount of time, I can present only so much information. However, I still had to present enough information to fill a semester or a quarter. So, even though I cannot give one tried and true method for understanding every artwork from every culture and time period in the world, if I *can* give you a path to follow and help develop the critical skills to be able to evaluate art, art criticism, and art history writing, then you, as the student, can take the lead from there. As the saying goes, give a man a fish and he will eat for a day; teach a man to fish and he will eat for a lifetime. You are getting the basic tools for being able to confidently approach art, but the rest is up to you to discover.

PART 1

Approaching Art: Institutions

THE FIRST POINT that needs to be made is that art is important. Some people try to deny the importance of art, but that is to overlook some fundamental facts about art; people collect it, people protect it (sometimes even at the risk of their own lives), and some people spend their whole lives studying it. Some people also try to dismiss the relevance of art to their own lives, but there are enough people out there who have devoted their lives to art that the subject deserves reevaluation. How could so many people find something important that others dismiss?

Every day we are bombarded by images; from the billboards we see along freeways to television commercials. Everywhere we look there are brand names and logos. We are conditioned to recognize branding by the clever placement of paid advertisements, and we are not even safe when shopping as the stores play their own commercials over loudspeakers urging us to try their latest product. Paper placemats at fast food restaurants advertise their latest offerings as we munch away from selections ordered from the dollar menu. At the end of the day, can you remember even a quarter of the images you saw? In the past, this kind of product overload caused the bastions of high culture to seethe with anger, but not these days. How can you fight against a sea of images?

As more and more people come of age who have never lived a life without constant advertising, the images are being looked at and studied for their ability to encapsulate modern life and culture. We look to see what these images "say" about our value systems and the roles men

1

and women play in society. There is a problem with image overload—our ability to be critical of what we see decreases when the number of images that surrounds us increases. For example, have you ever heard the newest song, only to think it is terrible? Over time you keep hearing this song that everyone else says is great and eventually you start singing along to it, too. Maybe you justify that you just had not given it a chance, but more likely you heard it so many times in so many places that it just grew on you. After a while you liked the song and maybe even could not figure out why you originally hated it.

Over-saturation of images has this same effect on our ability to be critical about art. It is important to be critical of art because not all art is of the same caliber. It is very politically correct these days to say that all art has some merit, but have you not seen art that you thought was just terrible? Even well-known artists have their off days and sometimes produce a bad work of art. For example, some art historians agree that the works produced near the end of Jackson Pollock's life, a time marked by his downward spiral into alcoholism, were poor in quality compared to his earlier works. The only way to develop a sense about the quality of artwork is to view as many works of art as possible, and to learn as much as possible about the context of these works. This is not the same thing as the oversaturation of images that we experience every day. The difference is that when you look at many works of art, you will be looking at them actively and critically, not passively. What we are trying to develop in art appreciation is a toolbox for looking at art and to change passivity to activity in looking at the visual world. This toolbox should include a basic knowledge of art practices, vocabulary, a little history for context, and the knowledge of some really great works of art.

This first section will cover some common approaches to understanding the nature of art. Some of these are the historical approaches and others are current approaches. We will first examine the age-old question "What is art?," and then we will look at some of the most common ways we come into contact with art: through art history, educational institutions, and through museums and galleries.

CHAPTER 1 — What Is Art?

WHAT IS ART? This is a question that can never be conclusively answered. That probably was not the answer you expected, but one answer will not suffice because the answer varies from culture to culture, and generation to generation. Just when a society thinks it has an answer and knows what defines art, something changes and everyone has to begin over again. Art is such a specific story that only certain generalizations can be made. Even the nature of art is hotly debated. It seems it is easier to declare what is *not* art, than to define what *is* art. You will, however, know good art when you see it. Although no two people may agree on what *is* good art, you will be struck by the work and find yourself transfixed. Something that you cannot verbalize will draw you in and you will want to stare over every inch of the work. Maybe you will leave after a while and search out other works by the artist, or maybe you will purchase a small reproduction of the work. For each person this will happen differently, and do not be surprised if you are struck by a work of art in person that seemed rather boring in a textbook, or even if a work you loved from your text is disappointing in person. It happens to all of us.

Artwork should be viewed in person, not only seen in textbooks or on a computer screen. Art is not merely about viewing images, but about the physical experience. The experience is wrapped up in going to a special place, like a museum, and seeing the works that hang side by side. It is walking into a Roman building and seeing it as it was viewed by people almost two-thousand years ago. Nothing quite lives up to experiencing the space of a building you

have only read about in a text or seen on a computer screen and been amazed by the sights and sounds and smells of actually being there. Likewise, to see the color of a painting change with the light as you move around it, to see its delicate brushstrokes, or even the slight crackle of age to its varnish far outdoes a flat image on a screen.

Is Art Whatever I Say It Is?

There are many people today who, when speaking about art, will say that art is "whatever you say is art." Actually, though, art is whatever the parent culture says is art, which makes the definition of art relative to location, culture, and time. The definition of art as relative to location means that art can be something different in different locations, which ties into the concept that art's definition is relative to culture. Location and culture are discussed as two separate items because the location of culture is not fixed. Culture is a part of who you are, and when you move, your culture moves with you. Also, the location of the culture can affect the art produced. Suppose you grew up in a rural farm community and then move to a large city. You still retain elements of your culture; but that culture may be different than if you had stayed in that rural area. Now, instead of a world view based on the life that you grew up with, you have expanded your field of view to include the culture of the city. Location and culture, then, can be united but can also be separate elements. The definition of culture as relative to time is also important. Culture is not fixed over time, but may change as the needs of the society change. In regards to art, we have to specify what we are discussing in order not to overgeneralize and misrepresent the artwork produced.

Our own erroneous conception that "art is what you say it is" actually comes from the last century and a half in art in the western world. This time period encompasses a number of western artistic movements, many of which sought to challenge a very rigid and traditional notion of what could be considered "good" art. In the past, fine art had been defined not only by subject matter in the west, but also by the materials artists used. Only certain materials were thought to be appropriate for making art that was worthy of collecting and displaying. One of the ways

artists began challenging this definition of art was by creating art from ordinary materials such as newspaper or common household items. These materials had never before had a place in fine art production. One of the best-known examples dates from 1917 when French artist Marcel Duchamp (1887–1968) placed a urinal on its side, signed it "R. Mutt" and called it *Fountain*. Duchamp called his appropriations of mass-produced items ready-mades, and this bold gesture of offering up a urinal as fine art signaled a change in the very notion of what constitutes art. He argued that art was not so much about an artist creating a discrete object with his, or her, own hands, but about an artist taking an object and having the viewer see it in a whole new way. Idea became as important as the act of creation had been for the artist.

The result of this change in art was that the definition of fine art had to undergo a broadening to include these newer works of art made with newer materials. What followed was a distortion of the aims of these movements and the mistaken belief that anything could be considered art. If one artist offered a urinal as art, why not any other object as well? To many viewers it surely seemed that anything could be considered art, but that unfortunately implies a carelessness about the creation of the art itself when, in fact, the practitioners of this new art were actively breaking down traditional barriers in the art establishment. The use of new materials was a calculated assault on traditional artistic values in the western world.

The "Canon" of Art History

In art history, all of the art considered great and worth studying is known as the Canon, with a big "C." **The Canon of Art History** is the total of all the works of art that have remained the favorites of art historians over time and that are most often taught about in an art history survey course. These works are not only well-known and greatly admired, but people travel great distances to see them, and the very notion of being worldly may hinge on whether or not you have seen these works in person or are able to recognize them. The Canon is not something as official as an actual list of important works of art, but is more of an agreed upon body of works that are taught about in courses and

researched. Works of art included in the Canon do have a few things in common, though. They tend to:

1. be relevant to successive generations
2. fit into our notions of the development of the history of art
3. be the best expressions of their artistic movement or time period

Knowing this about the Canon, how would you, if you were an artist, assure that your artworks will someday be included in the Canon? There is no one sure-fire method for being included, and which artists are presently included can change, but the general benchmarks for works of art included in the Canon are that the artists:

1. are, or were, some of the best in their field
2. shaped the course of art history by which other artists they influenced
3. had a kind of staying power that has kept them popular long after they lived and died

Some artists, however, were popular when they lived and fell out of favor after they died. Some artists were never widely popular during their lifetimes but rose to fame posthumously, and others were always popular in life as well as after death. For example, Raffaello Sanzio (1483–1520), commonly known by the name Raphael, was very popular when he was alive, was very popular for centuries after he died, but is not as popular as other artists these days. He is still extremely well-known, most people recognize his name, and he is one of the most well-respected old masters, but other artists who were not always as well-respected in their day, such as Leonardo da Vinci (1452–1519), are now generally more popular. When he was alive, Leonardo da Vinci was admired as an artist by other artists, but was notorious for not finishing works of art and for being too experimental with his subject matter and technique for his patrons, resulting in the rejection of some finished works of art by the people who ordered them. He was a visionary artist, but not everyone appreciated this, especially when artworks that were paid for were never finished. Each artist has her or his own biography to explain

their popularity and no one general explanation will suffice for all artists.

Likewise, specific works of art have also changed in popularity. For example, the Mona Lisa by Leonardo da Vinci has always been held in high esteem as a painting, but its theft from the Louvre in 1911 catapulted it to world stardom. The Canon of Art is truly a changeable entity, responding to the whims of time and situation.

If the Canon of Art can change, what use is learning about it? The Canon collects together the works that are considered worth studying in a given time period. It helps us to determine benchmarks for quality in art and it provides artists with a base of artworks which they may work in opposition to. What this means is that artists cannot challenge the world of art unless they understand those works that are valued the most, and the Canon is the compendium of those works. On the other hand, knowledge of the Canon may also hinder artistic experimentation because of the desire of artists or viewers to conform to, or only like, traditional depictions. For example, many people do not like abstract art because it does not look like traditional works of art which often have a recognizable subject; viewers want to look at works of art and see something depicted. Many people do not like abstract works because they do not conform to their notion of the Canon.

CASE IN POINT
The Changing Popularity of Monuments in Pisa

If someone were to ask you what the most famous monument is in the Italian town of Pisa, you would, no doubt, immediately blurt out the Leaning Tower of Pisa. If someone told you they visited Pisa, wouldn't you ask if they went up the tower? Would you be surprised to learn, then, that people in the past went to Pisa not to see its now-famous leaning bell tower, but to see a monument that has since been virtually destroyed? Would you also be surprised to learn that art historians consider the other structures in this part of Pisa to be much more art historically significant than the tower with the poor foundation?

(Continued)

In Medieval and Renaissance Italy, a bell tower was a source of civic pride for a town and was situated alongside the main cathedral of the city and its freestanding baptistery. The bell tower in Pisa was built to be a great symbol of civic pride and the lean it developed caused it to be the source of great embarrassment for the city for centuries before it became the quintessential Italian tourist curiosity it is today. You will notice, however, if you visit the town of Pisa that all the buildings in this area, not just the bell tower, are leaning due to poor soil and insufficient foundations. The tower's lean started not long after construction began in 1173. Over the years, many attempts were made to stabilize or correct the lean of the tower, but most attempts only succeeded in making things worse. The latest fix in the 1990s was merely to prevent it from spontaneously collapsing by straightening it up slightly and stabilizing its foundation. What is amusing is that people in Pisa were worried that the commission working to save the Leaning Tower of Pisa might actually straighten it out completely! If the tower were straightened, they reasoned, no one would come to visit Pisa. So, over time, the reviled tilting eyesore became the source of civic pride for the Pisans that they had first desired to be built. Now going back to my first point, if it wasn't the tower people came to see, what was it?

Visitors to Pisa in the past actually went there primarily to view the frescoes of the neighboring Camposanto. The Camposanto was significant in part because, during the Crusades, a shipload of holy soil was brought back to Pisa and the Camposanto Monumentale was constructed around the soil to serve as a cemetery. Over time, its walls were covered with beautiful paintings that became famous all over Europe. Unfortunately, the city of Pisa was bombed many times during World War II, but the worst artistic destruction came when a bomb landed in the area and caused the lead roof of the Camposanto to melt and run down the walls, destroying those admired wall paintings.

The case of the Leaning Tower of Pisa and its popularity highlights a point concerning art history. Although this structure is very commonly popular, for art historians there are more significant artworks to see in the baptistery and in the cathedral. For example, many people do not go into the baptistery, but inside is an Early

CASE IN POINT *(Continued)*

Renaissance pulpit by Nicola Pisano that can be found in every beginning art history textbook. Similarly, the acoustics in the baptistery are so precise and amazing that several times a day, the security guard stationed in the baptistery will go to the center of the structure and sing. The resulting echo lasts so long that the guard is able to sing accompanied by his own echo. Not many people know about this performance because most visitors to Pisa rush to see the Leaning Tower. This goes to show that there can be differences between what is popularly admired and what is considered significant by art historians. Keep in mind, too, that what is popularly significant and art historically significant can change, and for art historians that means that the Canon can change.

Some Categories of Artistic Production

Even though we now see that art is not just what you say it is and that there is a generally agreed upon body of artworks considered worth knowing about, it is easier to understand that there are some categories into which artistic production can be broken down. There are an infinite number of categories, but we will discuss a few that you are likely to run into in your own life. It is hoped that you will begin to understand these parameters and their significance for art. The three categories we will discuss are:

FINE ART

POPULAR ART

CRAFT

Although we will treat each category as equal to another, this is not always the case with the general public and art specialists, and has not always been the case historically. Ranking and categorizing art has been done for hundreds of years and many attempts have been based on judgments of taste. Traditionally,

the most respected form of art is fine art with popular art next in line, and then craft coming in last, if even considered art at all. Some artists today are crossing the traditional boundaries between these works and combining the categories of popular art and craft with fine art. In many ways these strict separations of artistic categories can be thought of as obsolete, but it is still important to understand the separations. In this text we will mostly discuss fine art, but we will cover craft production used for fine art in Chapter Thirteen because, much like fine art, craft deals with the production of a specific material object; meaning that something physically results when art and craft are practiced.[1]

Fine Art

In western culture, **fine art** is usually referred to as "high" art to denote that these works of art are of exceptional quality and held in high esteem by the art establishment. Traditionally, works of fine art tended to be defined by medium and included painting, sculpture, and architecture. Today, however, as more artworks are being made out of alternate materials, defining fine art in reference to medium is quite inaccurate. In response to this situation, the term fine art is now used to refer to creative objects or ideas that are considered the best examples of cultural achievement, and additionally works that have been produced by the best artists of the time. This category does not include works of art that incorporate popular culture or mass media, those works of art are in a different category of art.

In addition to medium, fine art can also be defined by setting. Fine artworks tend to be found in art museums and art galleries. They are set apart from the world in these special locations where they are protected, preserved, and researched. Specialists at these institutions choose objects to be shown that are produced by people who consider themselves to be artists. Sometimes museums and galleries can have an anointing effect on art; meaning that anything shown in a museum or a gallery may be considered fine art. This approach, though, should be treated with caution because it is too easy to accept everything one sees in a museum as art and allowing the museum or gallery to dictate art to the viewer does not encourage further discourse about the nature of art.

Popular Art

If there is a category of art that is referred to as "high," then it reasons that there must also be a category of art that is referred to as "low." **Popular art** refers to mass-produced art objects and images meant for mass consumption. Popular art includes the art in magazines, on television, folk art, tattoos, greeting cards, and posters, to name a few examples. These images are often widely reproduced, sometimes of a cheap nature, and generally are prized for their entertainment value and mass appeal. Popular art is the form of visual imagery that is encountered most often in the course of daily life, far more than fine art. Popular art is simplistic and often able to be understood at first glance, while fine art takes some time to come to understanding. As a caution, some people confuse the category of popular art with a specific twentieth-century movement in art history known as Pop Art. While Pop Art used popular culture as a basis for its imagery, the two terms should not be used as interchangeable since Pop Art is considered a formal movement in fine art.

Historically, popular art has been thought to be incompatible with fine art and one of the main differences between fine art and popular art is that while popular art may be incorporated into fine art, fine art has limited incorporation into popular culture. When fine art is incorporated into pop culture imagery, it tends to be in a very shallow manner and removed from the fine art context. Fine art in pop culture may be used as the subject of a magazine ad or a television commercial. For example, fine art was used in a television commercial advertising eyedrops. In the commercial, the main figure in Vincent Van Gogh's painting, *Self-Portrait 1887,* is irritated by the cat from a nearby painting, *Woman with a Cat* by Édouard Manet, and a vase of flowers in Henri Fantin-Latour's *Roses Dans Un Vase de Verre.*[2] A website for the company explains the television commercial and how it was made, even identifying the works and their ownership. In fact, the website notes that the commercial was filmed in the South African National Gallery in Cape Town, South Africa instead of on a film set. This is an example of fine art incorporated into pop culture, but in a very superficial manner. The fine art is used to sell a commercial product and is not present for appreciation or education. Instead of using a famous person such as an actor to sell the product, an allusion to a well-known artist, Van Gogh,

is used. This is not an isolated example of fine art used in popular culture, but the end result is usually the same; the art is used for its ability to be recognized, not for its merit as fine art. This example also highlights consumerism as an important element of popular art. Pop culture art objects are usually commodities to be bought and sold.

A Note on the Terms "High" and "Low" in Art

When discussing art in terms of "high" and "low" we have to careful of implied value judgments that can come with these terms. In this text, it is recognized that the categories are each valid in their own way and that there can be good and bad "high" art as well as good and bad "low" art. The terms "high" and" low" are used because this is a traditional designation, not an intended value judgment on the works themselves.

Craft

Craft is an odd category to try to describe because a viewer will often recognize craft when they see it, but it is not always easy to explain. The category of craft may include woodworking, ceramics, glassmaking, jewelry making, weaving, quilt-making, needlepoint, knitting, and even crochet. The list could continue because the amount of craft-based creative objects is infinite, but craft objects tend to have three things in common:

1. Process; an emphasis on how the work was made
2. Material; what the object is made of is a defining parameter
3. Utility: the fact that the item may be used

An in-depth discussion of craft and craft theory will be conducted later in Part Three, but briefly stated, craft works are often prized for the skills of the creator; made out of certain materials such as clay or glass or fabric, to name a few; and the craft objects are useful in nature. In addition, a defining characteristic about the craft practitioners themselves is that they often do not receive the same kind of formal training that artists receive. In fact, many craft practitioners are taught through family and friends. Many craft works, however, may be collected and displayed in the same manner as fine art and may fetch very high

prices at auction.[3] Lastly, many works of craft, when they were completed, were not thought of as being art because of their utilitarian base. Early American quilts, while now highly sought after by collectors and very valuable, were once made for the express purpose of keeping warm. Many of them were made by women who gave no thought to including their names on the finished works, leaving us today to reconstruct the identities of these early craft practitioners.

Genres and Visual Styles of Art

The previous three categories break artistic production into categories based on public reception and tradition. When discussing art in terms of "high" and "low" we have to careful of implied value judgments that can come with these terms. In this text, it is recognized that the categories are each valid in their own way and that there can be good and bad "high" art as well as good and bad "low" art. The terms "high" and" low" are used because this is a traditional designation, not an intended value judgment on the works themselves. **Genre** is a term that refers to the type of art based on its subject matter. Genre should not be confused with **genre painting,** which is a term used to describe paintings of scenes from everyday life, or the term **new genres,** which is a term referring to a category of art based on ideas and new artistic practices, especially those that are technology-based or difficult to categorize in traditional terms. In France in the seventeenth century, the genres of painting were very well-defined and thought of as constituting a fairly rigid hierarchy of art. The historical list of genres includes, from most to least important; paintings of historical events (history painting), portraits, scenes of everyday life (genre painting), landscapes, and still life paintings. The genres were ranked in this manner to show the importance of people as a subject of art, but this ranking has fallen out of favor with the passage of time.

Historically, genre used to refer mostly to painting, but as modern artists began to use varied materials the definition of genre began to expand. Genre now refers to the subject matter of all fine art, and one of the notable features of art, and often the first to be noticed, is the subject matter. The genre categories that

will be discussed in this section are a mixture of old and new. The following three genres are categories used to describe a work of art based on the subject that is represented:

FIGURATIVE

LANDSCAPE

STILL LIFE

And the next three categories are used to describe how that subject is presented to the viewer:

REPRESENTATIONAL

ABSTRACT

NON-OBJECTIVE

Genres are quite useful because they help the viewer understand what to expect from the work of art based on each genre's own history and standard of representation. The following section will give a few examples of common genres and some of their traits. One thing to note is that for each category the subject may be taken at face value, not referring to anything more than the subject itself, or it may act as a metaphor for the artist's beliefs about the world. In addition, many works of art incorporate multiple subject categories; a landscape may also incorporate portraiture or a still life may be found in a portrait.

Three Genres of Art

Figurative

Figurative art is a form of representational art that focuses on people, including portraiture, and may range from **figure drawing,** art studies of human anatomy for the purpose of instruction and practice, to portraits which reveal the character of the sitter. Some of the earliest art in the world is prehistoric figurative cave art, although only a few examples still exist. It is believed that the depiction of humans in cave art is related to religion or religious rituals to ensure success in hunting and for their survival. Some examples of figurative cave art, such as in the paintings at Lascaux in France, show small stick-figure like

humans while others, such as the paintings at Pech-Merle in Southern France, are impressions and outlines of human hands on the walls of caves.

People depicted in figurative art may represent individuals or a whole segment of a population and our key to knowing the difference often resides in the title of the work of art. For example, Dorothea Lange's (1895–1965) *Migrant Mother, Nipomo* [Figure 1] shows the viewer a photograph of a woman and her three children. This portrait may either be read as standing for the individual mother, or for mothers in general who are going through hard times. The title, however, does not provide a name for the woman, only labeling her as a "Migrant Mother." Taking this information into account one can conclude that she represents a certain segment of the population and her body is a metaphor for the poverty and suffering of this segment of the population. A deeper discussion of this work of art will be undertaken later in Part Four.

Portraits are recognizable images of individuals and can be thought of as commemoratory images, or images for remembrance. The form of a portrait can be quite varied; some portraits are idealized, made to look better than reality, while others are brutally honest in their depictions, showing every wrinkle and bulge. Whether a portrait will be flattering or not depends on the culture and the identity of the sitter. For example, many portraits of rulers tend to show them as idealized and youthful, like portraits of Egyptian pharaohs, while many portraits of commoners are more realistic and true to life. When trying to understand a portrait, the character of the sitter should be taken into account and scrutinized, as well as the amount of the sitter's body that is depicted. There are different terms for portraits depending on how much of the body is shown. The standard categories for portraits are depictions of head and shoulders, half length, three-quarter length, and full. Head and shoulders includes just an image of the head and shoulders of the person, but when head and shoulders and some of the upper chest of the person are shown in a sculpture this is called a **bust**. Half-length portraits show the person from the waist up, sometimes seated, while three-quarter length portraits show the figure from the knees up, also sometimes seated. A full-length portrait shows the entire person including the feet and may or may not have a background.

Still Life

A **still life** is an arranged array of inanimate objects used as the subject of a work of art. A still life may be solely about the representation of the objects themselves or the objects can be used as symbols for more complex concepts. An example of a still life style that uses objects as symbols are **vanitas paintings,** or works of art that use certain arranged objects as a metaphor for death and afterlife popular in the Netherlands in the seventeenth century. Vanitas works depict either transitory objects like flowers and insects, or symbolic objects like hourglasses, skulls, and weighing scales to act as visual reminders to the viewer that life is short and to look to the salvation of a spiritual afterlife. Other still life paintings are just still life paintings, such as still life paintings produced by beginning art students for practice. Still life is an ideal vehicle for practice since the objects do not move and the lighting can be fixed. Unless perishable materials like fruit or flowers are used, it is possible to work on a still life over a long period of time.

Landscape

Landscape art uses the land as the subject of a work of art. Some landscapes are purely to record the lay of the land, perhaps an area familiar to the artist or a landscape to capture the beauty of a place, and other artists use landscape as a metaphor. Sometimes a landscape is a smaller component of a larger work of art, like the background for a portrait, or other times the landscape *is* the subject. Some art historians claim that landscape painting is a recent phenomenon, but there are in fact historic examples of landscapes in Minoan and Roman wall painting.[4] Landscape art has a long tradition, and some landscapes are recognizable places painted from life while others are fictional sites or arrangements of pieces and parts of other real areas. The practice of going out of doors and painting an entire landscape is known as *plein air* painting and became popular in the nineteenth century as commercially manufactured tubes of paint became popular. This made the materials of oil painting easily portable.

Certain landscapes include people and others include grazing farm animals, known as **pastoral scenes.** When people are included in a landscape the meaning of the work may be arrived at by observing the relation of the figure to the landscape. Is the

figure bigger and in the foreground, or is the figure miniscule and difficult to locate? Are there traces of civilization in the landscape? Does the landscape show the land accurately or is it idealized? Answering these questions about landscapes can help to find meaning in a work of art. An example of a landscape is British artist Charles W. Taylor's (1878–1960) *Essex* [Figure 2], from the early twentieth century. In this engraving, the flatness of the countryside is emphasized by the empty space that occupies the upper third of the work of art, broken up only by a few short lines. There are no people present, but there is evidence of civilization in the form of a road and a wood railing. The focus of this landscape, then, is on the severe flatness of the land and the beauty of the natural landscape.

In many ways, **cityscapes** and **seascapes** are related to landscapes because the same investigative questions for landscape can be used. A cityscape shows a scene of a city while a seascape is a painting that has the ocean as its subject. An example of a seascape is Katsushika Hokusai's (Japanese, 1760–1849) *The Great Wave at Kanagawa* from 1831–33 [Figure 3], which is part of a group of prints called *Series of Thirty-Six Views of Mount Fuji*. The irony of this work is that Mount Fuji, a huge mountain, is dwarfed by the great wave that also tosses around the fishing boats. The relation of the figures to the sea emphasizes the vulnerability of these men to nature as they go about their daily business.

Three Visual Styles of Art

Now that we have looked at three possible categories of art (genres) based on what is being represented in the work itself (people, land, and inanimate objects), let's take a look at a different set of three categories used to describe the visual style used to portray the subject of a work of art. These three categories progress from more recognizable to less recognizable imagery.

Representational

Representational art is art that depicts an object or a subject as it really appears to the viewer in life. These are accurate depictions of recognizable objects or subjects that look the most like the object or subject would look in person. Representational art has a long history because the earliest works of art that we have

are generally representational. Representational works of art also tend to be those that many viewers are readily drawn to and understood because people are naturally inclined to be attracted to things they recognize and understand.

Many artists of the late Nineteenth century, however, criticized the tendency of representational art to be a so-called "window onto the world." What this means is that if a work of art is intentionally highly realistic (intentionally and truthfully representational) then the artist is creating a world that we, as the viewer, are visually stepping into much the same way that you find yourself lost while watching television- it is as if you are transported into the action of the show or movie. Artists of this time were critical of art that intentionally copied the world around them and decided through their art practices to make art something altogether different- an expression of an individual vision, not a copy of the real world, and their work eventually greatly strayed from representational depictions.

Abstract

Abstract art is often confused with non-objective art and sometimes the terms are interchanged incorrectly. The process of abstraction is the process of simplifying or distorting a recognizable object or subject. This may be done to the extreme that the original object or subject may not be recognizable as it is represented in the work of art, but in the end, the work of art is based on and object or subject from the visible world. If there is no physical object as the basis for the artwork, then it is considered non-objective art.

Abstract art is not only about visual distortion, but also seeks to create a wholly new expression of its subject. Recognizable subjects can be distorted for a number of reasons; sometimes artists are so tired of realistic representations that they choose to distort reality in order to create a new reality in the work of art, and other times distortion or simplification has been arrived at as part of an artistic exercise to vary reality. Either way, artists who engage in abstraction are not attempting to record realistic depictions of the visible world, and comparing illusion to abstraction misses the point of abstract art and can hinder appreciation and understanding.

An example of a well-known abstract work of art is Pablo Picasso's (1881–1973) *Les Demoiselles d'Avignon,* a painting of women which incorporates a still life on the table in the foreground. [Figure 4] These still life elements, as well as the women, are abstracted. Although the still life objects are still somewhat recognizable as grapes and other fruit, they have been simplified to their underlying geometric forms. The opposite of abstract art is **representational art,** which depicts recognizable imagery. If the still life on Picasso's table looked exactly like a photograph of fruit, that would be an example of representational art. In this case, Picasso is choosing to create a new depiction of reality by abstracting the women and the still life. A comparison of these women and fruit to real women and fruit would be useful for discussing the extent of abstraction employed in the work, but using the real objects as a benchmark for assessing quality in a work of abstract art is a useless exercise.

Non-objective

Non-objective refers to artwork that has no physical object as its subject and is also known as non-representational. While other works of art may abstract an identifiable object, non-objective work does not try to imitate any object from the visible world. Non-objective works of art may sometimes be difficult to understand and recognizing that these works are not trying to imitate anything else is helpful for appreciating them. If the viewer of non-objective art does not approach the work of art expecting to see a scene illustrated, then the viewer will not be disappointed when the scene is not present. So what should one expect when looking at a non-objective work? Non-objective works are usually appreciated for the elements they do have, whether it be color, or line, or the simplicity of the composition. It really does vary from work to work and no one explanation will suffice.

For example, American artist Jackson Pollock (1912–1956) is best known for his non-objective drip paintings such as *Autumn Rhythm (Number 30)* [Figure 5] from 1950 which does not attempt to illustrate anything from reality. No matter how long it is viewed, no hidden image will ever appear. The subject of the work is the paint itself and how it is applied to the canvas in swirls and drips. The reason behind making a work of art such as this is to explore art that is not representational and to convey

emotion through the frenetic energy of the application of paint to canvas. There are many different forms of non-objective art and it is difficult to provide one explanation for every non-objective work of art. Each work must be understood on its own terms.

CHAPTER SUMMARY

- The question "What is art?" cannot be answered in a general manner because one answer will not suffice for every society around the world. The question may, however, be answered specifically referring to the definition for art for a specific culture, location, and time period.
- Works of art that are generally agreed to be of high quality and worth studying compose what is known as the Canon of Art History. The Canon helps us to determine benchmarks for quality in art, provide artists with a base of artworks which they may work in opposition to, but may also hinder artistic experimentation or reception because of the desire of the artist or viewer to conform to traditional depictions.
- Categories of artistic production give us insight into why certain works are made, what their function is, and how people perceive their importance. These categories are fine art, popular culture, and craft.
- Subject matter of art is broken down into different genres. Genres help us to understand what to expect from the work of art based on each genre's own history and standard of representation. Some genres include figurative, still-life, and landscape.
- Another way to understand art is to separate works into categories based on how imagery is visually presented to the viewer. These are representational, abstract, and non-objective art.

NOTES

1. The exception to this rule includes certain conceptual and performance art pieces. This will be discussed in detail in Part Three.
2. The commercial in question was produced by the Pataday Corporation and a summary of the commercial, how it was made, and the paintings used in the commercial can be found at the Pataday Corporation website in the "Art Gallery" TV Ad section. www.pataday.com/about-pataday/artgallery.asp

3. Some early American quilts can sell for as much as $50,000.

4. The existence of frescoes from Akrotini and Roman wall paintings of landscapes disputes the definition of landscape given by the online glossary for the Tate Museum, www.tate.co.uk which states that "the appreciation of nature for its own sake and its choice as a specific subject matter for art is a relatively recent phenomenon. Until the seventeenth century landscape was confined to the background of paintings. . . ." The fresco examples date back much further than the seventeenth century.

ART AND ARTISTS

Figurative Art

John Currin, *The Hobo*, 1999. Museum of Contemporary Art, San Diego.
Willem De Kooning, *Woman I*, 1950–52. The Museum of Modern Art, New York.
Lucian Freud, *Reflection*, 1983–85.
Thomas Gainsborough, *Jonathan Buttall: The Blue Boy*, c. 1770. The Huntington Library, Pasadena.
Jeff Koons, *Michael Jackson and Bubbles*, 1988.
Dorothea Lange, *Migrant Mother, Nipomo Valley, California*, 1936.
Lascaux Cave Paintings, Dordogne, France, c. 15,000–13,000 BC.
Édouard Manet, *Woman with a Cat*, 1882. National Gallery, London.
Robert Mapplethorpe, *Ajitto (Back)*, 1981.
Pech-Merle Cave Paintings, Lot, France, c. 22,000 BC.
Vincent Van Gogh, *Self-Portrait 1887*. Art Institute of Chicago, Chicago, Illinois.

Still Life

Paul Cezanne, *Still Life with Fruit Basket*, 1888–90. Barnes Foundation, Pennsylvania.
Henri Fantin-Latour, *Roses Dans Un Vase de Verre*, date unknown. Private collection.
Audrey Flack, *Marilyn*, 1977. Collection of the University of Arizona Museum, Tucson.
Rachel Ruysch, *A Vase of Flowers*, 1706. Kunsthistorisches Museum, Vienna.
Harmen Steenwijck, *Vanitas*, c. 1640.

Landscape/Cityscape/Seascape

Albert Bierstadt, *Among the Sierra Nevada Mountains, California,* 1868. National Museum of American Art, Smithsonian Institution, Washington, D.C.

Thomas Cole, *The Oxbow,* 1836. Metropolitan Museum of Art, New York.

Caspar David Friedrich, *Cloister Graveyard in the Snow,* 1810.

Gardenscape from Villa of Livia, Primaporta, Italy, ca. 30–20 BC.

Martin Johnson Heade, *Thunder Storm on Narragansett Bay,* 1868. Amon Carter Museum, Fort Worth, Texas.

Katsushika Hokusai, *The Great Wave at Kanagawa* (from a *Series of Thirty-Six Views of Mount Fuji*), ca. 1831–33. The Metropolitan Museum of Art, New York.

Hudson River School.

Spring Fresco, from Room Delta 2, Akrotini, Thera (Santorini), Greece, c. 1650 BC.

Vincent Van Gogh, *Starry Night Over the Rhone River,* 1888. Musée d'Orsay, Paris.

Representational

Chuck Close, *Linda,* 1975–76. Akron Art Museum, Ohio.

Jean-François Millet, *The Gleaners,* 1857. Musée d'Orsay, Paris.

Rachel Ruysch, *Flower Still Life,* after 1700. The Toledo Museum of Art, Toledo.

John Constable, *The Haywain,* 1821. National Gallery, London.

Thomas Moran, *The Grand Canyon of the Yellowstone,* 1872. National Museum of American Art, Smithsonian Institution, Washington, D.C.

Abstract Art

Georges Braque, *The Portuguese,* 1911. Öffentliche Kunstsammlung Basel, Kunstmuseum, Basel.

Willem de Kooning, *Woman I,* 1950–52. The Museum of Modern Art, New York.

Marcel Duchamp, *Nude descending a Staircase, No. 2,* 1912. Philadelphia Museum of Art, Philadelphia.

Georgia O'Keefe, *Evening Star, III,* 1917. The Museum of Modern Art, New York.

Pablo Picasso, *Les Demoiselles D'Avignon,* 1907. The Museum of Modern Art, New York.

Non-objective

Josef Albers, *Homage to the Square*, 1951. Yale University Art Gallery, New Haven.

Helen Frankenthaler, *Small's Paradise*, 1964. National Museum of American Art, Smithsonian Institution, Washington, D.C.

Ellsworth Kelly, *Red, Blue, Green*, 1963. Museum of Contemporary Art, San Diego.

Franz Kline, *Mahoning*, 1956. Whitney Museum of American Art, New York.

Robert Motherwell, *Elegy to the Spanish Republic XXXIV*, 1953–54. Albright-Knox Art Gallery, Buffalo, New York.

Barnett Newman, *Vir Heroicus Sublimis*, 1950–51. The Museum of Modern Art, New York.

Jackson Pollock, *Autumn Rhythm (Number 30)*, 1950. Metropolitan Museum of Art.

Mark Rothko, *Orange and Tan*, 1954. National Gallery of Art, Washington, D.C.

Clifford E. Still, *1946-H (Indian Red and Black)*, 1946. National Museum of American Art, Smithsonian Institution, Washington, D.C.

CHAPTER 2

The Discipline of Art History

IT IS NOT ALWAYS NECESSARY to know the background of a work of art in order to appreciate it, but it often helps, especially with modern and contemporary art. In comparing art appreciation to art history, the following analogy is useful; appreciating art can be like appreciating a flower, it is not necessary to become a botanist to find the beauty in a flower, but knowing a few details about the flower and its life cycle might make it that much more interesting to the casual observer. There is a definite difference between art appreciation and art history; **art appreciation** is a study of art meant to introduce the student to artworks themselves through developing and understanding of formal content of art and process as well as themes in art, while **art history** is an area of academic study that emphasizes understanding the historical or social relevance of a work of art. While art appreciation gives students the fundamentals to be able to appreciate and enjoy art, art history is a formal discipline that closely examines works of art through formal structures. One of the central aims of art historians is to determine the original context of a work of art, what that work of art meant to people of that time, and what it means to people today. Art historians want to know why an artwork looks the way it does and why it was made. As a formal academic discipline, art history has its own norms for discussing the subject of art and it is helpful to understand some of the ways art history is structured and taught in order to understand how it is somewhat different from what you will learn from this text, which is an art appreciation text.

The History of Art History: Two Key Figures

Although there are many important people in art history, the discipline of art history generally traces is roots back to two key figures; Giorgio Vasari and Johann Joachim Winckelmann. Giorgio Vasari (1511–74) lived in Florence during the Renaissance and in 1550 published *Vite de' più eccellenti Architetti, Pittori et Scultori Italiani*, which is referred to now by art historians as *Lives of the Artists*. This pivotal text tells the story of the most famous artists of Vasari's time. It is organized by artist and each artist's section includes a biography and a critique of their body of work. *Lives of the Artists* includes information about which artists trained with other artists and which ones were famous at that time in history. At the time *Lives* was written, however, the quality of an artist's work was assessed on the degree of naturalism or illusionism in the work. The more realistic, or representational, the work, the better the work was considered to be. The reason that Vasari is so important for art history is because he is considered the first person who attempted to construct a narrative history of art including biography. *Lives* is a very important text in art history, but unfortunately some of the biographies relate myths about artists that cannot be substantiated and may in fact contain false information or gross exaggeration.

Another important figure in art history is Johann Joachim Winckelmann (1717–68). Winckelmann was German writer who lived part of his life in Rome and wrote about and studied classical art **Classical art** is the art of ancient Greece and Rome. It was Winckelmann's belief that Greek art was the most perfect art ever and he wrote many texts on classical art, the most famous of which is his 1755 text *Reflections on the Imitation of Greek Art in Painting and Sculpture*. Winckelmann is the figure responsible for the concept of studying art in terms of periods and styles and further reinforced the notion that the classical period is the epitome of artwork in the western world. Although classical art is now over two thousand years old, its effect is still felt in art and architecture. Classical art is still regarded by many as the most perfect style of art and classical elements such as columns are still very common in architecture. It is especially common to see the classical influence in American art and architecture because Greece is seen as the world's first democracy and part of the ideology

of the United States is based on the idea of the United States as a democratic country. The most obvious examples of the classical influence in the United States are older government buildings and state capital buildings.

The two things that these authors have in common is their insistence that "good" art is art that is illustrative and looks "real." Although that is no longer a requirement for acceptable art in the twentieth and twenty-first centuries in the art world, it still remains a benchmark of talent for many outside the art world. Many well-known artists in the last one hundred and forty years have been working against this premise that art should be illusory, that it should copy directly from real life. Instead, many artists have been trying to create art that is an interpretation of life or a re-envisioning of the physical world, instead of a mere recording of it. Although we will talk about photography later in Chapter Eleven, it is important at this point to mention that the invention of photography in the early half of the 1800s caused many artists to realize painting was not the only method for creating a realistic visual record of life, and that painting did not objectively record real life, but that the real world was interpreted through the artist in the painting. And if there was another more objective method for recording visual life, some reasoned, then art had to have a different purpose in this world. This premise contributed to the rise of the Modern movement in art in the later half of the nineteenth century and changed the character of art as we presently know it.

The Structure of Time in Art History

In order to make art an easily understandable subject, the history of art has been broken down into periods and styles which are roughly chronological with some overlapping of time periods here and there. The study of art history usually begins in survey courses in prehistoric times at about 25,000 BC. Usually, the periods of western art history are taught in these loosely chronological cultural sections, and art historians also separate themselves by which period of art they study:

> Prehistoric, Near Eastern, Egyptian, Aegean, Greek,
> Roman, Early Christian, Byzantine, Art of the Middle Ages,
> Romanesque, Gothic, Renaissance, Northern Renaissance,
> Baroque, Neoclassicism, Romanticism, Realism, Modern,
> Contemporary

This period system is useful for teaching art and structuring a chronology that relays art as a series of time periods gaining influence from previous styles and making breaks with tradition. The problem with breaking the history of art into sections in this manner is that a number of the cultures overlap chronologically, and this structure does not express the complexities of how so many of the cultures influenced one another. Since the discipline of art history tends to compartmentalize art into periods and cultures, it is difficult to account for this complex intermingling.

Within each of these art periods, the works themselves are usually taught chronologically, from old to new. The rationale behind this structure is to again show how art builds upon the styles of the past and how artworks may conform to tradition or may react in opposition to it. One of the issues that vexes art historians in this chronological sequence of art and artists is what happens when they encounter an artist or a work of art that does not fit easily into the chronology. This is more common with ancient works of art because the dating system is pretty inaccurate in the sense that the dates of ancient works of art are sometimes based on very educated guessing and stylistic considerations. For example, if two Greek vases are found that cannot be dated, and one vase has stick figures painted on it while the other has three-dimensional figures, the stick figure vase will probably be dated older than the more realistic one. The rationale for this assignment of dates is that as societies progress, human depictions become more lifelike and three-dimensional.

But what happens in a society where stick figure depictions are prized over more realistic depictions? Historically, art historians tended to describe these periods in a society's history as a decline and that as the society declined, the depictions became less sophisticated. This concept has since been reevaluated. For example, art historians in the past used this rationale to explain away most of the depictions of the middle ages and this helped to contribute to the naming of the middle ages as the "Dark Ages," a time of limited learning and rudimentary-looking art. Now, the less than realistic depictions of the middle ages are attributed to religion and the fact that focusing on life was not as important as focusing on the afterlife. People from that time period generally

believed that if the present life was not as important as the afterlife, then it did not matter if the depictions were realistic. Too much focus on the present life, they reasoned, could be detrimental to one's standing in the afterlife.

Often, this entire problem with dating art is avoidable because so many objects *can* be dated with some degree of reasonable certainty. For example, some artworks may depict scenes of specific historical events whose dates are already known, meaning the work was made after the referenced event, while in other cases art objects are found in the same site with other datable objects. For example, the eruption of Mt. Vesuvius in Italy on August 24, 79 AD destroyed the city of Pompeii (as well as nearby Herculaneum) while at the same time preserving it under a blanket of hardened ash. It is reasonable to assume, then, that any artifact recovered from excavations at Pompeii can be no newer than 79 AD, the year the city was destroyed. The only complication, then, is trying to determine how far before the eruptions the works were made.

Other works of art are fairly easy to date because the date is written on the work of art. The practice of signing and dating works of art was sporadic from ancient times to the Renaissance, but as the focus in art began to center on the individuality of the artist, more and more artists began to sign their works. It is now a common practice to sign and date works of art, but from time to time unsigned works will arise and disputes of their authenticity will occur. For example, a recent stash of supposed Jackson Pollock paintings was found that are smaller in size[1,2] and do not really look like his signature art style, but the owner of the works and some other scholars claim that these works are indeed by Jackson Pollock. Without a signature and a date it is difficult to tell for certain, and stylistic analysis and scientific testing has thus far been inconclusive. One of the issues surrounding the Jackson Pollock paintings is that if these paintings are real, they change the already-established chronology of Jackson Pollock's life. Sometimes, when a work of art turns up that disrupts the established history of art, other art historians are reluctant to believe the works are real because the result may be a change to their conception of the story of art history. Often, newly found works of art by well-known artists are decried as being fakes or forgeries, until proven otherwise.

Important Issues for Art Historians

There are many concerns art historians must juggle when trying to understand a work of art. Among these concerns are:

<div align="center">

ATTRIBUTION

CONTENT

CONTEXT

INTERPRETATION

PATRONAGE and OWNERSHIP

</div>

Although they are listed sequentially, they are actually intertwined and mutually dependent on one another; a change in understanding in one area can change understanding in the other areas. For example, a change in authorship can lead to a change in context and interpretation, as the context changes from the life of one artist to the life of another. When all these elements of authorship, content, context, interpretation, and ownership are brought together by art historians they help form a complete picture of a work of art.

Attribution—Who Made It?

The first thing an art historian would want to determine about an unknown work of art is who made it. Sometimes this is an easy process and may include just reading the signature on a painting, but artist identification can become difficult when a painting has no signature, or if a work of art is very old or of unknown origin. In the case of very old works of art, art historians always have to be aware of forgeries because the best forgers employ many tricky techniques to create convincing fakes. For example, a forger of ancient Greek art may locate ancient quarried marble and use the ancient marble to make a new sculpture even going so far as to use reproduction tools from the correct time period. The discovery of forgeries in museum collections is not very often publicized because it is embarrassing to think that experts can be duped, but it is thought that many museums unknowingly own forgeries of ancient art. If a forgery is identified as an authentic work of art, that incorrect identification could invalidate the identification of other authentic objects. Often, when forgeries are discovered in museum collections, they are quietly disposed of.

When an art historian determines the artist of a work of art, it is said that an **attribution** has been made. For example, the painting Autumn Rhythm is attributed to Jackson Pollock. If we do not know who made the work of art, as is the case with many ancient works, then the artist is unknown and there is no definite attribution. Sometimes, however, it is clear to art historians that one unknown artist created multiple works of art. The works of art are linked together stylistically- they all look like they were done by the same person. In this case, art historians give the unknown artist a pseudonym to let people know that one person is responsible for multiple works. A good example of this naming quirk is the anonymous Italian painter, Master of St. Francis, or the anonymous ancient Greek artist, the Andokides Painter.

Attribution is important for places like museums and art galleries because monetary value can change with attribution, raising or lowering the purchase price or insurance value for a piece of art. Attributing an unknown work of art to an artist is still not certain for many works of art and attribution can change with scholarship. For example, the case of the painting *Young Woman Drawing* (sometimes also called *Portrait of Mlle Charlotte du Val d'Onges*) of 1801 illustrates the problems art historians can encounter with attribution and the effect attribution can have on the reception of a work of art. *Young Woman Drawing* is a painting of a young lady wearing a white gown of the time period, seated before a window, and supporting a drawing pad on her legs while looking out at the viewer. This work became part of the collection of the Metropolitan Museum of Art in the early half of the 1900s, and at the time it was thought to have been painted by the celebrated French Neoclassical artist Jacques-Louis David. A couple of decades later, the work was reassessed and the attribution changed to Constance Charpentier, one of David's students, and a woman. After this change in attribution, the work was not regarded as highly as when it had been thought to have been made by David, even though the only thing that had changed about the work was its attribution. Some time later, the attribution of the work to Charpentier was questioned and the work was listed as having been painted by an unknown artist, a common practice when authorship of a work of art is questioned. Recent scholarship, however, has provided a new attribution and the work is now listed as having been painted by Marie-Denise Villers (1774–1821).[3] Although the authorship of this work of art seems to have been cleared

up, the subject matter of the work is still under some dispute, as you will see in the next section on content.

Content—What Am I Seeing?

Content describes the fixed internal components of a work of art. In other words, the content is the subject of the work- what the work depicts. When you think about content, you should think about what you are seeing in front of you in the work of art. When a work of art is made, the content is fixed and does not change. For example, a portrait painting of a person will always be a painting of a person, but the believed identity of that person, the sitter, may change. Content and interpretation both deal with constructing meaning; however, content is distinct from interpretation because content is fixed while interpretation may vary with the passage of time or reevaluation of the work of art. For example, in the previous section, the alternate title, *Portrait of Mlle Charlotte du Val d'Ognes,* was given for *Young Woman Drawing* by Marie-Denise Villers. The official Metropolitan Museum of Art title is rather vague, only listing it as a woman drawing, while the other title gives a specific name. The reason that the work's official title is *Young Woman Drawing* is because the identity of the sitter, the subject of the work, is unknown. The sitter was once identified as *Charlotte du Val d'Ognes* most likely because the painting was at one time owned by the Val d'Ognes family.[4] To further confuse the whole situation, in the description of the painting given by The Metropolitan Museum of Art, it says that this may actually be a self-portrait of Marie-Denise Villers,[5] presumably because it depicts a young woman drawing and Villers was a female artist. Whenever the subject of a work of art is unknown or the identity of a sitter is unknown, art historians will default to a general title so as to avoid confusion.

Sometimes, the content of a work of art is easy to determine, but other times it is not. This is often the case with abstract and non-objective art. Usually, the best way to determine the subject of an abstract or non-objective work of art is to try to determine what it is you are looking at. The subject of an abstract painting may very difficult to determine because it usually involves identifying the object that is abstracted. Reading the title of the artwork is very useful. For example, if a squiggle of lines is identified as a dancer, then you can start to see how these elements form a dancer. Non-objective works, although they do not have

an object as their subject, are often easier to identify because the subject is the most obvious element, such as color or line.

Context—What Was Happening When the Work Was Made?

Context is the situation that surrounds the creation and reception of a work of art. This includes the social and political situation at the time of the art, the place the art was made, the events of the artist's life included in their biography, the date the work was made, and how and where the work was received by viewers. Social and historical events can influence the way an artist thinks and acts, while an artist's life is included as part of context because events in the life of the artist often inspire works of art. The biography of the artist includes their training as well as where they have lived, and the people they may have interacted with. Context also involves reconstructing the time period in which the work was made as well as determining a date or range of dates for the work in question. Knowing the exact date of a work of art is important because knowing the exact date can help to develop the biography of the artist. If the artist is not known, then context relies heavily on social and historical situation and dates. Lastly, context includes how and where a work of art is received by viewers because viewer feedback can impact the production of an artist. In terms of the effect of the other categories on context, attribution is very important because a work of art is understood within its context, but that context may change if attribution is changed. This is illustrated in the case of *Young Woman Drawing;* now that the work is thought to be by Villers, it is believed to be a self-portrait. This information would not have been available had the context of the work of art not changed.

To see how all the elements of place, biography, date, and reception come together to create context, let us consider the case of Pablo Picasso's *Les Demoiselles d'Avignon* [Figure 4]. The work of art was painted in 1907 at a time when Picasso was living and working in Paris. In 1907, Paris was the center of the art world and a place of artistic innovation where many other famous artists, such as Vincent Van Gogh, Georges Seurat, Édouard Manet, and Paul Cézanne, had at one time lived and worked in the late 1800s, and where other famous artists, such as Henri Matisse and André Derain, still lived and worked. The climate

of experimentation in art was still in full swing in Paris in 1907, and within this climate Picasso felt emboldened to try a new expression of painting, resulting in *Les Demoiselles d'Avignon*. When Picasso was finished with his new experimental painting, he brought his friends to view it, and when Picasso revealed it to them:

> Leo Stein [American art collector and critic] burst into embarrassed, uncomprehending laughter; Gertrude Stein [an author as well as Picasso's friend and patron, and sister of Leo Stein] lapsed into unaccustomed silence; Matisse swore revenge on this barbaric mockery of modern painting and Derain expressed his wry concern that "one day Picasso would be found hanging behind his big picture."[6]

The negative reception of his work by fellow artists and close friends meant that this painting, now considered one of the most important works of art in the twentieth century, remained out of public view for over a decade as it sat hidden in Picasso's painting studio. These events, from the climate of Paris in the 1907, to the reception of the artwork by other artists, form the context of the work of art.

Interpretation—What Does It All Mean?

Interpretation is a process through which art historians come to understand a work of art using both content and context to determine meaning, as well as **subtext,** the underlying secondary meaning of a work of art. For example, a painting of flowers is generally about an accurate representation of an arranged group of objects, but some flower paintings are also about mortality because flowers are short-lived. Mortality, then, is the subtext of the work of art, the component of meaning that is not as obvious, but can be arrived at through interpretation. Interpretation of a work of art not only includes an understanding of the work's content, but how the work of art functions in a society, or possibly what a work of art means for the society of the time it was made, or even extend to its interpretation for audiences now. Interpretation relies heavily on the understanding of content and when content is not fully understood, any final conclusions about the work of art must be delayed. For example, a complete understanding of *Young Woman Drawing* must be delayed until the identity of the sitter is determined, although some art historians might engage in academic speculation. In this work, the content has remained

constant, but interpretation has changed over time. That is why content and interpretation are two distinct elements to aid in understanding a work of art.

Art historians, no matter what they study, are always trying to get inside the mind of the artist or step into the time of the artist. Unfortunately, this can never really be done impartially because people are a product of the time and culture in which they were born and raised. Many people believe that no matter how hard a person tries to understand another time period or culture, they are limited by their own world view resulting from their own culture. A recent trend in art historical writing tries to combat this inherent bias by having the art historians insert themselves into the text, acknowledging their inherent biases, instead of following the form of traditional academic writing where the voice of the writer is impartial. Whatever the solution, what is important is that art historians are now aware of these biases and many are rewriting the scholarship of art history.

A relevant example that illustrates how a person's own viewpoint can interfere with understanding of the art of another culture is the famous example of the Victorian Era British archaeologist Sir Arthur Evans and the excavation and description of the Bronze-Age site of Knossos, located on the island of Crete. This excavation was begun in the last years of the nineteenth century and what Evans discovered on Crete was a large architectural complex dating back to around 1700 BC. In Evans's world view, one influenced by coming from a culture with a monarchy, such a large complex *had* to be a palace for a king and queen. Today, a reappraisal of the site of Knossos suggests that this was not a palace, but a large administrative and religious center, and the discovery of additional such complexes on a fairly small island seems to reinforce this reappraisal of the site. As a result of Evans's preconceptions, he called the whole complex a "palace" and named rooms of the "palace" accordingly, such as the "throne room" and the "queen's megaron." Evans also reconstructed the site without accounting for the fact that this multi-level site had collapsed when it deteriorated, and some areas that are constructed on the ground floor may actually have been on the second floor of the complex. Unfortunately, for scholarly research, the damage has already been done and a quick Internet search reveals websites presenting incorrect information about Knossos and evaluating the site solely as a palace site.

Patronage and Ownership—Who Paid For It and Who Owns It?

We will learn later in the chapter on Art Education that artists of the Middle Ages and Renaissance in Western Europe were very different from artists today; artists of that time were essentially craftsmen for hire who made works of art to order for patrons. A **patron** is a person who provides financial support for an artist or who commissions a work of art from an artist. A **commission** is when a contract is drawn up between an artist and patron for the completion of a work of art. When a patron solicits an artist to create a work of art, a contract is usually drawn up and a sum paid to secure the commission. These old contracts from the Renaissance are important to art historians because they set forth the terms of the commission including the parties involved, the size of the work, which figures will be created by the master artist and which will be created by his assistants, when the work will be delivered, and sometimes even the specific paint colors that should be used. For example, if a very specific and expensive paint color is required, then the contract would mention it and provide an extra sum of money for its purchase.

Understanding the roles patrons and artists play in the art world of a given time, and the power wielded by each party, is important because patronage can have an effect on art and the form or final content of a work. For example, in Renaissance art, a patron could specify that certain figures be included in the work of art, such as certain saints or martyrs. At one point during this time, the Catholic Church was the greatest patron of the arts, and when artists were commissioned to create works of art for cathedrals and churches the artist had to work under the direction of a church official who made sure that the images conformed to established church doctrine. In the old days, a patron had a lot of power over the outcome of a work of art and could even reject a completed commission if it did not meet his or her standards. There are many documented examples of artists whose finished commissions were rejected by patrons.

Caution should be taken today, however, with reading too much about the patron into the work of art because artists today tend to do most of their work on speculation rather than commission. Renaissance artists working on commission already knew who they were making the work of art for, and the creation of that work fulfilled a set contract. Artists today tend to make works of

art and then find an audience or a buyer for those works. In many ways this can be a riskier way to work, but in the end there is less outside control on the artist than working on commission. Artists who do work on commission today also have much more control over the terms of their commissions. A patron today is more likely to commission an artist to work in their own unique style rather than dictate style or content to the artist.

Either way a work of art is made, be it through commission or working on speculation, the resulting artwork will at some point be turned over to its new owner, and probably pass from owner to owner over time. Determining ownership is important in art history, and the record of ownership for a work of art is known as a **provenance**. The word provenance comes from *provenir*, a French word meaning "to come forth," or "to come from." A provenance is an artwork's pedigree, or lineage, extending from the original artist to the present owner, listing every owner in succession, and sometimes even the inclusion of the work in major art exhibitions. The documents associated with a commission can be very important in establishing a provenance because they usually list the artist, the patron (who is usually the first owner of the work), the size of the work, the materials, subject matter, date of completion, and price.

A complete provenance can be used to authenticate a work of art, but should not be the only means of authentication since frauds involving falsified or modified provenances have occurred. In addition, the work's authenticity may come under dispute if the provenance is broken or has gaps. For example, Leonardo da Vinci's (1452–1519) *Mona Lisa* [Figure 6] was stolen in the early twentieth century, and some art historians claim that the version now shown in the Musée du Louvre is not the real painting, but a very good copy. Most art historians agree that the original version was recovered and returned to display, but because the world lost sight of the *Mona Lisa* for a while, questions about its authenticity still persist.

As stated above, the provenance is a record, and as such the form the provenance takes is merely a list of confirmed ownership with supporting research. Let's take a look at the provenance for a painting. The provenance of *Young Woman Drawing* is recorded as:

> Val d'Ognes family; commandant Hardouin de Grosville (by 1897–1912; sold to Wildenstein); [Wildenstein, Paris,

1912; sold to Rothschild]; baron Maurice de Rothschild, Paris (1912–15; sold to Wildenstein); [Wildenstein, Paris and New York, 1915–16; sold to Fletcher]; Mr. and Mrs. Isaac D. Fletcher, New York (1916-his d. 1917)[7]

This listing seems complicated, but it provides the people who owned the work, and dates when the work was transferred to another party, starting with the earliest known owners. Part of the text included with the painting gives the final clue as to what happened to the work; the work was part of the Mr. and Mrs. Isaac D. Fletcher Collection and was a bequest of Isaac D. Fletcher to the Metropolitan Museum of Art 1917.[8] But what happens when you know very little about the work of art?

If we look at the provenance for a work of art that has been excavated and found its way into a museum collection as opposed to being created and transferred by sale, we will see a difference. This is the provenance for an Egyptian work of art from the Metropolitan Museum of Art. The provenance for the faience *Hippopotamus* of ca. 1961–1878 BC. is as follows:

Excavated by Sayyid Pasha Khashaba (Said Bey), May 1910. Acquired by Khashaba in the division of finds. In Cairo with Maurice Nahman, November 1910. Purchased from Nahman by Dikran G. Kelekian, 1911. Purchased from Kelekian, 1917[9]

With this kind of a provenance, the exact creation date as well as its original circumstances are unknown, so the first entry is when the object was excavated, instead of created. The provenance also lists a time when it was documented to be in someone's possession and that location.

At the time that the *Hippopotamus* above was excavated, many unscrupulous people were passing off forgeries as real excavated antiquities, and so all of these little verifiable details help confirm the authenticity of this particular object. Also, the fact that the Metropolitan Museum of Art lists each object's provenance prominently on their website creates transparency and gives a feeling of trustworthiness in an institutional system that has historically been plagued with black market acquisitions. In conclusion, provenance seems very simple, but it can affect the reception of the work of art (whether it is considered real or not), which can then affect the value of the work of art, and even the perceived cultural value of the work of art.

Interpreting Art: Evaluation and Meaning

Art is a highly subjective field to study. Art is evaluated every day by both professionals and regular people. Everyone has an opinion about art or specific artworks, some personal and some professional, and all are considered to be valid approaches for understanding art. The following are a few examples of structured approaches that art historians use to evaluate art, from public to private, historical to modern. As you will see in the section on art history methodology, each approach has its parameters and limitations, so art historians today tend to combine approaches, using the ones that suit their works best in order to provide a greater, more well- rounded picture of the work of art.

Structured Approaches to Evaluating Works of Art

Aesthetics, Taste, and Connoisseurship

One of the older, more established approaches to evaluating art revolves around the study of aesthetics. **Aesthetics** is a branch of philosophy concerned with beauty in art, and one of the central aims of aesthetics research is to try and determine the nature of beauty and how it is understood by viewers of art. One of the debates surrounding aesthetics is whether beauty is inherent to the artwork and recognized by viewers, or whether beauty is something that is not inherent to the work of art, but is determined by each culture and era. The eighteenth-century philosopher Immanuel Kant wrote about art, and in his writings claimed that beauty is universal. What he meant is that if an object is beautiful, then anyone from any culture should be able to recognize its inherent beauty. Beauty, he claimed authoritatively, resided in the object itself. Today, however, it is believed that concepts of beauty are constructed in cultures and even vary from person to person, depending on cultural background and upbringing. This involves a certain amount of cultural relativism, meaning that we must understand works of art differently from different cultures. Art historians today generally agree that in order to

understand a work of art you must first try to understand each culture's concept of beauty for a given time, and whether or not a certain work of art is, or was, considered beautiful in its time. It seems necessary, then, that certain criteria must be developed for evaluating works of art.

The criteria for evaluating western art are bound up in the concept of taste, and there are two approaches to understanding the concept of taste. The first approach concerns individual taste, or preferences, and the second is the concept of "cultured" taste, or whether or not you have "good taste" or "bad taste." The first facet is merely whether or not you personally like something. Personal preference is considered a valid approach for appreciating art, but in art appreciation we stress that personal preference be well-reasoned and not wholly arbitrary. The first gut reaction to a work of art of approval or disapproval is a valid response that should ideally be followed with personal reflection on why or why not a work of art is liked or disliked. Personal preference is conditioned by culture and sometimes it is difficult to appreciate something artistically from outside of your comfort zone, so this must also be taken into account when viewing and evaluating works of art.

The second meaning of taste refers to cultural judgments and acceptable standards of conduct for a culture or society, and is intertwined with the concept of connoisseurship. **Connoisseurship,** as a category for understanding art, is the evaluation of works of art for the purposes of attribution and inclusion in the Canon of art. A connoisseur has been described as, "an authority on beauty and aesthetics, who is more capable than others to pass judgement [sic] on the quality of cultural objects [art]."[10] Connoisseurship, then, involves close examination of a work of art, and a connoisseur may have detailed knowledge about intimate details of the work of art not readily observed by the general public. It also implies a person whose interest in a subject verges on obsession. Imagine a scenario in which you encounter a person in a casual setting that you have not yet met and, in the course of conversation, ask him or her about his or her preference for wine. Consider these two possible responses:

I like wine.

I am a connoisseur of wine.

The first response implies a passing regard for the item in question, while the second response implies a thorough knowledge

and appreciation of the subject far beyond the former. That thorough subject knowledge is what separates a connoisseur of art from someone with a passing interest. In the last half century, connoisseurship has declined in popularity as social history and new art history approaches have taken over as dominant methodologies. Connoisseurship is often now regarded by some in the field of art as outdated or old-fashioned, but the connoisseur still has an important place in art appreciation that cannot always be replaced with social art history, especially in the evaluation of the authenticity of works of art. Connoisseurs' knowledge can be used to authenticate works of art.

Bringing this back to our discussion of taste, taste relates to connoisseurship because the connoisseur is often seen as an arbiter of "good taste," or all that is worthwhile to appreciate, or of high quality. We have all seen something that made us think, "that's in bad taste." Today, a lot of people express disapproval of something by saying "that's trashy" or "that's tacky," but what they are really doing is making a value judgment based on the norms of their own society or lifestyle, or even age group. This implies some amount of relativism in general in the making of judgments, and so you might be moved to think that taste is "in the eye of the beholder," but remember that there are norms in society that condition our acceptance of what is in good or bad taste, and that there are also norms in the art world. If you do not agree with this premise, just think of the typical reaction of a group of people to the "taboo" topics of incest, murder, or even cannibalism. It would be very difficult to use cultural relativism to explain these taboos as harmless manifestations of a society. In art appreciation, there are certain parallels between taste and the evaluation of art, but in art we talk about "good art" and "bad art." Discussing art as either "good" or "bad" is a touchy subject because it does imply a value judgment that transcends the supposed impartiality of art historians. Art historians tend not to talk about "good" or "bad" art, but those are precisely the terms that many students use to refer to works they either like or dislike.

Art Criticism versus Historical Scholarship

When we think about what makes art "good" or "bad," we often think about the writings of art critics. **Art criticism** is a field that engages in making a clear distinction between "good" and "bad" art, and this open evaluation of artworks often involves personal

opinion based on scholarship, or even informed personal preference. How then, is the art critic different from the art historian? One source highlights the difference between art history and art critcism:

> It is sometimes argued that there is a clear distinction between scholarship (or art-historical research) and criticism. In this view, scholarship gives us information about works of art and it uses works of art to enable us to understand the thought of a period; criticism gives us information about the critic's feelings, especially the critic's evaluation of the work of art. Art history, it has been said, is chiefly fact-finding, whereas art criticism is chiefly fault-finding.[11]

What is also unique to art criticism, and what also separates art criticism from art history, is that art critics evaluate the newest works of art or newest art exhibitions. Art critics are the people who see the newest gallery showings and write about what they see. Some critics evaluate older works of art, but they are most effective when they tell us what they think of new artists, since art historians traditionally cover older works. In recent years, however, increasing numbers of art historians are specializing in contemporary art, and this enables them to work as both art historians and art critics.

Art historians who engage in historical scholarship, on the other hand, are distinct from art critics because art historians are generally concerned with reading and researching works of art in as neutral an atmosphere as possible. Whereas art critics make their mark by criticizing works of art, art historians try to investigate correlations between history and art, and to reconstruct the time period in which the artist lived and even his or her living conditions. Art historical scholarship involves the evaluation of historical documents and in-depth research. Current thought, however, makes the argument that no scholarship is impartial since we are all products of our time and culture, and that our own time and distance are barriers to clear understanding of other times and places. Art historians have responded to this criticism by acknowledging their own biases in their writing and letting the reader know their background or philosophy on art.

Methodologies of Art History

Understanding the content of a work of art can be a complex task. As a response, art historians have developed a number of formal structures, referred to as methodologies, to provide a

framework to aid in research and writing about art. These methodologies can be fairly complex to understand, but they generally guide interpretation of art. If you were to decide to become an art historian and continue your education in graduate school, you would learn about the different formal approaches art historians use to describe and understand art. These methodologies serve as a basis for understanding art as well as the discipline of art history. The following methodologies are among the most straightforward and easily applied to evaluating and interpreting many different works of art. Each approach has its parameters and limitations, so art historians today tend to combine approaches, using the ones that suit their works best in order to provide a greater, more well- rounded picture of the work of art.

Formalism

In Chapters Five, Six, and Seven we will look at the formal elements of art, color, and principles of design. **Formalism** is an approach to interpreting a work of art through an evaluation of its formal elements, focusing on form over content. Using formalism, you do not have to know the content of a work of art in order to appreciate it because the visual impact of the arrangement of formal elements is more important than interpretation. When we only look at structured elements to visually describe a work of art, we are engaging in a formal discussion of the work of art. Instead of describing a scene that may be depicted on a painted surface, we might describe the way the artist uses line, or light and shadow in the work of art. This approach can be useful when trying to discuss a work of art from another culture or a work of art that you do not know anything about; it is an objective inroad to discussing a work of art. Unfortunately, strict formalism necessarily involves ignoring the context and content of a work of art, and its use has been criticized as an approach to understanding because it ignores social and historical context as well as biography, providing an impersonal account of art.

Iconography and Iconology

Iconography is a process by which the viewer tries to determine the meaning of the visual elements present in a work of art, progressing from general to specific, in order to construct an underlying narrative for a work of art. Iconography is used to determine the specific meaning of objects and images, while

iconology looks at the relation of the image to the larger social context of the art itself. An art historian relying on iconography would first identify specific elements in the work of art, try to determine what they mean by themselves, and then construct a narrative of the work from the interplay of its distinct elements. In this process, content is more important than form. However, strict adherence to this approach may neglect certain elements related to form that are important in understanding the work of art.

Biography and Autobiography

One approach to understanding a work of art is to look at the life of the artist. Since formalism and iconography tend to ignore the role of the artist in creating a work of art, some art historians appreciate biography for its emphasis on art as a production of an individual human being. Many artists, on the other hand, especially like biography because they often feel that their role in creating a work of art is neglected through formalism and iconography. In the introduction to a series on artists' accounts of their own works, the following passage sums up a desire to focus on the artist in studying art:

> The history of art has run a complex and often confusing course, and yet we still rely heavily on critics and historians to interpret for us the developments of modern art and even the works themselves. Robert Motherwell, one of America's most distinguished artists and the originator of *Documents of 20th-Century Art*, believes that the writings of artists and their associates should be made available in English to enable students, artists, and general readers to study and understand the art of this country at its source.[12]

Biography and autobiography together can be useful, to an extent, in understanding a work of art, but must be applied with caution. Like the phrase "hindsight is 20/20," we tend to know much more about the context of an artist's life through research than the artist knew when he or she was alive. Events that happened at the time the artist lived may, or may not, have affected their life and their work and art historian have to tread lightly and carefully when relying solely on biography. Of course, the greatest limitation to relying solely on biography and autobiography for understanding art is that it is limited only to artists

who actually have biographies, and works of art that are correctly attributed. Some works are evaluated biographically, only to later find out they were by another artist.

Age and proximity of death is also another area of biography where caution must be taken. It is often recounted that Gianlorenzo Bernini's (1598–1680) later works were very religious because he was close to death. It is true that Bernini was quite advanced in age, but he did not know exactly when he was going to die, so how could his impending death affect his work? More than likely, he became reflective in his later years and so turned more towards religious subjects. Another example of biography and art evaluation is the case of Michelangelo Merisi da Caravaggio, known to us simply as Caravaggio (1571–1610) who used his own likeness for the image of the beheaded Goliath in his *David with the Head of Goliath,* painted between 1606 and 1610. It is well-known that in 1606, Caravaggio murdered a man and fled from where he was living in Rome, so many people relate the use of his face for that of Goliath to his tumultuous life. However, his other works are deeply moving and realistic religious works. How, then, can we reconcile Caravaggio as Goliath with the Caravaggio as creator of religious images?

Feminist Art History

Closely tied to biography is the approach to art through gender, known as feminist art history. **Feminist art history** is considered a contextual approach because the focus is on studying women artists, how works of art depict women, and how works of art by women are received. Feminist art history has much in common with biography because feminist art history attempts to balance the impersonal approach of formalism by focusing on gender and might raise the question of why not many women are studied in art history, or how the treatment of women in society reflects them as subjects of art. Feminist art history has been very useful in highlighting how art can reflect social conditions, but feminist art history can also be taken to an extreme where the methodology is applied too strongly to a work of art, in effect resulting in a distorted interpretation. In the following chapter you will be able to read how some art historians have used gender to explain art, from the placement of figures in a composition, to the treatment of a subject of a composition.

CASE IN POINT
Finding Balance in Interpretation

It may seem confusing to try to understand works of art with the variety of approaches available today. In the previous section, we saw how art historians can apply a number of different methodologies to understand art, and in this section you will get to see how a number of different authors have approached the same work of art, and the variety of ways they have described these works. This section uses some well-known artworks as examples to illustrate the different interpretations art researchers can bring to a work of art and for each artwork provides a variety of interpretations for the same work of art. Look closely at the work of art as you read the varied descriptions, and you will begin to appreciate how art historians approach sorting out meaning for different works of art.

CASE STUDY #1
Dorothea Lange, *Migrant Mother, Nipomo,* 1936

The subject of *Migrant Mother, Nipomo* [Figure 1] is a mother and her three children. The story behind this work of art is that Dorothea Lange encountered this woman and her family when she was hired by the United States government to document the plight of migratory pea pickers who were suffering because the crops had failed that year. Without any income, this family was destitute and desperate for relief. Other photographs from that same day show them sitting under a makeshift canopy with a few of their only possessions and a popular and inaccurate anecdote has the family having just sold the tires off their car for money to buy food.

The first description of this work of art comes from the book *Practices of Looking* by Marita Sturken and Lisa Cartwright, where the two authors take a visual culture approach to understanding meaning in Dorothea Lange's *Migrant Mother, Nipomo, California.* They write that:

> Dorothea Lange depicts a woman, who is also apparently a mother, during the California migration of the 1930s. This photograph is regarded as an iconic image of the Great

Depression in the United States. It is famous because it evokes both the despair and the perseverance of those who survived the hardships of that time. Yet the image gains much of its meaning from its implicit reference to the history of artistic depictions of women and their children, such as Madonna and child images, and its difference from them. This mother is hardly a nurturing figure. She is distracted. Her children cling to her and burden her thin frame. She looks not at her children but outward as if toward her future—one seemingly with little promise. This image derives its meaning largely from a viewer's knowledge of the historical moment it represents. At the same time it makes a statement about the complex role of motherhood that is informed by its traditional representation. . . .this photograph denotes a mother with children, but it casts this social relationship in terms of hunger, poverty, struggle, loss, and strength. Thus, it can be read in a number of ways.[13]

Sturken and Cartwright are making an observation about this work of art based not only on the iconic image of the Great Depression it presents, but also on the pose of the central figure in relation to her children. Other sources write that it was common of Dorothea Lange to pose her subjects for the most dramatic effect possible because she was hired by the United States government in order to document the rural poverty of displaced migrant farm workers such as this family. The despondency that Sturken and Cartwright read into this image may then be seen as being somewhat incorrect. The placement of the children is deliberate and although it *does* seem that they "cling to her and burden her thin frame" it seems like a stretch to conclude that this woman is "hardly a nurturing figure." That does not seem to be something that can be substantiated by viewing this photograph.

Other art historians have described this mother's seeming distance as being introspective, or sad, or even that her attention is otherwise distracted. The variety of interpretations for this woman's state of mind evidences the variety of interpretations that each viewer can bring to any work of art. This underscores the idea that ideas are not fixed to works of art, but depend on the viewer and

(*Continued*)

CASE STUDY #1 *(Continued)*

the viewer's own set of assumptions. Another textual account about this work of art approaches it with a focus on Dorothea Lange:

> Dorothea Lange, trained as a studio photographer, first turned to documentary photography in the early 1930s. She joined the FSA [Farm Security Administration] in 1935, hoping that her photographs might be used to improve conditions for farm families living in California migrant camps. She photographed Florence Thompson, a destitute pea-picker, in several different poses and from different angles before she got the shot she wanted. While printing the image, Lange cropped out much of the surrounding imagery, dramatically focusing attention on the migrant mother's anguished expression.[14]

In this second description, we are informed that this was, in fact, a posed photograph and that other such images were actually taken that day. In addition, we learn that only one was chosen as having the effect Lange was seeking, informing us that Lange made a conscious decision about which image was the most striking. Then, we are also told, Lange cropped the image for more dramatic effect. Lastly, we are also given the woman's name, Florence Thompson, which is a much more personalized approach than that of Sturken and Cartwright, who approach the image as an icon, and not as the recording of an intimate photograph of a real woman. Sturken and Cartwright characterize her expression as "distracted" while Venn and Weinberg characterize it as "anguished."

Out last, and shortest, appraisal of this image is as concise as it is impartial in its attempt to describe the subject of the image:

> With empathy and respect towards her subjects, Lange photographed a tired, anxious, but stalwart mother with three of her children in a migrant worker camp.[15]

In this brief description we are given both information about Lange, her attitude towards her subject, and the psychological and physical condition of her subject. These three interpretations of the subject of the same work of art serve to illustrate how interpretation of mood in portrait is subjective and difficult to arrive at. Too much interpretation can become imaginative and misleading rather than informative, and sometimes a direct approach brings the most clarity.

CASE STUDY #2
Jacques-Louis David, *Oath of the Horatii*, 1784

Jacques-Louis David's (1748–1825) *Oath of the Horatii* [Figure 8] is a well-known work of art from the late 1700s in France that has been the subject of many different interpretations by art historians. David's life is also quite interesting; after the French Revolution of 1789 David fell in with a radical faction and became head of propaganda, organizing rallies and making works of art that were increasingly radical in subject. As the French Revolution continued, factions quickly gained and lost political power which led to a very unstable situation in Paris. At one point, the faction David was affiliated with lost control and David found himself in jail awaiting death by guillotine. David began a campaign to remind the people of France that he was talented painter and to distance himself from his radical past. The ploy eventually worked, and David won his freedom and escaped the guillotine only to move into the service of the court of Napoleon when he came to power. David signed an oath of allegiance to Napoleon and when his rule came to an end, David had to leave France for his own safety.

The painting, *Oath of the Horatii*, predated David's brushes with the law, but is an artifact of the brewing political situation in France that would lead to the French Revolution just years after the work was completed. At this time in France it could be dangerous to challenge the authority of the rule of the king and artists who wanted to make political statements usually did so by using scenes from classical mythology that were widely known. In this case, the scene shows the three Horatii brothers who raise their arms as they swear on the swords held by their father that they will fight, or die fighting, for Rome. In the background their female relatives are filled with anguish and grief at the prospect of impending battle. Of the *Oath of the Horatii*, one art historian writes:

> Commissioned by the king, painted by the leading classicist of the time, the *Oath* is nevertheless a revolutionary work— and David was, for much of his career, a revolutionary artist. Here he enlisted a Roman myth in the service of ideals that would lead to the king's losing his head [in the French Revolution]. Louis XIV must have regarded the painting as an allegory celebrating patriotism. Others saw it as a summons

(Continued)

> to revolution. The ideals it extolled were unity, sacrifice, simplicity (a republican, not a royalist, virtue), and willingness to kill for the sake of civic honor. During the revolution David became the artistic dictator of France. Afterward, he became Napoleon's official painter. Always he believed that art "must be the expression of an important maxim, a lesson for the spectator. . . ." And by "lesson" he meant an idea that is acted upon.[16]

This description of the artwork crafts *Oath* as a piece of political allegory, understood by the people as a call to arms over the dire political and social situation in France. The art historian sees in this work evidence of the impending French Revolution, and the description itself follows a long-standing interpretation of the work of art perpetuated by most art historians.

Other, more recent, art historians, however, have cast this work in a different light, choosing instead to see evidence of gender bias, and *Oath of the Horatii* has come to be used as a popular visual example of the unequal gender roles in France at that time. A feminist art historian describes *Oath* in this manner:

> The severity and rationality of David's Neoclassicism, and his themes of patriotic virtue and male heroism, are important forerunners of the political and social upheavals of the next decade. The presentation of a world in which sexual difference is carefully affirmed is fully realized here. Not only are clear distinctions drawn between the male figures who, erect and with muscles tensed, swear allegiance with drawn swords, and the female figures who swoon and weep, but the entire composition reinforces the work's separation into male and female spheres. The arcade that compresses the figures into a shallow frieze-like space also contains the women's bodies within a single arch. Their passive compliant forms echo the poses and gestures of Kauffmann's [another, female, artist of the time] female figures, but here the sexual division into separate and unequal parts, which is intimated in so many earlier works, is given the absolute definition soon to be institutionalized in revolutionary France.[17]

These two descriptions are both informative, but provide a totally different interpretation of the same work of art; one seeing it in

CASE STUDY #2 (*Continued*)

light of social and political history, and the other seeing it in terms of gender. Nothing has changed about the subject of the painting between when these appraisals were written, but it is the approach of the historian that has changed. Apart, these summaries give markedly different viewpoints, but together they help to form a more complete story that speaks to the subject of the painting as well as the social situation in France at the time.

CASE STUDY #3
Pablo Picasso, *Les Demoiselles d'Avignon*, 1907

Earlier in this text we looked at the situation surrounding the creation of *Les Demoiselles d'Avignon* [Figure 4] in 1907 by Pablo Picasso when, after a tepid reception to his latest work, Picasso hid it away from public view for many years. Accounts of the subject of *Les Demoiselles* are varied and often stymied by the abstract quality of the painting, a painting without narrative. In the previous two examples a narrative, or story, could be constructed for each work, describing the back story as well as how the appraisal of the works fits in with their narratives. In the case of abstract works, writers seem to have a hard time evaluating artworks and instead tend to skirt the issue by describing seemingly irrelevant issues. Sometimes, it seems easier for art historians to talk about what is *not* there or what was initially *planned,* than what is actually present, and the following description comprises the bulk of what was said in a very short description of the painting:

> Studies show that originally Picasso had envisaged a
> composition with seven characters, two of whom were men,
> one a medical student, the other a sailor. In later studies he
> removed one of the women, changed some of the figures'
> posture and increased the angularity of their arms. The student
> became the woman on the left, his arm transformed into a
> breast, with a drape providing no more than token protection

(*Continued*)

CASE STUDY #3 *(Continued)*

of her modesty. Finally, the sailor disappeared, leaving us in the company of five women whom we can imagine as prostitutes, soliciting the observer with their insistent looks. There is a classical quality to the pose of the two central women. The faces of the two on the right have been disfigured by shading and, to make matters worse, the figure sitting with her back to us is presented full face, her chin resting on a deformed hand. We know that from contemporary observers and from X-rays that Picasso reworked these faces on the canvas itself.[18]

In this account, we learn about X-rays and the initial planning of the composition, but that does not truly inform us of how the *final* composition works. In this next account, the author makes a daring leap into explanation by attempting to describe the form and the effect it has on the reception of the work of art:

In this great composition Picasso follows up the new line of development which had started with Cézanne's rigorous nude compositions, but extends still further back to primitive humanity's earliest, most rudimentary experiments with form. . . . The large forms of the bodies confront the viewer in all their angular, grandiosely conceived ponderousness. . . . [the side figures] have been built up out of large, firmly defined planes, which are no longer modeled by light and by the contours that light reveals, but are as though hacked out with a knife and chisel. Especially do the heads of the two nudes at the right reveal the will to new form: the most dramatic contrasts supplant ordinary transitions, and thus in magic violence the new pictorial idiom is born. Even the space in which the figure stands seems to be sculptured—it is not an atmosphere . . . but a volume, a mass.[19]

This formal description is informative, but still something is missing in this description: the human element. In our final account, we go to the source of the painting, the words of Picasso himself. This is Picasso's own account of *Les Demoiselles* as recounted in an interview in 1933:

Les Demoiselles d'Avignon, how this title irritates me. Salmon invented it. You know very well that the original title from the beginning had been *The Brothel of Avignon.* But do you know why? Because Avignon has always been a name I knew very well and is a part of my life. I lived not two steps away

CASE STUDY #3 *(Continued)*

from the Calle d'Avignon where I used to buy my paper and my watercolors and also, as you know, the grandmother of Max came originally from Avignon. We used to make a lot of fun of this painting; one of the women in it was Max's grandmother, another one Fernande, and another one Marie Laurencin, and all of them in a brothel in Avignon. According to my original idea, there were supposed to be men in it, by the way, you've seen the drawings. There was a student holding a skull. A seaman also. The women were eating, hence the basket of fruits which I left in the painting. Then, I changed it, and it became what it is now.[20]

Finally, we have an account that pulls the essence of the other two passages together to form a complete picture, but by itself would be as limiting as the other two descriptions. Through a combination of all three descriptions, we learn here about the original composition, the finished composition and its formal elements, as well as the subject matter and what it really meant to Picasso.

CHAPTER SUMMARY

- Art history and art appreciation are two distinct approaches to understanding and explaining art. Art appreciation focuses on understanding art through formal elements or themes, while art history is a formal discipline focused on uncovering the social and historical relevance of a work of art.

- There are two key figures in art history, Giorgio Vasari and Johann Joachim Winckelmann. Vasari is considered the first person who attempted to construct a narrative history of art based on biography with the publishing of *Lives of the Artists* in 1550. Winckelmann's writing in the 1700s is responsible for the concept of studying art in terms of periods and styles and his studies of classic art further reinforced the notion that the classical period is the epitome of artwork in the western world.

- The story of art is broken down into roughly chronological cultural periods that help formulate an easily understandable history, but do not express the complexities and cultural interrelations of the various cultures.

- Art historians look to the areas of authorship, content, context, interpretation, and patronage and ownership to create an understanding of a work of art. These areas are mutually dependent on one another; a change in one area affects a change in another area.

- There are many approaches to evaluating works of art that range from informal to formal approaches. Aesthetics, taste, and connoisseurship all guide the appreciation of art in different ways.

- Art criticism and art historical scholarship are two unique and distinct approaches to evaluating works of art.

- Art historians use formal structures, or methodologies, to provide a framework to aid in research and writing about art. These methodologies include, but are not limited to, formalism, iconography and iconology, biography and autobiography, and feminist art history.

NOTES

1. Thomas, Kelly Devine. "The Newfound Pollocks: Real or Fake?" *ARTnews*, summer (2005). http://www.artnews.com (accessed May 31, 2007).

2. "Pollock Positive?" *Art & Antiques*, March (2007): 46.

3. A bit of information for this work of art can be found by searching the website for the Metropolitan Museum of Art, www.metmuseum.org

4, 5. Each work of art on the Metropolitan Museum of Art website is accompanied by a provenance and a description. www .metmuseum.org/Collections

6. Arianna Stassinopoulos Huffington, *Picasso: Creator and Destroyer* (New York: Simon and Schuster, 1988), 93.

7, 8. Accession Number 17.120.204, Metropolitan Museum of Art Collection Database, accessed March 18, 2014, http://www .metmuseum.org/Collections/search-the-collections

9. *Hippopotamus*, Accession Number 17.9.1, Metropolitan Museum of Art Collection Database, accessed December 18, 2013, http://www.metmuseum.org/Collections/search-the-collections

10. Lisa Cartwright and Marita Sturken. *Practices of Looking: An Introduction to Visual Culture* (Oxford: Oxford University Press, 2001), 49.

11. Barnet, Sylvan. *A Short Guide to Writing About Art* (New York: Longman, 6th edition, 2000), 172.

12. Introduction to Dore Ashton. *Picasso on Art: A Selection of Views* (England: Penguin Books, 1972), no page given.

13. Lisa Cartwright and Marita Sturken. *Practices of Looking: An Introduction to Visual Culture* (Oxford and New York: Oxford University Press, 2001), 37–38.

14. Beth Venn and Adam D. Weinberg. *Frames of Reference; Looking at American Art, 1900–1950* (Berkeley, Los Angeles and London: Whitney Museum of Art in association with University of California Press, 1999), 87.

15. H. H. Arnason. *History of Modern Art: Painting, Sculpture, Architecture, Photography* (Revised by Peter Kalb. New Jersey: Prentice Hall, 5th edition, 2004), 395.

16. Edmund Burke Feldman. *The Artist.* (Prentice Hall, New Jersey, 1982), 112.

17. Whitney Chadwick. *Woman, Art, and Society.* (London: Thames and Hudson, 1990), 162.

18. Boone, Danièle. *Picasso* (New York: Portland House, 1989), 64.

19. Jaffé, Hans L. C. *Pablo Picasso* (New York: Abradale Press, Harry N. Abrams, Inc., revised edition, 1982), 80.

20. Ashton, Dore. *Picasso on Art: A Selection of Views* (England: Penguin Books, 1972), 153.

ART AND ARTISTS

Caravaggio, *David with the Head of Goliath* 1606–10. Museo Galleria Borghese, Rome.

Dorothea Lange, *Migrant Mother, Nipomo Valley*, 1936. The Dorothea Lange Collection, The Oakland Museum of California, City of Oakland.

Jacques-Louis David, *Oath of the Horatii*, 1784. Museé du Louvre, Paris.

Leonardo da Vinci, *Mona Lisa*, ca. 1503–05. Museé du Louvre, Paris.

Marie-Denise Villers, *Young Woman Drawing*, 1801. Metropolitan Museum of Art.

Pablo Picasso, *Les Demoiselles d'Avignon*, 1907. Metropolitan Museum of Art, New York.

Pablo Picasso, *Les Demoiselles d'Avignon*, 1907. The Museum of Modern Art, New York.

CHAPTER 3 Art Education

THE TOPIC OF THIS SECTION is how people come to understand art and how art is mediated to the viewer through education. Art is a cultural expression, and because of this, everything surrounding the subject of art is constantly evolving. If a person wants to become an artist, there are currently two approaches: attending a formal educational program to learn about art, or teaching oneself how to be an artist. The following section will examine each of these two approaches as well as how people have historically been trained as artists because the way that art is studied in the modern world is not the way it has always been studied. It is important to understand artistic training because it can influence the nature of art. For example, if a student is always taught that art is one thing, then that student may always produce art that conforms to that ideal.

Formal Artist Training

Formal artist training consists of completing a formal course of study with set requirements and a specified goal, such as would be provided at a local college or university, or even a course at an art academy or learning about art from an established artist in a structured course. Formal training in the arts suggests that the student has had some sort of direction in the creation of art, although the form of that direction can be quite varied. In order to fully understand formal art training, our discussion will begin with historical art training and progress forward in the history of western art to the present formal art training system.

Historical Formal Art Training

In the middle ages in Europe, artists were considered to be skilled craftsmen, and art training consisted of membership in the guild system, which acted much like a modern workers' union, providing strength in numbers to protect members' economic interests. The guild system is not unique to Western Europe, guilds also existed in the Middle East as well as Asia;[1] but it is the medieval European guild system with which most people are familiar. In the European guild system, a master craftsman was in charge of his own shop and would accept an apprentice to learn the trade. The apprentices started their training at an early age and spent many long years under the tutelage of their master. The apprentices lived with their trainers, almost like family, and the family of the apprentice paid to place their child in this position. The duties of the new apprentice would initially be only peripheral tasks such as cleaning and organizing the shop, but as trust in the apprentice grew, he would be given more and more responsibility and be taught the methods of the trade. The apprentice was brought up by the master to be a trusted assistant because the work of the apprentice reflected the work of the master. After a certain level of skill was gained, the apprentice would leave the master's shop as a journeyman, who could be paid for his work but was not yet ready to establish himself as a master. When he was ready and had enough experience, the journeyman would seek out the local guild and apply for, and perhaps be granted, membership based on the production of a work of art worthy of master status.[2] Upon obtaining the status of master craftsman, the cycle would begin anew with the master establishing his own shop and taking on his own apprentice.

Through the guild system, it was assured that master craftsmen had the skills necessary to be successful artisans, and that a certain level of quality was established for artistic training. The guilds, however, were not just limited to art production but also included such trades as furriers, stone masons, and bakers, to name a few. Part of the strength of the guilds was that they could regulate both internal and external operations. Regulating internal guild operations meant that they could restrict their membership and set standards for the quality of the materials produced by the members of that particular guild, and external operations could be regulated by members taking part in

local government to ensure that the interests of the guild were properly represented and protected. For example, if enough guild members were locally politically active, they could protect themselves from outside threats such as increased taxation. Changing perceptions of the role of the artist in society during the Italian Renaissance necessitated a change in art education. The concept of the artist evolved from that of a hired, skilled craftsman to that of a specialized professional with unique talents—the artist as a "creative genius." A change in perception, in turn, necessitated a change in how artists were trained, and the craftsman began to be separated in education from the artist while at the same time the social status of the artist increased. In some places, such as Florence, informal academies were established. These academies were not like academies in the modern sense with a set structure and program, but were places where young and established artists would get together to work and discuss art practice and theory. Formal art academies established by artists, clergy, and wealthy citizens would soon come, followed by private academies that were neither supported by church nor state. These independent academies soon flourished, and art education continued its evolution from a focus on the practical education of the guild system to art education in the manner of the academic learning emphasized by Renaissance humanism.

While art education was keeping pace with Renaissance humanism on the Italian peninsula, in other areas of Europe artists continued to be trained in a modified guild system, and were no longer content with it. It differed from the medieval guild system because the status of the artist had changed. One example is the Flemish (from the area of Flanders) artist Anthony Van Dyke (1599–1641) who, having spent his formative years from the age of ten as an apprentice to the painter Hendrik van Balen[3] and later as an assistant to the very well-known artist Peter Paul Rubens, eventually left Rubens's studio to become a much admired painter in his own right. Many artists followed this path, but the limitation of the educational system in Van Dyke's time was securing a position as an assistant to a well-known artist, and the guilds themselves could make it very difficult for a nonguild-affiliated artist to have an art career. This was the case in Paris in the early 1600s, where the art guild was powerful enough to prevent foreign artists

from working in the city. Artists in Paris became outraged at the power of the art guild and petitioned the king of France to establish an art academy to provide training for artists without the oversight of the art guild.[4] These artists traded the oversight of the guild for the oversight of the government.

The establishment of the *Académie Royale de Peinture at de Sculpture* (Royal Academy of Painting and Sculpture) in France in 1648 marked a significant change in art education similar to that in Renaissance Italy, providing a structured art education with clear requirements. The difference, however, was that this was a training program overseen by the government, which in itself had both positive and negative consequences. On the positive side, this was a boon to art because it opened up art education to far more aspiring artists than the guild system could, or would, allow. On the negative side, this art became a tool of the government where Academy membership was required and artistic standards dictated. For example, the Royal Academy began to hold an annual (later biannual) art exhibition known as The Salon, named for the *salon carré* (a room) in the Louvre Museum where it was held. To have work shown in the Salon, artists had to be members of the Royal Academy, and during the period of the Academy and the Salon, the subject matter and form of art was heavily influenced by these institutions. Artists who did not conform to both preferred subject matter and form set forth by the Academy could effectively be blacklisted from the art world. This art monopoly only truly came to an end when artists had had enough and started showing their art in alternative spaces and galleries, which undermined the supremacy of The Salon. The Royal Academy and the Salon lost the majority of their clout as art underwent a profound change in style in France with the advent of Impressionist artists such as Claude Monet and August Renoir, and Post-Impressionists Henri de Toulouse-Lautrec and Vincent Van Gogh in the later 1800s.

Contemporary Formal Art Training

Undergraduate

The main vehicle for artistic training today is through college and university art programs. At present, there are a number of considerations a person must take into account when choosing

a formal course of study in the arts, from the school itself to the courses of study offered. Some students, when choosing to attend a college or similar institution, may opt to apply to a place that has been associated with the names of famous artists in the belief that financial or career success may be associated with a certain institution. For other future students, the choice of which formal program to attend is about finding a program that suits the individual goals or needs of the student. Generally, it is better to find a program where the student feels comfortable in the environment and has teachers who are in the student's chosen area of specialization. In modern art education, if the student does not come into the program with an idea of the area of specialization in mind, then through the course of taking the required preliminary courses at the program (introductory level courses designed to expose the student to a variety of materials and working styles while at the same time developing the student's artistic skills) it is hoped that the student will find an area of interest on which to concentrate for the remainder of his or her program.

College and university art programs are structured to expose students to a variety of art techniques and forms while requiring extra classes in the chosen medium to help the student achieve both technical and ideological proficiency. Today, only a portion of art education is really about technique while the other half is learning how to think like an artist; how to solve problems visually and develop an underlying theme or message for your work. Making successful artwork is only the beginning, and will not always ensure a successful art career since the artist must be able to negotiate the complexities of the art world and will be expected to be able to define how their work fits into contemporary art while at the same time exemplifying uniqueness. In order not to ignore the "academic" side of the university and college system, artists are also required to take general education courses outside their field of study and are also usually required to complete a number of art history classes to inform them of what artists have done before. This follows the belief that you cannot do something new until you know what has already been tried.

The formal course of art instruction in a college or university today consists of a number of "foundation" courses to expose the student to drawing and sculpture and improving

observational skills. At this point the student should have decided on an area of art to specialize in such as painting, sculpture, photography, printmaking, graphic design, industrial design, furniture, or jewelry, to name a few. This specialization is often referred to as the student's emphasis. The degree itself will be a Bachelor of Arts or a Bachelor of Fine Arts with an emphasis in the area of specialization. For example, a painter's college degree might be worded "Bachelor of Arts with an emphasis in Painting." Different colleges and universities will have different specializations and this may necessarily be part of the process of choosing the appropriate educational institution. After the foundation courses, the student must take courses in his or her emphasis. These are the classes where the student is focused on learning the techniques necessary and creating a body of work that demonstrates a mastery of the specialization. For example, a painting student may take intermediate and advanced courses in painting as well as special topic activity classes, like figurative painting, or special topic seminar courses, like contemporary issues for painters. These advanced courses make up the last few years of the art student's education, and upon completion of the course of study for both the art department and the college, the student graduates.

In the current university and college system, the separation between artistic fields and academic fields is at times very sharp. There are visual problem solving skills that are developed in the course of studying art that can be very different from the analytical reasoning required to complete courses outside of the creative arts fields. Once a student is fully entrenched in art, it may be difficult to "think in other fields" that are less about visual concerns and more about theoretical reasoning. This is probably the reason that sometimes art students are not thought of as being as academically motivated as students in other fields, but at the heart of this misconception is really a different method of problem solving used in art. Sometimes non-art students will choose an art class as a general education requirement thinking that "this will be an easy A" only to do very poorly in the class because they are not attuned to the way artists are trained to work through visual problems. These are generalizations, of course, but generalizations founded on years of observation, going through artist training in a university and a private art college, and teaching art students.

Graduate

So now that the formally trained artist has his or her BA, what will he or she do next? This answer depends on many factors. Some artists cease their formal education at this point and just get around to the business of making art. Others choose to continue their formal education and work toward a graduate degree in art. The most widely recognized graduate degree in art is the master of fine art, or the MFA. It used to be that the MFA was as high as you could go degree-wise in art, but things have changed. There is now a PhD in art offered by a handful of colleges in the Unites States and also many colleges in Europe. Even though the PhD in art exists, the MFA is still the most commonly earned graduate degree for artists.

MFA programs are usually two to three years in length and are a time of focused study for an artist. An MFA program should ideally prepare an artist for a studio career and help them establish connections in the art world. Artists debate the necessity of the MFA degree because, by some accounts, only half of the artists in well-known galleries have them. However, if an artist wants to teach, the MFA is almost universally required by colleges and universities and is the degree required to teach anywhere from a community college to the Ivy League. Many artists are also suspect of taking on the debt of a graduate education in a field where the returns and ability to repay those debts may be uncertain.

During the course of an MFA program, the graduate student will spend time clarifying their aims as an artist, writing about their own work, learning to speak comfortably about their own work, learning how to present it to others, and developing a strong body of work while at the same time being able to experiment in ways they may not be able to do later during an established career. Oftentimes, academic courses in art history and criticism are required, papers are written, and articles and theories are debated in class. At the half point of the degree, a midpoint review is often conducted. In this review, the faculty will review the artwork presented and give feedback or even challenge the ideas of the artist. In an academic master's program, there may be no midpoint or the midpoint may be an exam. For an artist, this midpoint is often a conversation about your work with three professors who may verbally challenge

your ideas and evaluate how well you are able to defend you work. Your ability to take criticism and grow as an artist may also be evaluated. It is at this point, as it is in most master's programs, that a decision is made as to whether the student will continue on in the degree program. This whole process is very stressful and even more so when you keep in mind that many master's programs (not just graduate art programs) require students to maintain A to A- averages. Falling into the B range of grades is considered marginal and may be grounds for removal from a program.

If the graduate student passes the midpoint, then the next big step is finishing coursework and preparing for the final review and graduate exhibition that caps off their program. The final review is often a similar format to the midpoint review with questioning and challenging of the artist's ideas and work. Some schools require a short written component outlining the premise of the exhibition and clarifying the student's ideas. Some programs do not require a formal written component at all. In an academic master's program, the degree is completed by writing a thesis (a very, very long research paper). In an MFA art program, the completion of a cohesive body of work shown and evaluated at the end of the program takes the place of the thesis.

For some programs, the final review is the graduate exhibition, and for others it is two separate events. The graduate exhibition can be either a solo exhibition, part of a small group exhibition of graduate students, or as one large exhibition of all the graduating students at one time. For more prominent art schools and programs, these graduate exhibitions are like a formal coming-out party that signals that the artists are now making the transition from student-artist to professional artist. In these exhibitions, the work is presented to the public and a catalogue is printed, and it isn't unheard of for artists to get their first solo exhibitions or major sales from them. If the school is well-regarded or well-connected, all the best gallerists and collectors will come to the graduate exhibition to view the work. Some graduate exhibitions are even curated by guest curators from prominent local museums and galleries.

CASE IN POINT
Is Art a Worthless Degree?

Why study art? This is a question that is being asked more and more in secondary education and institutions of higher learning as budget cuts are forcing schools and colleges to evaluate curriculum, resulting in cutting arts programs and focusing instead on math and science at the expense of the creative arts. A recent Forbes article entitled "The 10 Worst College Majors" written by Forbes' staff writer Jenna Goudreau[5] starts out by declaring "Not all college degrees are created equal." It seems that every year a new article is published trumpeting the top ten most useless or top ten worthless degrees in college, and usually art and art history are somewhere in that list, if not at the very top. The article outlines a study done by the Center on Education and the Workforce at Georgetown University that evaluated majors on the basis of "career prospects and expected salary." According to their list, a fine arts major comes in as the third worst major you could earn.

The crux about a sensationalist article like this is that while it has an eye-catching headline, no one seems to be critical about the criteria used to define "worthless." When you read other articles like this about "useless" or "worthless" degrees, you find that the determination of "useless" and "worthless" is based solely on income amounts after graduation. This survey does not take into account job satisfaction, and in the process dismisses people who choose to study such fields as art and art history, not to mention archaeology, anthropology, women's studies, and even English, according to some articles. The influence of studying art on a person's quality of life is difficult to measure because it is usually not directly related to money. Having an arts degree does not guarantee a job right out of college, and for a lot of art students a career path in the arts is not a direct line from college to job placement. As degree attainment and income level often do not correlate in people with arts backgrounds, having an arts degree is not always viewed as being successful. However, is success just about making lots of money? What about job satisfaction as a measure of success? What about happiness? What about the freedom to live your life the way you want? These are things that many artists experience despite being constantly told how "useless" their degrees are.

(Continued)

CASE IN POINT *(Continued)*

A 2011 article written by Dan Berret entitled "The Myth of the Starving Artist"[6] notes that "graduates of arts programs are likely to find jobs and satisfaction, even if they won't necessarily get wealthy in the process." One of the sources that the article looks at for statistical information is an annual online survey of arts graduates done by the Strategic National Arts Alumni Project (SNAAP). Findings from this arts survey, which includes questions about income level and job satisfaction, "demonstrates that arts alumni enjoy roughly the same levels of employment, and satisfaction with their education and their careers, as other college graduates," says Bill Barrett of SNAAP. While arts' incomes are still overall lower than the earnings of other graduates, they aren't as bad as general perception would have you think. The facts show that people who self-identify as artists aren't generally making money hand over fist, but they aren't exactly starving either. Another researcher, Steven J. Tepper, is quoted in the same article as saying, "More generally, the disconnect between salary and security on the one hand and meaning and satisfaction on the other suggests that many arts graduates appear to have devised ways to negotiate uncertainty and low wages to find personal fulfillment." Artists are creative people, and that creativity extends to how they structure their lives as well. If we only look at wages as a measure of job satisfaction and degree worthiness, we are only seeing half of the bigger picture in terms of the arts. Therefore, the answer to whether art is a worthless degree depends on what you define as worthless and whether you prize money over job satisfaction.

Informal Artist Training

The second method for learning to be an artist is through informal artist training. **Informal artist training** is art instruction not learned as part of a formal educational program. Informal artist training is often referred to by a variety of other names such as outsider, naïve, or folk (as in folk art). As a caution, be careful of

the application of the term naïve since it can sometimes be used in a derogatory manner for informally trained artists. The term naïve art is used to refer to informally trained artists because the technique, not the artist, is considered naïve. Edmund B. Feldman, his book *The Artist*, asks, and provides an answer to, a relevant question about informally trained artists:

> If naïve artists lack professional knowledge of their craft, are they merely bad artists? Some are. However, professional artists can also be bad. In other words, badness is not solely a technical matter; anyone can fail artistically.[7]

Unfortunately, this is exactly the stigma under which informally trained artists must labor, that they are just making bad art. Informally trained artists whose work is collected shows talent, but the artist is not familiar with the formal conventions of art. Why do many people appreciate outsider art? Feldman claims it is because outsider artists are often creating art for the sake of creating art, and people who appreciate art appreciate the genuineness of the expression. Feldman writes that:

> Sophisticated viewers are often attracted to naïve art because they have grown bored with cleverness, the repetition of familiar themes, the same devices of visual organization, the simulation of emotions that are not felt, the reference to ideas that are not truly understood.[8]

For many, then, the draw to outsider art is its newness and the unjaded approach the artist brings to creating the art or, more precisely, the perceived innocence of the artist. That innocence is of the art world itself. These definitions, however, are not catch-alls for anyone not trained in a formal setting, but can include specific groups of people and their participants may often fall into more than one category. Categorizing informally trained artists is difficult because the whole field encompassing informally trained artists is not as regimented as it is for formally trained artists and, because of their diversity, informally trained artists do not have the same representation or unity as mainstream artists. Informal artist training can then have both a broad and a narrow definition, and each definition affects how the artwork is viewed, so it is worth looking at a number of these categories to see how they differ from one another. The following are but a few of the best known terms for categories of art made by informally trained artists.

Outsider Art

Outsider art, although technically referring to the production of art by anyone outside of the mainstream "art world," can also be a term used to describe artwork made by incarcerated individuals as part of criminal rehabilitation programs (or as a jail time pastime), and artwork made by people with diminished mental capacity or the mentally ill. Oddly enough, this category can also include artwork made by elephants at the local zoo such as Ruby (1973–1998) who resided at the Phoenix Zoo most of her life and raised almost $500,000 for the zoo from the sale of her artwork.[9] This is not to demean the production of artists in this category, but the sheer variety of art forms and different levels of quality included in this term can cloud our reception of the art itself.

Due to the fact that a number of outsider artists are part of marginalized groups in society, outsider art at this time has not enjoyed the same respect in the established art world as works produced by formally trained artists. However, a number of galleries and museums have devoted their exhibition and selling space to outsider art, in part, because of its novelty as being outside of the mainstream movement in art. Unfortunately, a number of critics have complained that once the artwork is shown in a gallery or a museum, that it loses its outsider status. If we then alter the definition of outsider art to be artwork from marginalized groups of people in society, then we do not encounter the same problem because it is unlikely that many of the aforementioned groups would have the interaction with the art world on the same level as other formally trained artists.

Art Brut

Art brut means "raw art" in French and was a term coined by the mid-twentieth-century artist Jean Dubuffet to describe works of art made by outsiders to the art establishment, but especially art produced by the mentally ill. Dubuffet believed that art produced by these individuals was the purest expression of art and collected thousands of examples that have been available for public viewing since 1976 in the city of in Lausanne at the Château de Beaulieu.[10] *Art brut* is different from outsider art in general because it is more of an art movement from a specific time period in art history and championed by a well-known artist.

Folk Art

The difference between folk art and outsider art or *art brut* is that folk art relies on the incorporation of traditional forms and images into the art. **Folk art** is created around the globe and is an expression that generally tends to be craft-based and utilitarian, drawing on a long line of traditional representations unique to a specific geographic area or culture. Folk artists tend to see themselves as one more link in a long chain of artisans and their focus also tends to be on expressing a collective tradition rather than creating a new individual representation. This is not to say that folk artists never create anything new or unique, but that is not the main thrust of their work. Folk art does change over time and new folk art expressions are continually developed, but the emphasis on maintaining tradition is central to folk art. Folk artists are also informally trained, having learned their techniques from family or friends, and folk art often overlaps craft production and some fine art. For example, some folk artists like Anna Mary Robertson (1860–1961), who is more famously known as Grandma Moses, are painters but their painting style is very different from traditional fine art painting because they do not conform to the formal elements of art (these formal elements are discussed in depth in Part Two of the text) and their figures may appear simplified and flattened. The style is very straightforward, the scene is easily understandable and this direct approach to painting is appreciated by collectors.

If some folk art is craft, how then does folk art differ from craft production? It depends on the form that the art object takes. Not all craft artists are folk artists, and not all folk artists are craft artists, but a lot of folk art relies on craft. In terms of style, folk artists tend to perpetuate traditional styles while craft artists may use folk art as a base and then go on to create their own expression more loosely based on the folk art original. For example, Maria Martinez (c. 1887–1980) was a Native American Indian potter from the San Ildefonso Pueblo in New Mexico. She specialized in creating black-on-black ware pottery (actually matte-black-on-polished-black ware[11]), decorated with interpretations of pre-historic pottery designs unearthed from local archaeological excavations. The innovation that Maria discovered with her husband, Julian, was a method of firing that created a lustrous black surface in some areas while leaving a matte black surface in other areas [Figure 7]. Although originally made for educational

purposes, her pottery became known in its own right and people began to collect it. As her skill grew, she tried new interpretations of traditional designs. Maria, as she is commonly known, started out as a folk artist because her early works drew upon a long-standing tradition central to a specific geographic area, but her mature works elevated her work from folk art, to the level of craft art and, many would argue, to the level of fine art.

CHAPTER SUMMARY

- Artists may choose one of two paths to take for art training; formal or informal.
- Formal art training has a very long and structured history from the medieval guild system to modern day colleges and university art departments. Formal art training includes participation in a formal structured course of study with set parameters.
- Informal art training is a broad category that refers to any artistic training not covered by formal art training. Although informal art training does not always enjoy the same respect as formal art training, it has its own merits and the work of informally trained artists may also be hung in art museums and galleries.
- Included in the category of informal art training is outsider art, *art brut*, and folk art.
- Folk art and craft art often overlap, but not all folk artists are craft artists, while not all craft artists are folk artists. The distinction is whether or not tradition is the basis for the work of art.

NOTES

1. Edmund Burke Feldman, *The Artist* (New Jersey: Prentice Hall, 1982), 65.
2. Ibid., 72–73.
3. Erika Langmuir and Norbert Lynton, *The Yale Dictionary of Art & Artists* (New Haven and London: Yale University Press, 2000), 706.
4. Efland, Arthur D. *A History of Art Education*. New York: Teachers College Press, 1990.

5. Jenna Goudreau, "The 10 Worst College Majors," Forbes .com (Oct 11, 2012). http://www.forbes.com/sites/ jennagoudreau/2012/10/11/the-10-worst-college-majors/.

6. Dan Berret, "The Myth of the Starving Artist," InsideHigherEd .com (May 3, 2011). http://www.insidehighered.com/news/ 2011/05/03/graduates_of_arts_programs_fare_better_in_ job_market_than_assumed.

7, 8. Edmund Burke Feldman, *The Artist* (New Jersey: Prentice Hall, 1982), 30.

9. "Sad End for Phoenix's Celebrated Painting Pachyderm," CNN.com (Nov 6 1998). http://www.cnn.com./US/9811/ 06/dead.elephant/ (Accessed May 28, 2007).

10. Erika Langmuir and Norbert Lynton, *The Yale Dictionary of Art & Artists* (New Haven and London: Yale University Press, 2000), 29.

11. Richard Spivey. *María* (Flagstaff, AZ: Northland Press, 1979), 39.

ART AND ARTISTS

Formal Art Training

Gustav Courbet, *The Painter's Studio (Atelier)*, 1854–55. Musée d'Orsay, Paris.

Raphael Sanzio, *The School of Athens*, 1510–11. Stanza della Segnatura, Vatican Palace, Rome.

Anthony Van Dyke, *Charles I Dismounted, c.* 1635. Musée du Louvre, Paris.

Informal Art Training

Edward Hicks, *The Peaceable Kingdom*, c. 1834. National Gallery of Art, Washington, D.C.

Maria Martinez, née María Antonia Montoya, also known as Maria Poveka.

Grandma Moses/Anna Mary Robertson.

Henri Rousseau, *The Sleeping Gypsy*, 1897. The Museum of Modern Art, New York.

CHAPTER 4 — Museums and Conservation

ART IS VALUABLE, and because art is valuable we try to preserve it and house it in special places. The following is a concise history of spaces for exhibiting artwork. In western history, the development of the modern museum is often taught as a transition from personal acquisitions of extraordinary objects in secretive rooms, to large museums meant to provide the populace with a transformative experience. The concept of the museum as a public space must necessarily involve a discussion of the relation of museum to society. Unfortunately, there is a discrepancy in art history over exactly how far the history of the museum should be traced back in time; some people choose to start with ancient Greece, while others trace the beginnings to Renaissance Europe. For the sake of completeness, we will trace the roots of the museum all the way back to ancient Greece and then skip forward to the Renaissance in Europe.

A Brief History of the Art Museum

Our actual word for museum can be traced back to the ancient Greek word *mouseion* and was directly related to the concept of the muses in the arts. In Greek mythology, the muses were the nine daughters of Zeus, chief god of the Greeks, who were a source of inspiration to artisans and others in creative fields. The Greek *mouseion* was a structure for objects to honor the muses, but was

not like our modern concept of the museum because it celebrated not only painting and sculpture, but all the creative fields, and also sponsored lectures and performances. The Greek *mouseion*, then, is more on par with our conception of a modern cultural center.

The time between the Greek *mouseion* and the next major event in museum history in the Renaissance is time span of about fifteen hundred years. Part of the reason for this span of time is that sites for art generally tended to be places of worship (sacred spaces) and private homes (secular spaces). Art occurs in both of these spheres but we do not see the dedication of actual structures solely to art objects again until the Renaissance. When art is housed in a religious structure it is for the express purpose of the religion itself, and the fact that it may also be considered art is secondary to its intended purpose. In a home, certain objects may be considered art and treated with special reverence but, because homes by nature are private spaces, they do not usually qualify for the designation of museum.

A much discussed and debated precursor to the modern western museum is the Renaissance concept of the cabinet of curiosities, known in Italy as a *studiolo,* meaning "little study," and *Wunderkammer* or *Kunstkammer* in Germanic areas. *Kammer* is a chamber or a room, *Wunder* means wonder or miracle, and *Kunst* means art. These various cabinets were popular in Europe in the sixteenth and seventeenth centuries, and the placement of these collections in the timeline of museum development is often debated because they were not exclusively for housing art, but often also included natural objects and oddities ranging from stuffed birds to collections of seashells. These cabinets also tended to be private. The reason that these cabinets are studied is because they express certain concepts that museum researchers find in actual museums, namely the desire to catalog, preserve, and construct a narrative of knowledge.

The form of a cabinet of curiosities could be the size of a room or the size of a small piece of furniture with many drawers, like an actual cabinet. For example, the Italian *studiolo* has been described as:

> typically comprising a small, windowless room whose location in the palace was often secret, the walls of a *studiolo* housed cupboards whose contents symbolized the order of the cosmos.[1]

Studioli were not public spaces, but rooms reserved for the enjoyment and entertainment of a prince or other person capable of acquiring objects to collect. For example, there are accounts of a very famous *studiolo* arranged by Federico da Montefeltro, the Duke of Urbino, in Renaissance Italy. Other cabinets were later donated and incorporated into national museums. The arrangement of the contents of cabinets was determined by the owner as a personal expression of his or her understanding of the physical world, and could express an understanding of nature or science through their arrangement, and through the grouping of certain artifacts. In order to fully understand the arrangement of these cabinets, one would almost have to live at that time period, understanding the world in the way people of that time understood the world.

The Modern Museum

As the time period transitioned from the Renaissance to the modern period, people began to recognize the importance of Rome and its art, which was due in part to the earliest art historians who wrote about the glory of classical art, including the aforementioned Johann Joachim Wincklemann. Every well-born person who could do so would travel to see these great works of art in what would become known as the Grand Tour. Rome was an important stop and many wealthy people not only traveled to Rome to see the art, but brought works back home with them to other parts of Europe. People who traveled to collect art amassed great collections that they sometimes turned over to governmental institutions for protection and for the good of the country. At this time, national art museums funded by national governments were of supreme importance and major countries supported their own government-controlled museums in order to showcase art collected during colonization that was later donated from private collections. The collections themselves could be quite varied, ranging from masterworks of western art, non-western art, or even actual pieces of the Acropolis in Greece.[2]

According to author and art historian Tony Bennett, one of theories of how museums, as we know them, got their start in the 1800s was to enlighten the public by exposing them to the refinements of art.[3] It was believed that a person's quality of life could

be improved by viewing art, that art has a curative effect on the unenlightened populace. Bennett writes:

> Libraries, public lectures and art galleries thus present themselves as instruments capable of improving 'man's' inner life just as well laid out spaces can improve the physical health of the population.[4]

Bennett furthers his argument by asserting that the introduction/ formation of the modern museum was to be a tool of the government to mold its citizens into developing similar ways of thinking, that museum formation had an effect on national identity. In colleges today, classes outside your specified major are often required in an attempt to broaden exposure to other majors and ways of thinking, such as classes in the humanities to science or psychology. What is now required at colleges may seem akin to the purpose of the formation of the modern museum, but there is actually a fundamental difference. In 1800s Britain, it was believed that a transformation in the populace would occur not only by exposing the populace to the works of art, but by also exposing the populace to the high-class mannered people who regularly visited the museum. The museum then created a space where "the subordinate classes might learn, by imitation, the appropriate forms of dress and comportment exhibited by their social superiors."[5] While this may seem rather condescending in today's context, it is often thought today that class transformation can occur through structured education, or obtaining a degree. Each age, it seems, has its own strategy for improving the lives of the lower classes, and in the 1800s, the British thought it was through exposure to cultured life in the museum space. The function of the museum, then, was not just as a repository for beautiful objects, but represented the power of the government in its ability to acquire and display such objects of cultural importance.

Throughout the twentieth century, there has been a focus in the United States on the establishment of art museums. Art museums are independent institutions established to preserve and house art and can range from smaller regional institutions to larger well-funded museums. Many of these art museums are dedicated to the preservation and display of modern and contemporary art (from about 1860 to present); an area that used to be the domain of the commercial art gallery. Art museums can range from large institutions that showcase the work of a

single artist (such as the Andy Warhol Museum in Pittsburgh, Pennsylvania), or the smaller regional institutions and college art galleries found in most larger cities and on almost every college campus. Art museums can also contain the works amassed by a single collector transformed into a not-for-profit institution. The variety of art museum structures almost seems endless and, theoretically, anyone can establish an art museum, but unless the museum is well-funded, well-run, and well-supported by the community, it will probably not stand the test of time.

In regards to funding, art museums and cultural institutions in general may receive funding from a number of public and private sources including, but not limited to, private donations, general admission ticket sales funds, public tax money, the willing of estates, and operational grants from the government. Each museum, whether public or private, usually has its own hybrid source of funds, both from public and private sources. For example, private institutions may receive public monies from local governments in the form of revenues collected from hotel taxes levied on tourists. The rationale for providing a private institution with public money is that the local museums help draw the tourists to the city so that public monies collected from tourists are wisely reinvested privately.

In the last two decades of the twentieth century in the United States, the concept of the museum underwent a complete overhaul. An increasing number of museums transitioned from repositories of important cultural artifacts to sites for entertainment. The term "infotainment" was coined to describe this new structure in cultural institutions that cater to the public. Infotainment implies education (info) through entertainment. The people who run museums are acutely aware that in today's society you must be able to constantly reinvent your image in order to remain current with the tastes of society. While some people argue that art museums should not change with the times, that acknowledging current values implies cheapness, and they should stay aloof from changes in society, others argue that by altering their offerings, museums can cultivate the love of art in the populace. This has led to a change in museum exhibitions and the expansion of museum education departments, the latter of which will be discussed in the upcoming section on who works in a museum.

One of the changes directly related to exhibitions in the later twentieth century is the focus on "blockbuster" exhibitions.

Blockbuster exhibitions are those that may show anything from the work of the very well-known artists, like Monet or Van Gogh, to collections of important artifacts such as the grave goods of the Egyptian pharaoh Tutankhamen ("King Tut"). These exhibitions often draw more patrons to the museum in one month than usually come in a typical year, bringing in thousands of people and thousands of dollars a day. Blockbuster exhibitions generally have a few things in common; exhibition tickets are usually sold at a higher price than regular museum admission, these shows are heavily publicized in the media, and they always have some sort of merchandizing associated with them. In many ways, blockbuster exhibitions resemble a Disneyland ride where you pay a lot of money to stand in a long line, are quickly ushered through the experience, and at the end you have to walk through a gift shop to exit.

Despite some of their logistical drawbacks, blockbuster exhibitions can help to elevate both the status of the institution and the status of city in which it is held. Because an exhibition of this magnitude will only travel to a select number of museums, it is an honor for a museum to be selected (or allowed to rent) the exhibition. The cost to the museum is enormous if you consider that these works have to be shipped by special art shipping companies and fully insured against damage and theft. The city where the exhibition will be shown gets bragging rights to prove to other cities how cultured it is, and the local economy gets a boost because people will actually travel to see these exhibitions. Most importantly, the benefit of a blockbuster exhibition for the average patron is the chance to see famous works of art by famous artists all in one place without having to travel abroad. If you can look past the crush of people at these exhibitions and the blatant consumerism, blockbuster exhibitions are very enjoyable experiences.

Another, more recent, development in the museum experience, and one which requires no traveling whatsoever to see the works of art, is the display of museum collections online, in virtual, or website, galleries and museums. Website galleries may range from virtual museums with no physical location, to websites that mirror the collection in a larger museum. Most museums now have websites that provide not only visiting information, but often showcase all or part of their collection. These websites are the most reliable to learn about and view art because they have to match up to the same high standards of the museum itself. Usually,

the information on museum websites reflects the same information used to choose objects for display and for public education. Other websites are sometimes merely collections of pictures of art that the website owner has arranged on her or his own. These sites are less reliable because their creators do not have to know anything about art to create these sites. In addition, these sites also usually do not own the works they are displaying and may even be engaging in copyright infringement by displaying them.

CASE IN POINT
The Gates of Paradise, sort of . . .

Do you react differently to viewing an original work of art as opposed to viewing a copy? It used to be acceptable to go to a museum and view plaster copies of famous ancient works of art in museum collections in the 1800s, but that doesn't seem very acceptable today. The debate over the real versus the copy is an ongoing one in art. In the 1936 article by German writer Walter Benjamin entitled "Art in the Age of Mechanical Reproduction," Benjamin takes a critical look at the way in which mass reproduction of a work of art changes our experience of the original. Benjamin notes in his writing that works of art have always been reproduced, but that modern technology makes a vast difference, and I think we can really see that with the proliferation of Internet imagery of works of art. Benjamin's writing especially speaks to the realm of art when he writes about the "aura" that a work of art acquires over time (meaning that intangible monumentality and specialness that a singular work can get—think of the *Mona Lisa* by Leonardo Da Vinci). In a reproduction of a work of art that aura is absent because in this age we understand that there is a difference between original and reproduction and we ascribe a different feeling to seeing an original versus a reproduction. In his writing, Benjamin focuses on the difference we feel between viewing an original work of art versus a replica or a copy. In an age of media saturation, this is an important topic to consider in terms of art.

On that note, if you should ever be fortunate enough to find yourself in Florence, Italy, make sure to go and see the *Battistero di*

(Continued)

CASE IN POINT (*Continued*)

San Giovanni (the Baptistery of St. John), which is in front of the Basilica of Santa Maria del Fiore, otherwise known as *Il Duomo*. At the time the dome of the basilica was built, it was the largest dome in the western world and quite an engineering feat. In front of the basilica stands a baptistery (as the name indicates, these structures were used for baptisms) and the doors facing the basilica are the so-called "Gates of Paradise," given their nickname by Michelangelo, but created for the Baptistery by a man named Lorenzo Ghiberti. Ghiberti won a competition to create the second set of bronze doors for this baptistery and then was asked to do the third set as well. The so-called Gates of Paradise doors are the third set made for the baptistery and are probably the most famous doors in the world. Admire these doors and then look at a small sign to the left side of the doors which is almost unnoticeable. This sign, in Italian, reads, "*La porta orginale opera di Lorenzo Ghiberti e'stata sosituita con una copia il 3 Giungo 1990 per completarne il restauro. Quattro formelle gia restaurate si trovano esposte nel museo di Santa Maria del Fiore-Piazza Duomo N° 9.*" What this sign lets us know is that the doors you are looking at are a copy of the original doors that were removed for conservation in 1990 and then tells you where the originals can be found.

The original doors were completed in the mid-1400s, but time and the weather had already taken a toll on them when the Arno River overflowed its banks and flooded Florence in 1966, killing about a hundred people and damaging thousands of Renaissance works of art and manuscripts. The water at its highest point was just over twenty feet (it was lower in other areas of the city), and when you walk through the streets of Florence today, you can see plaques high up on the walls that mark the height of the water. The flood hit these doors and the force of the water severely damaged some of the panels, which had to be removed for restoration. Then, in 1990, the doors were completely removed and replaced with copies. The originals will probably never be put back on the cathedral because it was determined that they need to be kept in a stable environment to be preserved. The exterior of a building, with fluctuating temperatures and wet and dry conditions, is one of the least stable environments for a work of art such as this.

When I visited these doors I already knew I was looking at a copy because I had come across this in my research, but I saw so

CASE IN POINT *(Continued)*

many other people who could not read the Italian sign and knew no difference, but were appreciating these doors nonetheless. I almost felt sad knowing that these were not the original doors—I almost wished I hadn't known so I could stand before them in awe without thinking, "But these are replicas." I know that they are EXACT copies of the originals, but something kept nagging me because they were not the originals. If you were standing in front of these doors, would you feel any different knowing that they were copies? Do you think that knowing these are replicas would change your experience of them? Would you rather not know that they are replicas when you see them? Does it even matter to you to see a replica versus an original? It is free to see this set of doors, but would it matter if you had to pay to see a work of art and found out it was a replica? These are important questions to ask yourself in regard to art because the answers will give insight into issues of authenticity and appreciation.

By the way, if appreciating a copy is as good as the original to you, another exact replica of the Gates of Paradise can be found much closer to home. You only need to go to the front of Grace Cathedral on Nob Hill in San Francisco. I chanced across this particular copy one evening as I was looking for something else in the area. I took a wrong turn and found myself standing in front of these doors, and I don't know if it was the setting or if I might have felt differently surrounded by a large crowd, but I hate to say that standing in front of a replica of the "Gates of Paradise" in San Francisco just wasn't the same as standing in front of a replica of the "Gates of Paradise" in Florence.

Who Works in a Modern Museum?

There are many different people who work in a museum and these positions are arranged in a hierarchy that we will look at from top to bottom in terms of the amount of power wielded in the institution itself. Many people do not understand how works of art come to be collected and exhibited in museums. It is important to understand the operational structure of the museum in order

to demystify it; if we can understand that a museum is made up of many different people with specified roles, it becomes easier to understand the museum as a constructed institution. Not all museums are organized in the same manner; smaller regional museums may have fewer workers while large museums, like the Getty Center in Los Angeles, have numerous departments for each type of museum collection and even retain a research and art conservation staff. The following is the general organization for a medium-sized institution. As for the organization of the information, it is broken down into three groupings; the first is the primary personnel who are responsible for overseeing the direction of the museum and its acquisitions, the second category is the secondary personnel who assist the primary personnel and facilitate the day to day activities of the museum as well as running education programs and protecting the museum collection, and the third category is that of museum volunteers who are often unpaid and have little to no control over museum operations. The primary personnel are arranged in a strict hierarchy while the departments for the secondary personnel are generally of the same importance and in some institutions their job duties may actually overlap, especially if there are fewer staff members.

Primary Museum Personnel

The Board of Trustees

The role of art museum trustees can be complex and varied depending on the individual institution, but trustees usually provide a significant amount of financial support for a museum, and because of this they have a real stake in the way that the museum (their investment) is run. Trustees provide their own money to support the museum as well as sometimes raising funds for the museum because trustees tend to hold prominent positions in society and may have connections with other interested and wealthy parties. Trustees are usually elected to their position but do not have to have a background in art or art history to retain their position. Although trustees are not professionals in the same way as curators or directors, they play a vital role in running a museum, and can be thought of as the conscience of the museum: ensuring that the museum's **mission statement,** a statement outlining the purpose of the museum, is followed and that exhibitions are of good quality and beneficial to the community. The year

to year duties of the trustees include approving the museum's operational budget and, from time to time, the hiring and firing of the museum director. While the museum director is hired by the trustees, he or she does not really work for them in the same way that a normal person in a corporation works for a boss; the director does not have to seek approval from the trustees for all museum decisions. It is as if the trustees hire the director and he or she becomes autonomous except when something goes wrong. The trustees hold periodic meetings where the director and relevant staff keep the trustees informed of museum operations.

The Director

While trustees oversee the museum, at the top of the art museum hierarchy is the most public figure of the museum, the **museum director.** To become a museum director takes years and years of hard work, an advanced degree in art history, the publication of texts on art, and a strong record of overseeing important art exhibitions. The director not only holds the top position at a museum, but is also the figure responsible for the entire museum, much in the same way a CEO is head of a corporation. Considering that museum directors are responsible for valuable and irreplaceable cultural artifacts, the position of director is not taken lightly. To become a museum director takes many long years and directors often start out as museum curators, or even as college educators. The director serves both as the person who helps determine the direction the museum will take in its art exhibitions and collections, as well as being one of the major fundraisers for the museum and liaison to the board of trustees. He or she is ultimately overseen by the board of trustees, although the position of museum director is mostly autonomous as head of museum staff.

Curators

Curators are the people who oversee the actual collection of objects in a museum. These people arrange exhibitions, negotiate the loan of artworks from other collections, and often write the texts to accompany those exhibitions. They also meet with and entertain possible donors and interact with artists, as well as give tours to important groups of people and explain the exhibitions to other museum staff while also representing the museum in an official capacity. Curators are usually required to have at least a master's degree in the field of art history in their area of specialty

and it can take a long time to become a curator. In fact, many curators begin their careers as unpaid curatorial interns while they complete their graduate degrees. While interning, they may research artists for exhibitions or assist a curator with the development of an exhibition. The next step up from a curatorial intern may be a position as a curatorial assistant, then as an assistant curator, before finally becoming a full-fledged curator, and then possibly senior curator or head of the curatorial staff. Large museums have multiple curatorial departments representing each area of the collection, employing many different hierarchies of curators. Becoming a curator is a long process and it is not uncommon for curators to frequently move around the country from institution to institution as they move up the job ladder.

Secondary Museum Personnel

Educational/Outreach/Membership Departments

In museums, the educational, outreach, or membership departments are relatively new additions with the aim of introducing the museum to the public and structuring education programs. This may be done through the establishment of school programs, holding family days at the museum, and the running of art classes or art lectures for members of the public. The overarching aim of these departments is to create a public that appreciates the importance of museums and—it is hoped—will financially support them someday, since it is in the best interest of the museum to have a public that is well educated and appreciative of art. The membership department is often separate from the education department and primarily oversees museum members. People join museums for a variety of reasons: to financially support the museum, to participate in special museum events not open to the general public (like members' openings), and to get free admission on an unlimited basis.

Registrars and Collection Managers

Registrars and **collection managers** are the people responsible for maintaining the condition of the museum's collection and art on

loan from other institutions. They catalogue the works, frequently check the physical condition of the artworks, send artworks out for repair if necessary, and control the use and distribution of images of the artworks themselves. Registrars frequently circulate through an exhibition, notebook in hand, checking the condition reports of the works of art against their current condition and photographically documenting any change or deterioration of the works. If damage is found on a work of art, the curators will be notified and the registrar will work with art conservators to have the work removed from the museum and repaired.

The registrars also are responsible for accepting shipments of artwork for upcoming exhibitions and checking the condition of the works received against the condition reports of the curators who sent the works. Sometimes, registrars may even accompany very important artworks as they are sent to another institution. Registrars usually have at least a BA in art, art history, or museum studies with related experience in a museum, while some places may require a master's degree. Many registrars work as assistants before becoming a full-fledged registrar. Lastly, registrars play an important role in scholarship because they control the physical access to the permanent collection for scholars who would like to view the works in person.

Preparators/Installation Crew

The **preparators** oversee the installation of artworks for exhibition and may construct pedestals for display, build false walls in the galleries, arrange the light for the exhibition, and even fabricate wooden shipping crates for artwork. At the end of an exhibition, the preparators work with the registrars who check the condition of the objects before the artworks are crated for shipment to the next venue, or back to their institution of origination. Once the old works leave the museum, the preparators receive the new works and again work with the registrars to check condition. The preparators then work with the curators and an installation crew to install the artworks as walls in the museum are patched and painted, false walls are torn down or constructed, and the artworks are sited around the galleries according to a chart made by the curators. Often, a BA is required with related experience and a good knowledge of construction. One of the exciting job duties of the preparatory is work with artists on

installation works of art because they actually help to create the work of art (installation art will be explained in Part Three).

Security

One of the most seemingly underappreciated museum departments is security. The **security department** includes the chief of security as well as all the museum guards, often called museum attendants. Unlike movies that show museums with high-tech surveillance and laser beam alarm systems, most museum security systems are not that sophisticated and usually consist of the guards, some cameras, and a simple alarm system. Museums maintain their security through secrecy; they do not openly discuss their security systems for fear of theft or vandalism, which is more common than you will ever read about in newspapers. Many museums will not even let the press know of a theft because of the fear that people will realize their security is not all that effective. The exception to this rule is in the case of thefts of high profile artworks, like the well-publicized theft of two Edvard Munch (1863–1944) paintings, including a version of *The Scream*, in 2004. In this case, masked criminals armed with guns stormed the crowded Munch Museum in Norway and overpowered the guards. The museum heavily publicized the incident, not only because of the brazenness (and uniqueness) of the assault, but because it made it very difficult for the thieves to resell the artworks. The thieves were apprehended and the paintings were recovered in 2006.[6] The Munch Museum has since upgraded its security.

In day to day activities, museum guards are responsible for opening and closing the museum as well as ensuring the proper conduct of museum patrons and the protection of the works of art. These are the people you see standing around in the galleries all day watching the patrons and giving friendly warnings to people who try to touch the artworks, get too close to them, or take unauthorized photographs of the artworks. Usually, the guards are the museum workers who have the most contact with the patrons and are pretty knowledgeable about the works themselves. Each guard is usually assigned to a specific gallery or work of art and may fill out a condition report at the beginning of the day as well as at the end of the day. This provides a daily record of artworks in case one is stolen. At the end of the day, the guards clear the museum and make sure each area is secure before finishing their shift.

Volunteer Positions

Interns

Interns are people who work for the museum on special assignments or for a limited amount of time in order to gain experience in the field. Not all museums organize an internship program but these programs are vital for students pursuing a career in a museum. In larger museums, each department may have interns who perform a variety of duties from assisting with daily activities or to working on special projects.[7] For many interested parties, an internship is the first step in working in a museum. The vast majority of internships are unpaid, but some of the larger museums may offer a year-long internship with a monthly stipend.

Docents

The duties and backgrounds of **docents** may vary from museum to museum, but usually they are volunteers from the community who may or may not have an art or art history background, and their main duty is to provide museum tours for patrons and visiting school children. Docents usually receive some type of training in art history from the museum, and then additional training and information about each museum exhibition, although museum tours for donors and other high level people are usually conducted by curators because of their specialized subject knowledge.

CASE IN POINT
Protecting Art during World War II

It is amazing to think that art was the subject of so much consideration during the chaos and destruction of World War II. During the war, art was looted from museums and private collections all over Europe by Nazi soldiers under orders and was paraded around in exhibitions organized by the Nazis to show German citizens what kind of art they should like (very traditional) versus what kind of art they should not like (very modern and abstract). A lot of people

(Continued)

are also not aware that Hitler was a burgeoning artist who, at one time, lived in Vienna and was denied admission to a prestigious art academy in the city. Yes, Hitler had aspirations to become an artist, and it is with this in mind that scholars have been looking at Hitler's actions and the Nazi confiscations of art during World War II and his special distaste for modern art.

There are those who say that Hitler's preoccupation with art and persecution of modern artists stems from his own rejection as an artist. Almost as soon as Hitler and the Nazis gained absolute power of Germany in early 1933, they began a program of persecuting artists whose work was not traditional and conservative. The Nazi party even put pressure on the Bauhaus (a progressive art school that had moved to Berlin) to close in the April of 1933 and confiscated artworks by major modern artists. In this climate, many artists fled Germany and more than a few found solace in the United States.

Aside from the persecution of artists in Nazi Germany, when World War II finally broke out, many of the battles took place amidst historical monuments and cities. In order to protect cultural treasures, the Allied forces organized a special division of the military to make sure troops did not bomb important artistic sites in Italy. This division was officially known as the Monuments, Fine Art, and Archives program, but the art historians, art experts, professors, museum directors, and curators who were part of this team were known informally as the "Monuments Men." They were entrusted with advising bombing units of where important artistic sites were so they could avoid destroying them. In short, they were there to protect the cultural heritage of Italy from the ravages of World War II.

There were times, however, during the bombing campaigns of World War II when the destruction of historically and artistically important sites in Europe couldn't be avoided or were accidentally and, even more rarely, intentionally destroyed by bombs. The fact, however, that during a time of war a special military detail was entrusted with making sure that these accidents were avoided attests to the special place that art occupies in people's hearts. These men risked their lives to ensure that these buildings and their art survived the ravages of the fighting of World War II. It is acknowledged that there are places and items so special that people are willing to risk

> **CASE IN POINT** (*Continued*)
>
> life and limb in times of war to save these things. That is a very powerful thing to reflect upon. We still have many of these artistic sites in Florence, Rome, and Pisa because of the care, forethought, and special planning of the "Monuments Men" of World War II.

Art Conservation and Restoration- What Do People Do When Art Gets Damaged?

Despite the amount of care artworks receive in museums, they sometimes do become accidentally or intentionally damaged and require repair. Sometimes, damage is the result of natural disasters, civil strife, or destruction from the passage of time.

Conservation versus Restoration

Like anything else, works of art deteriorate with age and have to be treated to halt their deterioration. There are two approaches to treating works of art that need repair: conservation and restoration. **Conservation** is an approach to art preservation which stresses halting the deterioration of a cultural artifact such as a work of art, and includes cleaning a work of art and treating it to stop further deterioration. **Restoration** is when the work of art is returned to what is believed to be its original condition, usually through the re-addition of missing pieces for sculpture, or **inpainting** in the missing sections of paintings.

There exists a heated controversy among art conservators, art historians, and museum curators as to whether works of art should be preserved in their present state or returned to their "original condition" through restoration. Since we often do not live in the same period as when the work was created, we cannot always be certain about the original condition of the work of art. In addition, art materials and methods have changed dramatically over the centuries. When it is decided that a work should be restored, thorough research and scientific testing is performed to ensure that the end result is as true to the original as possible. For

example, scenes were painted on the ceiling of the Sistine Chapel in the Vatican in Rome by Michelangelo Buonarroti (1475–1564) between 1508 and 1512. Between 1977 and 1989, art conservators worked at restoring these paintings, and in the process removed both accumulated grime and later **overpainting** that had obscured various parts of painted human anatomy in the name of decency. This restoration is considered to be a success, with the greatest result of the restoration the newfound ability to be able to see the original colors Michelangelo used to paint the ceiling; instead of colors darkened with age and grime. These original colors are now again bright and clear, and this restoration was successful, in part, because of the good condition of the original painting itself. But what happens when the original is in bad condition?

This was the case with another restoration considered by many art historians and conservators to have been a huge failure: the restoration of Leonardo da Vinci's (1452–1519) *Last Supper,* painted between 1495 and 1498 on the wall of the refectory of the monastery of Santa Maria delle Grazie in Milan, Italy. Leonardo had used an experimental painting technique to begin with, and the paint started to fall off the wall within his own lifetime. In addition, there were numerous abuses to this painting ranging from the enlargement of a door through the bottom of the painting, to restoration attempts over the ensuing centuries that had deposited layer upon layer of paint over the original, to even the bombing of Santa Maria delle Grazie during World War II. The badly restored image was the one that had been reproduced and that most people are still familiar with when they think of the *Last Supper.* Against the protestations of art historians and conservators, the work was restored from the late 1970s to the late 1990s. People objected to the restoration because they claimed that there was so little left of the original painting that once the overpainting was removed, there would be nothing left to restore. The work was restored and the overpainting was removed, but the finished result is disappointing; the painting is lighter and the colors brighter, but a high percentage of the painting is now inpainting done by conservators to replace the missing original paint. One way that conservators designate inpainting is to paint the area a lighter shade of the true color so that the viewer will know that the work of art has been fixed, and the other approach is to paint the missing areas to match the existing areas seamlessly. In *The Last Supper,* the first approach was used and

the result is a mottled surface of light and dark, new and old. The way the public once knew this work of art now only exists in photographs and videos.

CASE IN POINT
Should the *Mona Lisa* Be Conserved and Restored?

The *Mona Lisa*, by Leonardo da Vinci (1452–1519) [Figure 6], is a small High Renaissance oil painting on wood from about 1503. The *Mona Lisa* is one of the best known artworks in the world and is on view in a climate controlled box in the Musée du Louvre in France, where the work is kept heavily guarded and safe behind bulletproof glass. Such great care is taken with this work of art because of its material and the fact that it has already been stolen. Oil paintings on wood are notorious for having problems as they age, the most serious of which is warping of the wood which may cause the paint to crack and fall off. As long as the *Mona Lisa* remains in this carefully controlled climate, it will theoretically not be subject to further deterioration and will remain safe from the threat of another theft or an attack by a crazed patron. At present, the work is only removed from view about once a year so that conservators can check its condition. While it is out of its chamber it is under heavy guard, and only a few people at any one time may be alone with it. Even though the painting now is under so much care, the paint has already darkened so much that elements of the painting have been obscured, and a crack in the wood is visible in the uppermost part of the work.

Some people want the *Mona Lisa* to be conserved so that darkened varnish can be removed to reveal the original colors of the work. When a work of art is as well known as the *Mona Lisa*, it becomes treasured by people around the globe, even though it is owned by only one museum. Conservation necessarily involves a certain amount of risk because conservationists have to use chemicals to clean art objects, and cleaning a painting involves the removal of old varnish and accumulated surface grime. Even under the best circumstances, a work of art can be unintentionally damaged during the conservation process. Should the Louvre decide to conserve the *Mona Lisa*, they will have to remove one of the most viewed works of art in the world from public view, and the *Mona*

(Continued)

CASE IN POINT *(Continued)*

Lisa could be off display for over a year. During this time, the wood panel the *Mona Lisa* is painted on could be subject to deterioration if the climate of the conservation facility is not correct, but the greatest fear is another theft while the work is out of its secure box, and theft is always a primary concern when high-profile works of art are undergoing conservation.

Do the benefits of conserving the *Mona Lisa* outweigh the possible risks, and will the public still love the *Mona Lisa* when she no longer looks the way we are used to seeing her?

CHAPTER SUMMARY

- The history of the museum is told as a progression from a vehicle for the private entertainment of royalty, to a place for the advancement of the public through exposure to culture, to a space for public enjoyment and education.

- The contemporary museum is a space that is trying to define itself as a place of both education and entertainment, while at the same time a place for art research and protection.

- Many different people work in museums, ranging from paid positions to volunteer positions, and the amount of power wielded in the museum is structured according to a strict hierarchy, with trustees, directors, and curators at the top, and docents and volunteers with little power at the bottom.

- When art gets damaged, art conservators are called in to perform repair work. There are two approaches to treating works of art: restoration and conservation. Restoration is restoring the work of art to its believed original condition while in conservation measures are used only to halt further degradation.

NOTES

1. Tony Bennett, *The Birth of the Museum* (New York and London: Routledge, 1995), 35.

2. These pieces of the Acropolis comprise the so-called Elgin Marbles, donated to the British Museum in the early 1800s.

3. Tony Bennett, *The Birth of the Museum* (New York and London: Routledge, 1995), 17.

4. Ibid., 18.

5. Ibid., 28.

6. "Scream Stolen from Norway Museum," *BBC News*, 22 August (2004), http://news.bbc.co.uk/1/hi/world/europe/3588282.stm (accessed June 22, 2007).

7. For example, as a curatorial intern at the Museum of Contemporary Art in San Diego in the early 2000s, I worked on a project researching contemporary artists and developing a filing system with relevant information about each artist. I often wonder if this system is still in place.

ART AND ARTISTS

Joseph Cornell, *Romantic Museum*, 1949–50.

Leonardo da Vinci, *Mona Lisa*, ca. 1503–05. Museé du Louvre, Paris.

Mark Dion, *Scala Naturae*, 1994.

Mark Dion, *Cabinet of Curiosities for the Wexner Center for the Arts*, May 10–August 10, 1997. Wexner Center for the Arts, Columbus, Ohio.

Marcel Duchamp, *Boîte-en-valise [Box in a Valise] (de ou par Marcel Duchamp or Rrose Sélavy)*, 1935– 41. The Museum of Modern Art, New York.

Fluxus, *Flux Cabinet*, 1975–77. The Gilbert and Lila Silverman Fluxus Collection Foundation, Detroit.

Futurists.

Guerrilla Girls.

Komar and Melamid, *Scenes from the Future: The Guggenheim Museum*, 1975.

Charles Wilson Peale, *The Artist in His Museum*, 1822. Pennsylvania Academy of the Fine Arts, Philadelphia.

Hubert Robert, *Projet d'Aménagement de la Grande Galerie du Louvre (Refurbishment Project of the Grande Galerie of the Louvre)*, 1796. Musée du Louvre, Paris.

Edward Ruscha, *The Los Angeles County Museum on Fire*, 1965–68. Hirshorn Museum and Sculpture Garden, Smithsonian Institution, Washington, D.C.

Making Art:

Visual Considerations

LOOKING AT ART can be a moving experience, but how can you describe a visual experience in words? Because humans communicate through verbal language, words are needed in order to discuss the form and content of art, and over time a set of terms has been developed to describe art. We consider these terms to be the vocabulary of art. This vocabulary is discussed in two separate categories; the formal elements of art, and the principles of design in composition. Together, these two sets of vocabulary are used to describe the varied elements that come together to create a work of art. They are very useful in a discussion of art because, theoretically, if nothing is known about a work of art, this vocabulary could still be used to describe the work. It should be understood, however, that since artistic expression is so diverse and in a continual state of flux, these categories will necessarily have to evolve with the changing art climate. In addition, these terms may be applied in different ways for different types of artwork from sculpture to painting, to new forms of expression.

The two categories, the formal elements of art and the organizing principles of design, are the artistic "tools" that serve markedly different purposes in the creation of a work of art. The formal elements are the tools used to create works of art, while the principles of design describe how those "tools" are arranged and work together in the **composition,** the total arrangement of visual elements in a finished work of art. The following section is broken into a chapter on the formal visual elements of art, color, and the

principles of design in composition. Although color is officially one of the formal elements, it is discussed in a separate chapter because of its complexity. These formal elements and principles of design are meant as a guide to visual understanding, but will not reveal the entire meaning of a work of art in itself; they are but one more tool to provide meaning in art and construct understanding.

The Formal Elements of Art

Line

Line is the most basic component of art. The simplest line that you encounter almost every day is the mark left on paper by a ballpoint pen. If a pen is allowed to touch only one place on a piece of paper, a singular mark is made: a dot. A drawing can be made up entirely of single dots, a technique known as **stippling** [Diagram 1a], but line is used more often in drawing because of its ability to be expressive. The single point is the basis of line; however, if that pen is dragged across the surface of the paper from that first point, the pen creates a line which is described as a continuous moving point. In this case, the line is only the thickness of the pen point, and the length is as long as the stroke of the pen. When line is discussed as part of a work of art, length and width are important because the character of line can contribute to the meaning of a work of art; thick lines may be described as dark and ominous while thin lines may seem delicate and lightweight, or a grouping of short lines may seem upsetting while a long flowing line may be seen as graceful.

Lines do not always have to truly exist in a work of art. Artwork can be made up of **actual lines** [Diagram 1b], lines that exist in space and have physical substance, or lines that do not actually exist in space, called **implied lines.** Actual lines are like those made by a ballpoint pen, and implied lines exist only because the eye tends to make relations between points. A good example of an implied line is a dotted line because a dotted line is not a continuous, unbroken line,

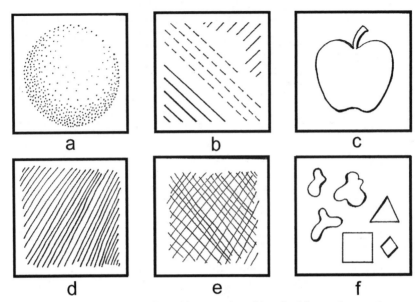

Diagram 1a–f 1a: stippling; **1b:** actual and implied lines; **1c:** contour line; **1d:** hatching; **1e:** cross-hatching; **1f:** organic and geometric shapes.

but is composed of dots placed in close proximity to one another. It is the connection of these spaced dots by the eye that gives the impression of a line. For example, the lines that divide lanes of traffic on a highway are made up of a series of dashes that follow one another and curve with the road to delineate lines of traffic, but the series of dashes is not in fact one long, continuous line.

Line maybe used to describe the exterior lines of an object, or the interior lines of an artwork. **Contour lines** [Diagram 1c] are used to outline, or trace, the outer edges of an object, but usually do not provide any interior detail. A favorite exercise in beginning life drawing classes is to draw the contour of the person in order to learn how one part of the figure relates to the whole. In order to describe the rest of an object and to make it look three-dimensional, different groupings of lines are used to describe interior space. **Hatching** [Diagram 1d] refers to lines that are parallel to one another, while **cross-hatching** [Diagram 1e] refers to sets of parallel lines that overlap each other in different orientations. Hatching and cross-hatching can be used to create light and dark areas in a work of art and, when using hatching, the degree of lightness or darkness is determined by the placement of the lines

in relation to one another (near or far). In cross-hatching, light and dark are determined by the degree of overlap of the lines, and the number of lines themselves; more lines will produce darker areas while fewer lines will produce lighter areas.

Direction and character of line are also important. While interpretation of the meaning of directional lines is subjective, art historians working with the western tradition in art history tend to agree that certain line directions have certain meanings. For example, diagonal lines tend to imply movement in a work of art while horizontal lines may imply calm. These interpretations, though, are so subjective that it is best when looking at a work of art to evaluate the direction of line as part of the larger composition. Also subjective is the notion of character, a term used to refer to the feeling that a line inspires in the viewer. For example, a drawing may be made up of very precisely drawn lines that are carefully controlled, or a drawing may be made of frenetically drawn lines that overlap and snake around the paper while still presenting an image. The character of these lines is very different and can be useful in discussing a work of art, and in the western tradition we describe these frenetic lines as expressive, or **gestural.** Gestural lines are usually interpreted as implying energy and movement because they are not controlled and refined in appearance. Gestural lines are described as showing movement, although no actual motion is present. As you can imagine, interpretation of line quality can vary from artwork to artwork, and what one person interprets may not be the interpretation of another; however, the formal element of line is useful as an objective starting point for a discussion of the work of art.

Line can describe different aspects for sculpture and architecture. In sculpture, line refers to the lines of the work created by its shape and materials, or the edges of the sculpture. In three-dimensional works of art there are exterior and interior lines. Exterior lines are the lines of the outside edges of the sculpture, while interior lines are the lines over the surface of the sculpture, between the outside edges. In architecture, line refers to the lines of the building as well as line in any decorative ornament on the building. Line direction in architecture is important because a building constructed mainly of horizontal elements may seem to be squat and low to the ground, while a building with mostly vertical lines gives the impression of height.

Light and Value

There are two different types of light: natural and artificial. **Natural light** is the light from the sun while **artificial light** is light from all other non-solar sources such as light bulbs, LCD monitors, and candles. Each type of light has a different quality; natural light is considered to be the type of light that will reveal the truest colors, while artificial light tends to alter color quality. There are two ways light is distributed into the world: through direct light and through ambient light. **Direct light** is the light directly from a source such as the sun or a light bulb, and **ambient light** is light that is reflected from either natural or artificial sources.

In a work of art, the element of light can function in a number of different ways depending on the form of the artwork itself. In paintings or other flat media, light is illusory. For example, in a still life of fruit on a table, the objects may appear to be illuminated from a light source, but it is only an illusion created by the careful application of paint on canvas. For three-dimensional works, such as sculpture and architecture, light is that which illuminates the exterior of the work of art or building, or the light incorporated into the work of sculpture or building. For example, a building can be lit both from the sun shining on its exterior during the day as well as any artificial light on the building at night, and by artificial light inside. Similarly, a sculpture may be illuminated in a gallery, or in a sculpture park at night, or the artist may use light bulbs as part of the sculpture itself.

The quality of light is described in terms of **value,** its lightness or darkness, and the range from light to dark is often expressed in an achromatic value scale [Diagram 2]. Chroma refers to color, so an achromatic scale is a value scale without color, showing a progression from white to black. Value is also referred

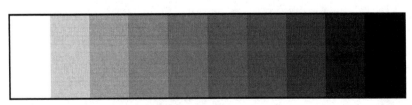

Diagram 2 Achromatic Value Scale
The achromatic value scale illustrates the progression from white to black in ten steps.

to as **tone,** and in a work of art tone is used to express the use of light and dark to create the appearance of three-dimensionality in a two-dimensional work of art. We refer to the appearance of three-dimensionality as **form.** Historically, light and dark are known by the Italian term *chiaroscuro,* a term that literally means light/dark, and in art refers to the realistic effect created by modeling forms with shading and highlights in painting. Chiaroscuro can be seen in Jacques-Louis David's *Oath of the Horatii* [Figure 8], where the light strikes the figures from the left side of the painting, creating highlights and shadows. Another Italian term, *tenebrism,* is used to describe an extreme form of chiaroscuro where sharp contrasts of light and dark are used, often incorporating spotlighted areas amongst dark, obscure backgrounds. In architecture and sculpture, light and value are often created by the play of light on the surface of the object, and the character of light varies with the time of day and the time of year.

To create realistic-looking forms in two-dimensional works of art, artists use three distinct tones; highlights, midtones, and shadows [Diagram 3]. **Highlights** are the lightest areas of the

Diagram 3 Highlights, midtones, and shadows on a sphere.

composition, **shadows** are the darkest parts of the composition, and **midtones** are the transitional areas between light and dark, highlights and shadows. The combination of these three tones contributes to the illusion of reality in works of art.

Shape, Volume, and Mass

Shape, volume, and mass refer to the different forms we find in art. A **shape** is a flat area with a clear boundary such as a line, or an area bounded by other shapes. For example, a square is a shape, but a cube is not a shape because it implies three-dimensionality. Shapes can be regular or irregular, soft-edged or hard-edged. Soft, irregular, rounded forms are referred to as **organic** [Diagram 1f]; they curve and bend like objects in nature. Forms with regular hard edges are referred to as **geometric;** they are squares and triangles and other shapes learned about in geometry courses. Shapes, then, are two-dimensional in nature but may also refer to shapes in three-dimensional objects. For example, a building might be described as rectangular, or a room described as square.

We can also see shapes alluded to in works of art based on the elements in the composition. For example, in Massaccio's *Holy Trinity* [Figure 9], the shape formed by tracing an imaginary line between the figure of Christ and the two flanking figures creates a triangle. The triangle does not exist as an actual shape defined by lines, but the visual impression of the triangle is implied through the placement of figures. Similarly, in a drawing or other work of art, we can look at the different types of shapes and make interpretations of them in relation to the context of the rest of the image. If we look at the context of Massaccio's *Holy Trinity*, we see a work of Christian art where the triangle refers to a religious context: the Christian trinity of the Father, Son, and Holy Spirit.

Mass and volume refer to the three-dimensional components of a work of art. **Mass** refers to a solid object, which also usually transfers to physical weight, while **volume** is the space contained within a three-dimensional object. An artwork can have real or imaginary mass and volume. For example, a cube on a table has actual mass and volume, while a drawing of a

cube has illusory mass and volume. To sum up the relation between shape, mass, and volume, think of a rectangle of flat cardboard. This flat rectangle is a shape that has mass, but if the cardboard is formed into a cardboard box, it then has both mass and volume. In architecture and sculpture, shape and volume are more tangible because of the actual space present and, in the case of sculpture and architecture, volume can refer to enclosed space in a structure or a sculpture, such as a room in architecture.

Space

In art, space can refer to a number of different aspects depending on the type of art. For three-dimensional art objects, space is the area around and between objects as well as the space occupied by a work of art in its setting, called **actual space.** In the case of Kenneth Price's three-dimensional sculpture, *Yang* [Figure 10], space refers both to the space around the entire sculptural form, the space between overlapping elements (the curve at the top of the sculpture), and the space of the museum in which it is displayed. For two-dimensional artwork such as painting and photography, space may refer to the illusion of depth created by using linear perspective, called **illusionistic space,** or also the exhibition space in a museum or gallery. For example, the people in Masaccio's *Holy Trinity* [Figure 9] seem to standing in an actual place with walls and a ceiling (giving the illusion of space), and the work of art itself is painted on the wall of a church (its actual space). For performance art and other ephemeral arts, the space is the site of the performance. In a discussion of architecture, space can refer to the interior, contained space of the building or the exterior space of the building, as well as where it is located.

Space is considered positive or negative. Actual, physical space that is occupied by a form that has mass or volume is called positive space. The opposite of positive space is negative space, the areas of an artwork where nothing is visually or physically present, including the space around the artwork. Negative and positive space are both especially important in architecture and sculpture because buildings and sculptures have mass and volume.

Linear Perspective: Creating the Illusion of Space

In a two-dimensional work of art, the illusion of space is created by using linear perspective. **Linear perspective** is a mathematical system for creating the illusion of depth in a flat work of art. In this system, the perspective lines of the work converge (or originate) at what is called the **vanishing point.** The imaginary lines that connect the actual lines of the object are called orthogonals. **Orthogonals** are the imaginary or implied lines that we use to determine where the vanishing points are in a work of art. These imaginary lines extend from the actual lines of the object and converge at the vanishing point, which is very often the focal point of the work of art or an important figure in a painting composition.

One-point, two-point, and three-point perspective are the standards for creating realistic artwork in the western world. In the Renaissance in Western Europe, linear perspective was considered an aspect of mathematics because it is very rational and formulaic. Artists using linear perspective would plan out their compositions very carefully to make it look as if their painted subjects were actually occupying a space in the world. Some art historians have even scrutinized paintings to find out the underlying mathematics in them and because, more often than not, linear perspective can point to the most important person or element in a composition. Others art historians calculate the size of objects in the paintings by measuring the linear perspective used. Today, we usually associate linear perspective with the fine arts instead of math because linear perspective is most often used by people trying to create the illusion of depth on an otherwise flat surface.

One-point perspective, often referred to as single-point perspective, is a system for creating the appearance of space where the illusion of depth is created using one vanishing point. As Diagram 4 illustrates, in single-point perspective, all the perspective lines of the work converge at the vanishing point, including both the exterior and interior lines of the object. Single-point perspective is effective for creating the illusion of space; however, it can be limiting, so some artists use two-point perspective to make the objects look more realistic.

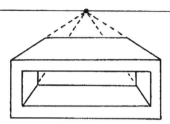

Diagram 4 One-point (or single-point) perspective with interior space also shown in perspective. The dashed lines represent the orthogonals which converge at the vanishing point, and the horizontal line is the horizon.

In two-point perspective, the lines of the object recede towards two distinct vanishing points, often set to either side of the object, or above and below the object. This creates the illusion that the object has depth and provides for the artist to be able to draw the object in a three-quarter view, as illustrated in Diagram 5. In addition to single-point and two-point perspective, artists can use three-point perspective to show an object receding from the viewer from the front, and also express how a tall object like a building changes its visual width as you look up at it, or how an object on a low table may also look different as you stand over it. In three-point perspective, the lines of the object recede towards three different vanishing

Diagram 5 Two-point perspective showing the object in three-quarter view.

Diagram 6 **Three-point perspective** showing the object receding down and away from the viewer. This perspective suggests that the viewer is above the object looking down on it.

points [Diagram 6]; one point each placed to either side of the object, as well as one point placed either below or above the object. The illusion created in this system is that the object has height as well as depth.

Now, let us see how linear perspective functions in an actual work of two-dimensional art. Again using Masaccio's *Holy Trinity* [Figure 9] as an example, we can locate the orthogonals by looking at the ceiling above Christ and following the lines of the ceiling down, where they converge on a figure of a skeleton in a tomb below the main painting that serves to remind the viewer of his or her own mortality. Very often, when the orthogonals converge at a vanishing point, that point is something or someone important; in this case a reminder of death for the mortals above.

Texture

Texture is used to describe the surface qualities of an object or material. There are two types of texture: actual texture and visual texture. **Actual texture** is the tactile texture of the object—what

you can actually feel with your own fingers. **Visual texture** is illusionary; it looks like it is tactile but it is not. It is merely an illusion. A common example of visual texture is manufactured wood flooring or faux wood paneling that looks like real wood grain, but is actually just a printed image of the actual texture. Two-dimensional works of art usually have to use visual texture to simulate reality, while in architecture and sculpture, texture is the texture of the materials used to create the work of art or the building, and in architecture visual texture is often used to simulate expensive materials. For example, Kenneth Price's sculpture, *Yang* [Figure 10], is an example of a work of art with actual texture because the surface of the sculpture is bumpy; if you could touch it, you could actually feel the texture of the surface with your fingers. In Jacques-Louis David's *Oath of the Horatii* [Figure 8] the columns in the background appear to be stone, but are just a painted illusion, an example of visual texture.

Time, Motion, and Change

Time, motion, and change are more complex formal elements that have gained popularity as artists have begun to explore newer forms of art in the twentieth century, such as performance and installation art. **Time** can refer to the internal length of a work of art (how long the work lasts), the time spent interacting with or viewing a work of art, or change as a component of a work of art. Some works are temporary in nature and, in those cases, time is the duration of the work of art. Time can also refer to the time you may spend looking at a work of art in a museum or gallery and, lastly, some works of art are meant to degrade over time, and so time is the length it takes for the work to change.

Motion is the movement or change in a work of art, but change in this sense is different from the change involved with time. In this case, change is actual physical movement, and a number of contemporary artworks incorporate movement. In addition, there are two categories of motion: implied and actual. **Implied motion** is the situation created when formal visual elements are used in a work of art to create the illusion of movement, while **actual motion** is where the work actually moves. For example,

In Jacques-Louis David's *Oath of the Horatii* [Figure 8], the three figures on the left look as if they are reaching towards their swords. The fluttering of their clothing and their postures give the impression of action, but it is in fact implied motion. In Christo and Jeanne-Claude's *Valley Curtain* [Figure 13], the work of art is a large orange curtain of fabric suspended across a valley that fluttered and swayed with the breeze, an example of a work of art that incorporated actual motion.

For architecture and sculpture, time and motion are important components because the view of the objects changes with the movement of the viewer. As a viewer walks around the sculpture or structure, it looks different from different angles. The work of artist Andy Goldsworthy (b. 1956) is a good example of time and motion. His sculptures are usually site-specific, meant to be placed in one location, and his outdoor works of art are created and then left in place to deteriorate over time, but documented through film and still photography. Time, then, is an important component of his artwork.

Actual movement is not often an internal component of architecture or sculpture because, even though small sculptures are always moveable, large scale sculpture is usually left where it has been sited because of the impracticality of moving it. However, recent developments in sculpture have led some artists to incorporate actual movement into their works, known as **kinetic** sculpture. These works may move under their own power with motors, or may be moved by external forces such as the wind or running water.

CHAPTER SUMMARY

- Formal elements are useful in making an objective appraisal of a work of art, and as a starting place for a visual appraisal of a work of art.
- The formal elements are the tools used to create works of art. These formal tools include line, light/value, shape/volume/mass, space, texture, and time/motion/change.
- The formal element of space includes linear perspective, a system used to create the illusion of three-dimensionality in a two-dimensional work of art. There are three main types of linear perspective; one-point, two-point, and three-point perspective.

- Each formal element functions in a different way for two-dimensional artworks, three-dimensional artworks, and architecture. The context of the work of art will determine how the formal element will function.

ART AND ARTISTS

Andy Goldsworthy, *Storm King Wall*, 1997–98. 5′ by 2,278′ long. Storm King Art Center, Mountainville, New York.

Masaccio, *Holy Trinity*, Santa Maria Novella, Florence, Italy, ca. 1428.

The Formal Element of Color

EVEN THOUGH COLOR is one of the formal elements of art, it deserves its own chapter because it is the most complex formal element. The following concepts and terms are important for understanding a discussion of color. Color has three characteristics: hue, value, and intensity. **Hue** is the pure state of the color itself and is referred to by the name we give it like red, blue, or green. **Value** is the lightness or darkness of a color; adding white to a color creates a tint of the color, adding gray results in a tone, and adding black creates a shade of that color. A chromatic scale shows the progression from lightness to darkness for a hue. Lastly, **intensity** is the brightness or dullness of a color, sometimes referred to as saturation.

The Color Wheel

In order to facilitate a discussion of color mixing, we have to understand the concept of the color wheel and a few related basic terms about color wheels. There are a number of different diagrams to explain the mixing ability of colors, but the most common is the simple color wheel [Diagram 7, found at the end of the book]. A color wheel lays out colors in relation to one another in the form of a circle with the colors aligned around a central space. On the color wheel, the placement of colors is very important and indicates their relative importance within color theory. The main important categories for colors on the color wheel are primary colors, secondary colors, tertiary colors, and

complementary colors. Another related term, analogous color, will also be covered.

Primary colors are the base colors from which all other colors are mixed. Primary colors are designated because they cannot theoretically be mixed from any other colors—they are considered to be pure pigments. For painters' colors (made from pigments), like tubes of oil paints, acrylic paints, and watercolors, the primary colors are:

<div align="center">

Red

Yellow

Blue

</div>

A **secondary color** results from the mixing together of two primary colors. When mixing oil and other pigment-based paints the mixtures and results are:

<div align="center">

Red + Yellow = Orange

Yellow + Blue = Green

Red + Blue = Violet

</div>

A **tertiary color,** sometimes referred to as an intermediate color, results from the mixing of one primary color with its neighboring secondary color. These are the mixes for tertiary colors for oil and other pigment-based paints:

<div align="center">

Red + Orange = Red-Orange

Orange + Yellow = Yellow-Orange

Yellow + Green = Yellow-Green

Green + Blue = Blue-Green

Blue + Violet = Blue-Violet

Violet + Red = Red-Violet

</div>

Complementary colors are pairings of colors across from each other on the color wheel, and are considered to be the most contrasting color pairs. These are the three complementary pairs for oil and other pigment-based paints:

<div align="center">

Red and Green

Blue and Orange

Yellow and Purple

</div>

When complementary pairs are mixed, the resulting colors are very dull in appearance, resulting in a dark neutral color. Additionally, in a complementary pair, one color absorbs the color the other reflects. Lastly, **analogous colors** are those colors that have a color in common, but have different proportions of that color. For example, orange contains red, so orange and red are analogous colors. Orange also contains yellow, so orange and yellow are also analogous colors.

Color Relativity, Mood, and Temperature

Color is not absolute, but depends on the quality of light and the color of the object itself. Color can describe the actual, true color of an object, referred to as **local color,** or colors can define form through use of **arbitrary color,** non-representational color chosen for effect or expressive purposes. For example, a landscape showing rolling fields can have green fields and blue skies, or it could also have red fields and orange skies. The first example would be considered the use of local color, while the second example would be an example of arbitrary color. Arbitrary color can be used to create mood in a work of art. For example, do you ever associate certain feelings with certain colors? Do you associate daring with the color red, or girls with the color pink? These are examples of color association and mood. All these examples are western notions of color—they can be different for other cultures, but the following are some western examples of colors and the moods, or concepts, associated with them:

Red—anger, seductive, daring

Blue—sadness, masculine

Brown—dirty, grimy, earthy, natural

Yellow—unease, a neutral gender color, tension, craziness

Pink—feminine, calming

Green—abundance, environmental

Purple—royalty, opulence

Orange—wild, daring, a fall color

> **White**—purity, innocence
>
> **Black**—mourning, sadness, oppression, fear, evil

Color is also described in terms of temperature. Yellow, orange, and red are referred to as **warm colors,** and blue, green, and violet are referred to as **cool colors.** Cool colors used in the background of a painting tend to recede, or not be as prominent as other colors, while warm colors placed near to the viewer tend to pop out at you visually, or advance.

In architecture and sculpture, the element of color describes the local color of the structural materials, from the color of the paint to the color of natural materials such as stone or brick. Color is an especially important element in architecture because of the size and prominence of buildings, and the cost of building; a building with a poorly chosen color will be much more noticeable and permanent than a smaller sculpture with a poorly chosen finish.

The Two Color Systems

Knowledge is not static in history; it changes with our understanding of the world and with our access to technology. One hundred years ago in art, the conception of color was slightly different from our own. With the invention and proliferation of television sets and computer monitors, our conception of color has fundamentally changed. Now, instead of just talking about how colors are created by mixing paints, we also have to discuss how colors are created in television sets and computer screens, since many people view color on televisions and use computers to view and print pictures of art. There has long been a framework for understanding the color of light, but it was not until artists started using televisions and computers to create art that it was vitally important in a discussion of art and color.

With the addition of new technology, we can divide the way we commonly experience color into two systems, the additive color system and the subtractive color system. In short, the **additive color system** describes light-emitting media, and the **subtractive color system** describes pigment-based media. One

way to remember the difference between additive colors and subtractive colors is to remember this phrase:

Computers add, painters subtract

Within these two systems, there are three very common ways we experience color that will be discussed in detail in this section:

1. the colors produced by computer monitors (additive color system)
2. the colors produced by mixing paint (subtractive color system)
3. the colors produced by printing inks (subtractive color system)

Additive Color: The Color of Mixed Light

A discussion of the **additive color system** needs to first start with a discussion of light and its spectrum, since the additive color system comprises colors which are created on light-emitting media such as computer screens, LCD projectors, and televisions. This kind of light is referred to as refracted light and the light is mixed to produce colors. Although computers and televisions have not been around for very long, light and the description of color dates back to the time of Sir Isaac Newton. Newton observed that when normal white light passes through a prism [Diagram 8, found at the end of the book], it is broken into bands of color that look like a rainbow, called a spectrum. He listed the color sequence he observed as:

red, orange, yellow, green, blue, indigo, and violet

We now refer to this sequence by the moniker "Roy G. Biv." Light, then, is really made up of bands of different colors, called the spectrum, that the eye takes in and translates to colors.

In the additive color system [Diagram 9, found at the end of the book], the primary colors are red, green, and blue (RGB) and all colors created are combinations of these colors, while the absence of all colors is black. The inclusion, however, of all colors is white. In addition, the more colors used, the more light is mixed, and the brighter the resulting colors. Unfortunately, the more

colors you add, the more probability that the colors will recombine back into white light. The absence of color is black because that is the absence of light. The secondary colors are different for the additive color system. Using RGB colors, the secondary colors are mixed as follows:

Red + Green = Yellow

Green + Blue = Cyan

Red + Blue = Magenta

Subtractive Color: The Color of Mixed Pigment

The **Subtractive Color System** [Diagram 9] refers to the mixing of pigment-based colors such as artists' paints and printers' inks. When people generally talk about color-mixing, they are referring to the subtractive color system for artists' paints. In the subtractive color system, the inclusion of all colors is hypothetically black, and the absence of all pigment is white. The primary, secondary, tertiary, and complementary colors provided at the beginning of this chapter reflect the subtractive system for pigment-based colors.

On the other hand, the base colors of printers' inks are cyan, magenta, yellow, and black, referred to as **CMYK.** The color black is referred to as K because the K stands for "key." Theoretically, the base colors are C, M, and Y, and black could be achieved by mixing these three colors but, unfortunately, because black is a very common printing color, it is too expensive to use the three colors to make black. Black ink is used as a separate color to keep costs down, and also because the black color resulting from the combination of C, M, and Y is not a desirable shade of black. Using printing colors, the secondary colors are mixed as follows:

Magenta + Yellow = Red

Cyan + Magenta = Blue

Yellow + Cyan = Green

This chart recaps the primary, secondary, tertiary, and complementary colors for each of the three areas of color mixing.

	RGB (additive)	CMYK (subtractive)	Oil Paints (subtractive)
Primary Colors	red, green, blue	cyan, magenta, yellow (may also include black)	red, yellow, blue
Secondary Colors	yellow, magenta, cyan	red, blue, green	orange, green, violet
Complementary Pairs	red/cyan blue/yellow green/magenta	cyan/red yellow/blue magenta/green	red/green yellow/blue violet/orange

CASE IN POINT
Ultramarine Blue and Images of the Virgin Mary

What could be worth more than gold? At one time the answer to that question was a paint known as "ultramarine blue." Ultramarine blue is made from a stone known as lapis lazuli, and during the Italian Renaissance, lapis lazuli was mined from highly secretive and heavily guarded mine locations in what is now known as Afghanistan, and carried in the trade routes to Western Europe through Venice. To create a paint from lapis lazuli was a labor-intensive process requiring many steps; nevertheless, ultramarine blue was popular in Europe from the 13th century until a cheaper synthetic version of ultramarine was developed by chemists in the 19th century. During the Renaissance, ultramarine blue was the most expensive and precious paint an artist could use, and because of that it was a color reserved for special figures in compositions.

For example, in Italian Renaissance cathedrals, altarpieces were made to provide images of holy people and saints and to illustrate biblical scenes for congregants. Renaissance altarpieces conveyed the status of the person who initiated the commission through the use of fine and expensive materials which, because of their high cost to the patron, were a mark of the sacrifice of the commission. Altarpieces depicting the Virgin Mary holding the Christ child are a common scene in many cathedrals in Europe and in Renaissance art collections in museums worldwide. When we think of the Virgin Mary and what she usually looks like in these works, one thing is

(*Continued*)

CASE IN POINT *(Continued)*

very common—she is usually shown wearing a blue garment, and that blue is none other than ultramarine blue. By most accounts, ultramarine blue was chosen as the color to clothe the Virgin Mary because of its preciousness and cost, not necessarily because of any special significance of the color blue itself. In fact, in other cultures and other places Mary has been depicted in art wearing clothes of red as well as purple. The use of blue for the Virgin Mary's garments was used so widely and for so long that even today, when ultramarine blue as a color has lost its significance as a status symbol, the Virgin Mary is still depicted wearing blue.

CHAPTER SUMMARY

- Color has three characteristics, hue, value, and intensity, and the value of color is expressed in a chromatic value scale. In addition, color is relative to light, and the quality of the light affects the nature of the color.

- Two systems exist for describing color, the subtractive system and the additive system. The color wheel lays out the relation of one color to another for each system and also indicates primary colors, secondary colors, tertiary colors, and complementary pairs.

- The additive system describes color for light-emitting media, while the subtractive color system describes color for pigment-based media such as painters' and printers' inks.

- Color can be thought of as warm or cool and the placement of warm or cool colors has an effect on how we perceive them in a work of art.

ART AND ARTISTS

Josef Albers, *Homage to the Square Series: "Ascending,"* 1953. Whitney Museum of American Art, New York.

Ellsworth Kelly, *Red Blue Green*, 1963. Museum of Contemporary Art, San Diego.

Barnett Newman, *Vir Heroicus Sublimis*, 1950–51. The Museum of Modern Art, New York.

Mark Rothko, *Orange and Tan*, 1954. National Gallery of Art, Washington, D.C.

Organizing Principles of Design

LINE, SHAPE, SPACE, color, light, and dark work together to contribute to balance, proportion and scale, rhythm, unity and variety, and emphasis. These elements all come together finally in the composition of the work of art. The organizing principles of design, then, use the formal elements to create a finished work of art. The following is a description of each of the individual organizing principles of design.

Balance

When a person thinks of balance, the first thing to usually come to mind is the balancing of physical objects so that they do not fall over. When people walk they need balance and one of the most embarrassing and disastrous things that can happen while walking is losing balance and falling down. In an art composition, however, **balance** is used to describe the arrangement of negative and positive space used to create the feeling that elements in the work of art are evenly distributed. Artists describe the even distribution of elements in a composition as having **visual weight,** meaning that some elements appear visually "heavy," or more solid and imposing, while others appear visually "light." The arrangement of visual weight in an art composition creates balance. Visually heavy elements may be very dark or very large in comparison to visually light elements, which may be very light or quite small in relation to the rest of the composition. When looking at the work of art, attention

may be drawn first to the heavier elements and secondarily to the lighter elements. In sculpture, visual weight is made up not only of the positive space, but also negative space, and solids should balance voids in sculpture. In general, works of art do not have to have exact balance, but they have to have the look of being balanced because the eye notices when things are out of balance.

There are three types of balance: symmetrical, asymmetrical, and radial. An object or two-dimensional work having **symmetrical balance** could be divided by a line running down the middle or across the center horizontally and still be balanced, or each side having equal visual weight. For example, Masaccio's (Italian, 1401–1428) *Holy Trinity* [Figure 9] is an example of a work with a symmetrically balanced composition because if a line were drawn down the middle of the work, the figures on the left would balance the figures on the right. In this composition there are two sets of positives in the composition, and although the figural pairs on the left and right are not identical, their placement suggests a balance of visual weight. Therefore, symmetrical balance is made through the placement of elements, such as figures, in the composition.

A work of art has **asymmetrical balance** when it is not symmetrical but still gives the impression of visual balance through the arrangement of unequally weighted elements. For example, Hokusai's *The Great Wave at Kanagawa* [Figure 3] is an example of asymmetrical balance in a composition; the great wave is placed to the left of center, but because the greatness of the wave is balanced by a large negative space on the right, the composition seems balanced, even though it is not symmetrical. A line drawn down the center of the work would show how the composition has greater visual weight on the left side. Balance, then, does not always have to be about positives in a composition, but may include areas of negative space. Asymmetrical balance can be visually unnerving if it is taken too far, but sometimes this may also be considered daring.

Lastly, **radial balance** is when the elements of a composition radiate out from, or are arranged in an array around, a central point of reference. A daisy would be an example of radial balance because all the petals radiate out from the center of the flower. Radial balance is least commonly used in traditional painting and sculpture, but appears more often in round architectural

spaces and religious art. Radial balance can be useful to express the importance of a single element of a work of art by visually placing the element in the center of the composition, and having all other elements radiate out from it. In order to determine if a composition has radial balance, a line would have to be drawn from the surrounding elements through the central point of the composition. If the surrounding elements have even placement around the central point, then the composition has radial symmetry. Robert Smithson's *Spiral Jetty* [Figure 14] is an example of radial balance where the form radiates out from a central point. As a note of caution, however, radial symmetry is easiest to spot when the composition is circular, but not all compositions with radial symmetry are round; a square placed evenly within another square, placed within another square has a variation of radial symmetry.

In architecture, balance is determined through the placement of elements such as doors and windows, as well as major forms of the architecture itself. A building might look lopsided if a large window is not mirrored by another large window, but by a small window. Similarly, if one side of a building is larger than the other, the whole structure will seem off-balance. Buildings can have symmetrical, asymmetrical, or radial balance, but radial symmetry is the least common among architectural structures, and buildings with radial symmetry tend to be round.

Proportion and Scale

In art, **proportion** is the size of things in relation to one another in a composition, and can be an expression of the comparison of an element in relation to the whole, or two elements compared to one another. For example, in Hokusai's *The Great Wave at Kanagawa* [Figure 3], it can be said that the figures are small in comparison to the wave, and the wave is large in comparison to the rest of the elements in the composition. As a principle of composition, proportion is useful when making a comparison of elements or a determination of balance. The human body itself has been a subject of study for proportion, and we call the ideal proportions of the human body the **canon of proportions.** The current canon of proportions in the western world is sometimes referred to as *eight heads proportion* because this canon of proportion relies on

the size of the human head as the base unit for measuring the rest of the figure. The first measure is the distance from the top of the head to the chin, equaling one head unit. The second measure is the same distance and extends from the chin to the nipple. The third measure is from nipple to navel, the fourth is navel to crotch, and then five through eight becomes confusing and contested the rest of the way down to the feet, with some artists claiming only seven total heads. While the canon of proportions can be useful for drawing the human body, the limitation is that not everyone measures up to this ideal, and different societies have had different understandings of ideal human proportions. For example, the ancient Egyptians based their canon of the human body on a base unit equaling the size of a person's fist, and the ideal human body was eighteen fists tall from the floor up to the hairline.

Scale differs from proportion because scale is the size of a depicted object or element to what it would really be like in person. This is the relation between the perceived size of the created illusion to the actual size of the real object. In *The Great Wave at Kanagawa* [Figure 3], Mount Fuji is a very large mountain, but in this image it is dwarfed by the great wave. In this composition, perspective has changed the scale of Mount Fuji.

Rhythm

Rhythm is the repetition of elements in a composition to create a pattern, with singular repeating elements usually occurring at least three times. Rhythm is used to provide visual interest in a work of art. Like music, rhythm in art can be regular or irregular, but still give the feeling of balance. When elements repeat at set intervals, that is called regular rhythm. For example, the *Black-on-Black Ware, Feather and Kiva-Step Design Plate* by Maria Martinez and Popovi Da [Figure 7] exemplifies regular rhythm in the surface decoration through the repetition of the feather motif around the edge of the artwork. These feathers, however, are broken up by two distinct groups of kiva-step design pairs that serve as alternate elements to separate the rhythmic repetition into two distinct groups.

In architecture, rhythm is used to create a pattern through repetition of visual elements, such as windows and doors. For example, the building *Fallingwater,* by Frank Lloyd Wright

[Figure 11], exemplifies irregular rhythm in its placement and repetition of horizontal balconies. An example of the use of rhythm in a non-objective artwork can be seen in the repetitive lines in Jackson Pollock's *Autumn Rhythm* [Figure 5] where, although the curving lines are not identical, their all-over coverage of the surface of the painting creates the feeling of balance and rhythm. In this case, rhythm is less about repeating visually distinct elements and more about creating an overall effect through the repetition of similar lines.

Unity and Variety

Unity is the overall sameness in a work of art, while **variety** is the overall difference. Unity can refer to many elements in a composition, from the sameness of the color scheme of a work of art, to shapes in the work of art, or even the textures in a work of art, to name a few possibilities. Variety can be expressed in these same works through a number of devices from adding a contrasting color, to varying the shapes in the composition, or even varying the texture in a composition. For example, in our previous example, the feather motif around the edge of the *Black-on-Black Ware, Feather and Kiva-Step Design Plate* [Figure 7] repeats around the edge of the plate, but is broken up by two sets of kiva-step designs. The feathers represent unity in the work of art, while the kiva-step designs represent variety. Unity and variety are working together in the same composition to give the appearance of harmony.

In addition to traditional forms of art, unity and variety may also refer to newer forms of artwork that take more unconventional forms, such as installation art or site specific sculpture (please refer to Chapter Fifteen for an in-depth discussion of these types of art). In these works, unity and variety can refer to the ideas behind a work of art as well as the form of the artwork itself. For example, if a sequence of works, called a series, is created by an artist, the series should have unity in its underlying idea. Many artists create series, but if an artist only created the same exact thing over and over again, it would become tiresome for the viewer. Each work in a series should have some variety for visual and conceptual interest. Unity and variety are present in both the idea behind the work of art, and in the work of art itself.

Emphasis

Emphasis is the focus of the composition. Emphasis is used to convey importance to the viewer through the creation of **focal points,** or points of interest in the work of art. There are a number of ways an artist might indicate the focal point of a work of art, but one of the most common methods is placing the most important element of the work of art right in the middle of the composition. Other times, especially when the most important element is not in the center of the work, the artist will use some device in order to bring our attention to the important element. That can include making the important element another color, highlighting it with a spotlight, or having other figures in the composition looking or pointing to the most important person in the composition. In many early Renaissance paintings, for instance, it is common to have another figure in the composition looking at or gesturing to the person of Christ. A good example of the element of emphasis is Masaccio's *Holy Trinity* [Figure 9] where not only is Christ in the center of the composition, but the Virgin Mary is looking out at the viewer and holding her hand up towards Christ.

A term for another method that uses scale to show the importance of an element in a composition is hieratic scaling. **Hieratic scaling** is used in a composition to indicate the most important person or object, which is depicted larger than the rest. For example, in many ancient Egyptian depictions, the pharaoh is shown dwarfing other figures in a composition. We know that in reality the pharaohs were the same size as ordinary men, but in their artwork the figures are given larger-than-life heights to indicate their important status in Egyptian society. In some compositions, varying levels of importance are indicated by more than two sizes of figures; the king or ruler may be the largest, the courtiers or priests may be the second largest figures, and the peasants may be the smallest figures.

CHAPTER SUMMARY

- The arrangement of formal elements in a composition is governed by the principles of composition.
- There are three types of balance: symmetrical, asymmetrical, and radial. Balance is used to describe the arrangement of negative and

positive space used to create the feeling that elements in the work of art are evenly distributed, that the work has equal visual weight.

- Proportion is the size of things in relation to one another, and scale is the size of a depicted object in relation to what it would be like in person.
- Rhythm is the repetition of elements in a composition to create a pattern, with the repeating elements occurring at least three times. Rhythm is used to provide visual interest in a work of art, and can be regular or irregular.
- Unity is the overall sameness in a composition, while variety is the overall difference. Unity and variety work together in a composition to achieve visual harmony.
- Artists use emphasis to indicate the relative importance of elements in a work of art.

ART AND ARTISTS

Katsushika Hokusai, *The Great Wave at Kanagawa* (from a *Series of Thirty-Six Views of Mount Fuji*), ca. 1831–33 (The Metropolitan Museum of Art, New York).

Maria Martinez and Popovi Da, *Black-on-Black Ware Plate, Feather and Kiva-Step Design,* Signed Maria/Popovi 670, undated (late 1960s to early 1970s). Collection of Charles and Georgie Blalock.

Masaccio, *Holy Trinity*, Santa Maria Novella, Florence, Italy, ca. 1428.

Frank Lloyd Wright, *Fallingwater (The Kaufmann House),* Bear Run, Pennsylvania, 1936–1939.

Making Art:

3 Material and Medium

THE PREVIOUS SECTION of the text outlined the formal visual elements and principles of composition, including a discussion of color. This part of the text explores the variety of materials and techniques available for artists to create works of art. It is important to understand how art is made because the physical form that art takes often influences its character. Each art material has its own physical limitations, and artists not only have to master the techniques of the medium, but also learn to work within those material limitations. Art materials have changed over time as artistic practice has changed, and when we talk about art we speak of material and medium. **Material** is what the work of art is made out of, such as wood, stone, metal, or paint, and the choice of materials can contribute to the meaning of a work of art. **Medium** is the mode of expression. For example, if the material is paint, then medium would refer to the type of paint used, such as acrylic or encaustic or oil. In the following section, we will look at the most commonly used materials and mediums of art in a structure that progresses from the most common materials, to the more complex, and even to the purely theoretical, while attempting to be as comprehensive and concise as possible. Some of the mediums described are actual material processes, while others describe newer approaches to art that span mediums and seem to transcend definition and categorization.

Drawing

DRAWING IS AN EXAMPLE of an art expression that has been revolutionized by advances in material technology, and with the advance of new materials, old materials have fallen into relative obscurity. The basic premise of drawing is that line and tone are created through the use of a drawing implement on a surface. To this end, there are quite a variety of tools that have been used to create drawings. The following list is not exhaustive but ranges from an historical technique that is unfortunately not used widely by contemporary artists, to the tools that are vital to contemporary artists. The historical technique of silverpoint is included to illustrate how diverse drawing implements can be, and how a once popular technique has been virtually lost over successive generations in favor of new technology. This technique is also covered because it provided the inspiration for modern day pencils, which are essential to drawing.

The surface on which a drawing is executed is known as the **support,** and a common support for drawing is paper. The relative roughness of the paper's surface is referred to as **tooth.** Paper with good tooth is rougher and will hold a line better than smoother paper, which may cause the drawing to turn out lighter, or even be easily brushed off the paper. Paper is often taken for granted today as cheap and readily available, but at one point in history paper was very expensive and artists only began to regularly create drawings after paper became cheaper to produce. Today, paper is much more affordable than the paint used for fine art paintings, and drawing is not only an excellent way to learn

about tone and the formal elements, it is also rightly assumed that many mistakes will be made as a beginning student. It is better to waste inexpensive paper as a beginner, than to waste paint and canvas.

There are many types of paper produced especially for drawing, ranging from the very expensive to the very cheap. Beginning students often use inexpensive newsprint for drawing, but newsprint will yellow and become brittle after just a few years because of its high acid content, so it is not an ideal support for a finished work of fine art. Unless decay is intended in the work, newsprint is only acceptable for student work and is usually not used for finished works of art. More expensive papers will withstand the passage of time and not be subject to yellowing and disintegration. However, all paper is delicate and must be carefully framed and preserved to ensure that it will withstand the ravages of time, sunlight, and decay.

There are two main categories that drawing media can be categorized into: dry and wet. Dry media is by far the most common material for creating a drawing, and dry materials include metal-based pencils and points, pencils, charcoal, and all the range of pastels, oil pastels, and crayon. Wet media refers exclusively to ink and pen, or ink and brush. Although it would seem logical to categorize wet media with painting, it is counted with drawing because it employs ink and not paint. Additionally, since ink produces a monochromatic drawing in varying shades of black, the focus of ink drawing tends to be on the creation of areas of tone through the use of line and wash. A wash is created when ink is watered down and a larger area of the paper is covered.

Methods of Drawing: Dry Media

Silverpoint

Silverpoint is a type of metalpoint that uses a length of silver wire to create a drawing. **Metalpoint** refers to any method of drawing where metal is used to create the line and can include silver, gold, copper, and lead (this is where we get the common misconception that pencils are still made of lead). Metalpoint was a drawing

method invented in the middle ages that became popular during the Renaissance in Western Europe. Unfortunately, silverpoint and most of the other types of metalpoint began to fall out of favor with artists when, in the 1700s, graphite became popular as a drawing material. Although very few people work in silverpoint today, silverpoint can create a very beautiful, delicate line. To work in silverpoint, the end of a piece of fine gauge silver wire is rounded and inserted in a stylus. Although the wire could be held with the fingers when drawing, it is easiest to mount the wire in some kind of holder like a pin vise because it is extremely difficult to grasp thin wire without bending it and hurting the hand. The wire is then used to mark the ground, leaving miniscule specs of silver behind as line. Fine metal wire is measured in gauges and the higher the gauge the smaller the diameter of the wire. In the United States, "two gauge" wire is quite thick while "thirty-six gauge" wire is closer to the thickness of a strand of hair. For silverpoint, a wire between sixteen and eighteen makes a good, sturdy drawing tool, although thicker or thinner wire will produce different effects of tone.

When silverpoint lines are first drawn, they have a lighter bluish-grey appearance that darkens over time to a brown as the line is exposed to the air. This process is similar to the way silver jewelry will tarnish over time if not cleaned and shined. Silverpoint is very different from most types of drawing because it is impossible to erase silverpoint lines, and because the tone of the line will not change with variation in pressure from the artist, which means it does not matter how hard or soft the artist draws because the tone will always remain the same. This is markedly different from most other drawing techniques where the harder you press, the darker the tone that is created. In silverpoint, tone is achieved through the use of hatching and cross-hatching, but to achieve a very light or dark area in a drawing, the artist may choose to highlight with white chalk or shade areas with black chalk or graphite pencil. Additionally, the paper used for silverpoint should have enough tooth for the stylus to leave a visible mark, and it is difficult now to find a suitable paper for silverpoint. There are still some manufacturers of paper especially for silverpoint, but a good, cheap surface can be created by coating a piece of sturdy paper with a thin coat of a neutral color acrylic paint.

Pencil

By far the most common drawing implement is the graphite pencil, which was developed from the technique of metalpoint, especially metalpoint using a lead stylus. We still refer to the innermost part of a pencil as the lead, but pencils today are generally made with graphite, a substance made from a combination of clay and carbon. The thin graphite is traditionally encased in a wood sheath which is removed by sharpening, and this form can be traced back to the 1500s in Europe. Most people are familiar with the yellow number two pencils used in school, but artist pencils are different from these because artist-quality pencils come in varying degrees of hardness (designated by the letter H) or softness (designated by the letter B). The harder the lead, the more precise the line, and the softer the lead, the thicker the line produced.

Pencils have the advantage over silverpoint of being erasable, but the degree of erasability depends on the drawing surface used, and the hardness or softness of the lead. In addition, certain grounds have more texture and hold the graphite better. As most students already know from using a regular pencil, only a limited amount of erasing can be done before a hole is worn through the paper. The usefulness of a softer pencil is the ability to create areas of tone which serve to complement the lines of the drawing. Even as expressive as pencil drawing can be, however, pencil drawings are usually considered to be preparatory studies for creating other works of art and it is not as common at present to see drawings exhibited as finished works of art.

Charcoal

Charcoal is a carbon-based material made from burnt wood and comes in a variety of thicknesses of either hard or soft consistency. Charcoal, because of the simplicity of obtaining the material, is one of the oldest art methods in the world, dating back to prehistoric cave drawings some 27,000 years old. In prehistoric times, chunks of burnt wood from the remains of the cooking fire were used to draw on cave walls and ceilings, but the process of making drawing charcoal is now more refined. Drawing charcoal comes in two main kinds differentiated by material; willow is made from willow branches, while vine can come from a variety of woody plants. Both willow and vine charcoal sticks begin as tree branches cut into standard lengths which are then heated in an oven. This

heating process creates charred wood that keeps its form and does not immediately disintegrate upon handling. A certain amount of disintegration, however, is desirable to create a charcoal drawing because as charcoal is used, small pieces of the burnt material flake off onto the support to create line and tone. One of the drawbacks of using charcoal is that it is a messy material and does not adhere well to paper by itself. To remedy this situation and ensure that the drawing will not become damaged, a charcoal drawing needs to be "fixed" to its support with a spray sealant, called fixative, to prevent the charcoal from becoming smudged. Before aerosol hairspray fell out of favor due to environmental concerns, it often served as the poor art students' fixative. To "fix" a charcoal drawing, the fixative is sprayed over the surface of the drawing and allowed to dry. As a caution, fixatives should be used carefully because many of them are made of acetone and xylene,[1] a very toxic substance that should not be inhaled.

Charcoal is somewhat unique as a drawing material because it can easily be worked positively or negatively, in an additive or subtractive method. Using charcoal additively is when the charcoal is used to make a mark on the page, like a regular drawing. Additively, tonal value is determined by the amount of pressure applied to the surface of the paper with the charcoal stick and whether or not the charcoal is of hard or soft consistency. When charcoal is used in a subtractive method, the paper is first toned with the charcoal and then the charcoal is erased with an eraser or rubbed off the surface of the paper with a rag or even a *chamois*, a small piece of very supple animal skin. In this case, the eraser becomes the drawing implement. The focus for this type of drawing is on capturing the highlights of the subject, while regular drawing lends itself better to expressing the shadows of an object. Both of these approaches, however, can be combined for use in a singular drawing.

As a medium, charcoal is usually reserved for preparatory studies or to plan out a composition for a painting on a canvas. However, some artists today are exploring the use of charcoal drawing as a medium for finished works of art and as a way to make experimental works of art. One such contemporary artist is William Kentridge (b. 1955), who uses charcoal drawings to create animation films. First, Kentridge creates a charcoal drawing on a piece of sturdy paper. Next, he repeats a process by which he photographs the drawing and then redraws some areas and erases others to create a new "scene" in his animation, which

also has the effect of leaving ghost images of the other previous scenes. The same piece of paper is used over and over, stopping only to photograph the different stages of the drawing as he works. In the process of creating the animation, the drawings are destroyed by the alterations and thereafter only exist in the video of the animation.

True Chalk, Compressed Charcoal, and Conté Crayon

True chalk is a natural material that comes straight from the ground in black, red (called sanguine), and white. The limitation of true chalk is the few color choices available. Much of the chalk sold in art stores today is not true chalk, but manufactured chalk and chalk pastel (which is described in detail in the next section). Similarly, **compressed charcoal** is not really charcoal at all, but a product made by compressing lamp black (soot from burnt oil) and a binder,[2] which produces a much denser and more permanent material than charcoal. When used in drawing, compressed charcoal creates a darker, blacker tone, and unlike willow or vine charcoal, compressed charcoal is not easily erased.

The third material, **conté crayon,** has characteristics similar to compressed charcoal and is made by combining chalk and gum arabic, a substance made from the acacia tree. Conté crayons are useful for drawing because they keep a fine edge and can be broken into smaller pieces for more edges, although the line they produce is not as dark as compressed charcoal, nor as messy. The most common conté colors are black, umber, and sienna. Conté crayons and chalk are often used to create drawings on paper that is a midtone such as tan, light brown, or gray. In these drawings, a conté crayon is used to create dark tones, the paper represents the midtones, and white chalk is used for areas of highlight. These types of drawings were very popular in the High Renaissance, but are also used by many artists today. True chalk, compressed charcoal, and conté are commonly used with charcoal and so must be fixed to the paper in a similar manner to prevent smudging.

Chalk Pastel and Oil Pastel

A manufactured drawing material, **chalk pastels** are made from powdered pigments combined with a binder, such as wax or

glue, to form a hard stick. The composition of pigment to binder determines whether these sticks will perform more like chalk or more like a crayon. Pastels have less binder, while oil pastels have more binder. Like charcoal, pastels do not bind with their supports and must be treated with a fixative to ensure they will not rub off or become smudged. Care must also be taken when framing not to use a material like Plexiglas, which creates so much static that the Plexiglas will attract the pastel particles and actually remove them from the paper, damaging the drawing.

Oil pastels are a variation on chalk pastels and are made of pigment mixed with fatty substances or wax. In some ways, oil pastels are a marked improvement over chalk pastels because of the brightness in color and better adhesion qualities, but they also tend to be very bright (garish) and can become smudged or scraped off the surface of the paper long after the drawing has been executed. Like charcoal, oil pastels can be worked either positively, by application of oil pastel to a surface, or negatively, by coating the surface with oil pastel and scratching through to reveal the support underneath. This ability to be scraped away, moreover, can be helpful for correcting mistakes. Oil pastel is also unique because colors can be mixed on the support while drawing, although this is sometimes an undesirable, unintentional side-effect.

Methods of Drawing: Wet Media

Ink with Brush or Pen

Drawing with ink is a challenging technique that can yield exciting results. In **ink drawing,** different types of line and areas of tone are created by using different types of brushes or an ink pen. The type of pen used for ink drawing is a fountain pen with interchangeable nibs, and the brush most commonly used is a bushy Asian-style brush with a bamboo handle. The way the brush or pen is held, as well as the amount of ink and water on the brush and the texture of the paper, affects line quality. The line can either be made with the tip or the side of the brush. Using the tip of the brush creates a thin, crisp line and using the side of the brush creates a wide line. By changing hand position the artist can create a variety of tones in one single brushstroke. The character of the line is affected by the amount of ink and

water on the brush, and ink that is used straight is very dark, but it can be thinned with water to create a wash. Once the ink is thinned with water, it takes on many of the same characteristics of watercolor. Brushes can be used with a lot of ink or almost dry, creating different areas of line and tone. Using a dry brush will give a jagged, rough line while using a brush with lots of ink and water will give a smoother line.

Paper, as well, has an effect on ink drawing. The paper that ink is applied to does not necessarily have to have any special preparation, but should be a paper that is stable enough to take water. Some paper is smooth while other paper has texture, but the choice of paper is entirely up to the artist and his or her preference. The main limitation of ink as a drawing material is its permanence. It is nearly impossible to correct an ink drawing once the ink has dried. Some amount of correction can be achieved by adding water to the drawing, but this is often to the detriment of the paper, which may fall apart with too much water. One technique, called wet on wet, calls for the paper to be wet before drawing begins, and creates a very soft look in the drawing, relying almost exclusively on the creation of areas of tone. Too much water in this technique, however, will ruin the work and cause the ink to run down the paper.

NOTES

1. Acetone and xylene are the ingredients in Prismacolor's Final Matte Fixative for pastel, charcoal, and pencil. The danger warning on the spray can states "extremely flammable, harmful or fatal if swallowed, vapor harmful, contents under pressure." Oddly enough, xylene is also widely used in the restoration and conservation of works of art.

2. Ray Smith, *The Artist's Handbook*. (London: DK Publishing, revised edition, 2003), 92.

ART AND ARTISTS

Pencil

Egon Schiele, *Schiele, Drawing a Nude Model before a Mirror*, 1910. Pencil. Graphische Sammlung Albertina, Vienna.

Charcoal

Altamira cave paintings, Santander, Spain, ca. 14,000–12,000 BC.
Gustave Courbet, *Self-Portrait (The Man With the Pipe)*, 1847.
Wadsworth Atheneum, Hartford, Connecticut.
Lucian Freud, *Head of a Man*, 1986. The Museum of Modern Art,
New York.
William Kentridge, *Weighing . . . and Wanting*, 1997. Museum of
Contemporary Art, San Diego.
Käthe Kollwitz, *Lascaux cave paintings*, Dordogne, France,
ca. 15,000–13,000 BC.

Conté Crayon

Lucian Freud, *Christian Berard*, 1948.
Lucian Freud, *Girl in a White Dress*, 1947. Conté crayon, and pastel.

Ink

Lucian Freud, *Self-Portrait*, 1940. Ink.

Painting

WHAT IS PAINT? Along with drawing, painting is one of the oldest forms of art discovered in prehistoric caves in Europe. The basics of painting have not really changed a whole lot in the last 27,000 years except for the addition of a variety of substances mixed with powdered pigments. In prehistoric times, pigments were mixed with animal fat to paint images of hunting and animals like bison and horses on the walls of prehistoric caves. New developments have resulted in a variety of new types of paint and a deep understanding of different types of painting materials and media.

Before we can begin to understand the basics of the different types of painting materials and mediums we have to first understand the basics of artists' pigments. Paints are made from **pigments,** which are the powdered forms of excavated earth elements (minerals), plants, insects, or even semi-precious stones. Each element, plant, or stone has a unique color that it is prized for, and by grinding it into a powder it can be combined with a liquid, such as oil for oil paints, acrylic polymer emulsion for acrylics, or egg yolk for egg tempera. This liquid is referred to as the **vehicle** or **binder. Binder** is the substance that is mixed with the powdered pigment to create paint. The vehicle can also refer to the **diluent,** or the substance used to thin a paint to provide for more fluid handling. In oil painting, turpentine, or more recently turpenoid, is used as a diluent. The vehicle, then, indicates the medium of the work—whether the work is oil painting, acrylic, or watercolor, to name a few, and is the substance that allows for the adhesion of the pure

powdered pigment to a **ground,** the liquid coating that forms the surface on which a painting is executed, whether that ground is coating paper, canvas, or plaster.

Historically, artists' paints were made either by the artists themselves, or by a studio assistant under the supervision of the artist. A change occurred, however, during the late 1800s when companies began to manufacture artists' oil paints in tubes and pots. This eliminated the need for artists to mix their own paints, made the paints highly portable, and ensured a stable degree of quality from tube to tube of paint. Before the 1840s, artists' paints were stored in pig bladders, but after the 1840s a number of developments occurred in paint storage resulting in the modern paint tube, including one tube style that resembled a syringe.[1] Metal tubes eventually became popular and are still commonly used. The importance of placing paint in tubes is to seal the paint from air, preventing it from drying out. An early result of paint sold in tubes was that many artists in the mid-1800s began to work out-of-doors in a style known as *plein air;* painting scenes of the countryside and people from life instead of working from sketches made outdoors and brought back to the studio.

A secondary result is that many artists today have never mixed their own paints, saving them from possible toxic danger, but also distancing them from the preparatory process of painting. Some contemporary artists, however, have chosen to return to mixing their own paints, with varying degrees of success. In oil painting, if an incorrect ratio of pigment to oil is used, it will retard the drying process of the paints, which can lead to the degradation of the painting itself. There is one well-known artist, who shall remain unnamed, who mixes his own oil paints and whose paintings have caused a nightmare for painting conservators called in to treat paintings that still drip oil and are tacky to the touch years after they were painted.

Paint toxicity is still a concern in painting. Today, some pigments are synthetic because of the danger of using some of the true pigments. Oil paints made with toxic pigments are required to display a cautionary statement on their packaging warning consumers about possible safety hazards involved in using the paint. Painters are usually cautioned not to eat, drink, or smoke while using these colors, and to wear gloves. Some of the more common toxic pigments are flake white and naples yellow, both made with lead, and chromium oxide green. The degree of toxicity varies

for the different pigments, which can be purchased in powdered form. The cost for certain powdered colors can be prohibitive, and pigments purchased in powdered form are used by painters to make their own paints, and by art conservators who mix the powder pigment with very expensive non-oil binders to touch up paintings. Unfortunately, great care must be taken with these pigments to avoid inhalation and spillage.

Tools of the Painter

For most of these painting techniques, brushes are used to apply the paint to the ground, although the ground tends to vary with the painting materials. Some grounds are better suited to some techniques than others, and brush styles and materials also are particular to the painting technique. Brushes for painting are basically the same as they were back in prehistoric times. The best brushes have bristles made of animal hair attached to a wooden rod. Bristles vary depending on the type of animal they come from or whether they are synthetic. Boar's hair (or hog hair) and squirrel are very popular yet expensive brush materials, while sable (weasel) is cheaper. The choice of brush depends on the desired stiffness of the bristles. For example, boar's hair tends to be a more rigid material and is well suited for oil painting while squirrel provides softer bristles more suited to watercolor. Synthetic bristles can be either hard or soft and tend to be cheaper but more prone to staining because they are made from nylon. Synthetic brushes tend to be white, while boar's hair is blond and squirrel is brown. Natural hair brushes also have a characteristic smell when they are wet, like a wet dog. Great care must be taken with good brushes because they can cost upwards of fifty dollars and are easily ruined with mistreatment. Brushes must be carefully washed after every use in a mixture of mild soap and tepid water, because hot water will cause the glue to soften and the bristles to fall out. After they are washed, brushes need to be reshaped and let dry. If brushes are not thoroughly washed and dried, the next time they are used the old paint can come out and mix with the new paint.

Besides paint, there are a few extra tools that are essential for painting. Painters need to have a surface on which to mix colors, called a **palette,** although the term palette refers both to the surface on which paints are mixed as well as the choice of colors a

painter uses for a painting. Palettes can be made from a variety of materials including wood, plastic, and glass. The most popular and traditional style is the hand-held kidney-shaped palette with a thumb hole. These wooden palettes were especially popular when it was common for oil painters to use earth-colored grounds because the wood of the palette approximated the color of the ground.[2] Glass palettes are usually simple home-made rectangular pieces of glass backed with white paper and taped around the edges to prevent cuts. Glass palettes are especially useful because even dry oil paint can be scraped off with just a razor blade. The other commonly used type of palette is the disposable paper type that comes in a pad. This type of palette has some advantage because each paper can be thrown away after use. Watercolor is a little different because the palette has to be able to contain water, so painting trays with multiple compartments are usually used.

Since mixing paint with a brush is not very useful, **palette knives** are commonly used for paint mixing, although they can also be used to apply paint with oil, acrylic, and encaustic. Palette knives are not really knives, but flexible metal tools with a sharp side that can be used to scrape paint of a canvas or the palette. Another useful painting tool is the **mahlstick.** A mahlstick, or maulstick, is a long wooden rod with a padded end, usually used by oil and fresco painters to support and steady their brush hand for detail work. The term comes from the Dutch words *malen* ("to paint"), and *stok* ("stick"), and maulsticks are thought to have first been used in the 1500s in Northern Europe, since they appear in a number of self-portraits of the time.[3]

Oil Paint

Even though **oil paint** is not the oldest painting method, it is the first method discussed because oil painting is considered by many to be the epitome of painting techniques and is by far the most common type of paint used today, with acrylics as the next most common. If we start with oil painting as the standard for painting, it becomes easier to compare the other methods against it, since oil paint is very unique, whereas acrylic paint shares some of the same qualities with other types of paint. The origins of oil paint are uncertain but artistic tradition told to us by Giorgio Vasari is that the invention of oil paint can be traced back

to the early fifteenth century to the Flemish painter Jan Van Eyck, even though there are indications that it is, in fact, much older than that. The materials of oil painting have remained consistent since the 1500s and paintings executed properly in oil are some of the most durable paintings; many have lasted intact for almost five-hundred years.

Oil paint is made by combining powdered pigment with oil, usually linseed oil, and thinned with turpentine, a substance distilled from pine trees. The use of oil gives oil painting a number of advantages over different types of paint; it retards, or slows, the drying time and gives the painting luminosity. Since the pigment particles are suspended in oil, this allows light to reflect in a different manner. An oil painting can be executed on a variety of different surfaces from cloth to metal to wood. By far the most popular surface for oil painting is canvas. Linen is another popular, but expensive, choice for oil painting. The fabric support for a painting is called a **canvas,** even if it is made out of linen. A canvas is made by constructing a frame of wood and covering it with tightly stretched fabric that should make a drum sound when flicked with the finger. There are two types of wood frames for canvases: stretcher and strainer. Stretcher bars are the type commonly sold in art stores that have slotted corners and **keys,** small triangular pieces of wood that are hammered into the corners of the bars to stretch the fabric taught. Strainer bars are fixed and cannot be "keyed out" like stretcher bars. The advantage of using stretcher bars is that the keys can be used to stretch the canvas tight if it ever starts to sag or warp. A canvas can start to sag as a result of fluctuations in humidity.

Stretching a canvas, however, is not the last step before painting can begin. To prepare a canvas for paint it must be covered with a layer of gesso. **Gesso** was historically made from a combination of animal glue and burnt gypsum,[4] or even chalk or lead, but now refers to any liquid, water-based coating that is applied to a canvas and allowed to dry. Gesso is used to prime canvas because it seals the fabric and prevents it from leaching the oil out of the paint. Once the gesso is dry, the canvas is ready to accept a painting and is considered to have been "primed."

There are two main approaches to creating a painting; building up the painting using layer upon layer (called **indirect painting**), and *alla prima* (also called **direct painting**). The traditional method of layering is a method in which the artist begins with a monochromatic underpainting and often builds up

the color slowly through **glazing,** the layering of transparent oil paints. A layered painting can take a long time because the paint usually needs to be allowed to dry between layers. The final top layer of a layered painting is a clear varnish coating. These layers and varnish create a strong painting surface. Jacques-Louis David's *Oath of the Horatii* [Figure 8] is an example of a layered painting.

On the other hand, the ***alla prima*** painting method is a direct method where the work is executed all at once, often called wet into wet. This method has been popular since the later nineteenth century when artists began to feel stifled by the slowness of the process and wanted to capture things quickly in paint. Jackson Pollock's *Autumn Rythym (Number 30)* [Figure 5] is an example of an *alla prima* painting. Although *alla prima* is now the more common method for modern painting, a number of younger artists are researching and using traditional painting methods in their art. Choosing a painting method is completely up to the discretion of the artist, but the layered approach creates very durable paintings. Conservationists face a challenge with *alla prima* works, and many *alla prima* works even from the mid-twentieth century are already falling apart. This is due in part to the use of **impasto** that is a term for the thick application of paint. The thick layering of the paint in the impasto technique leads to uneven drying, and even drying and even paint thickness is needed for paintings to remain stable.

Egg Tempera

The term "tempera" can refer to more than one type of paint, but historically the most common form is egg tempera. When students hear the word tempera they often think of the tempera sold in craft stores or used in school art classes in the lower grades, but that is a more recent form of tempera and is not a common material used for creating fine art. Traditionally, **egg tempera** is a fast-drying type of paint made by mixing ground pigments with egg yolk and water and was commonly used for fine art paintings in the early Renaissance through the 1400s.[5] When dry, the resulting painted surface eventually becomes very hard and resistant to water. Egg tempera adheres best to rigid surfaces, such as wood panels, which are less prone to the

flexibility of canvas as a ground. Due to the fact that egg tempera dries so rapidly, it must be mixed as needed and does not store well. Also, incorporating egg whites into the mix can negatively alter the consistency of the paint if the proportions are not correct. One of the unique qualities of egg tempera is its rapid drying time. The stroke of paint dries almost immediately after it is applied to the painting, which both affects the resulting look of the painting as well as the ability of the artist to rework a painting. The artist must work quickly using hatching to build up color and form and is not able to blend colors as he or she paints. In this respect, egg tempera has little in common with modern oil painting, which is often worked *alla prima*, but much in common with traditional layered painting and even drawing, where the composition is built up slowly with the application of one line of color at a time.[6]

Like traditional painting, Renaissance artists built up their paintings one area at a time, overlaying layer upon layer until the painting was finished. It is easy to see how the labored layering of egg tempera, which was popular before oil painting in Western Europe, influenced the way artists later used oil paint. With egg tempera, however, any desired blending of colors was done when the pigments were mixed with the egg yolk immediately before they were applied to the surface of the painting. If a mistake was made the artist could only paint over it. As we saw in oil painting, oils can take weeks to dry and mistakes or offensive areas of the painting can be scraped off the surface of the canvas with a palette knife.

Also, unlike common oil painting, egg tempera is usually applied to a board covered with gesso. This is the best surface to ensure adhesion of the paint to the ground. It is also said that true gesso made with chalk or lead is the best coating for the board because modern gesso does not bond as well with the paint.[7] Generally, egg tempera is used by itself as a painting medium, but sometimes you will see paintings described as being made with oil paint and egg tempera. This is because egg tempera was sometimes used as an underpainting for oil paintings. The layering of egg tempera under oil paint is acceptable, but because of the different drying characteristics and differing elasticity of oil paint and egg tempera, tempera mixed with oil or painted over oil paint will not last.

Acrylic Paint

The history of acrylic paint goes back to the earlier part of the twentieth century, but the popularity of acrylic paint only goes back to the 1950s. **Acrylic paint** is made by suspending pigment in an acrylic emulsion which, when dry, forms a very stable waterproof surface. Although acrylic paint is relatively new, sixty-five or so years for acrylic versus about five hundred years for oil paint, acrylic paintings have held up rather well over time. Their durability rivals that of a well-layered oil painting but without the yellowing that is so common of oils. Many artists appreciate acrylic paint because it dries quickly, cleans up with water, is not as messy as oil painting, and can be thinned down for thin washes like watercolor or even used in an airbrush. These same reasons, however, are the same reasons many people prefer oil over acrylic (except for its messiness). People who are used to the slow-drying time of oil do not like how quickly acrylics dry because, like egg tempera, the colors are difficult to blend. Acrylic manufacturers have addressed this problem by creating blending mediums to make acrylics act more like oil paints without the mess and the hazard. These include gel mediums to thicken the paint and retarders to slow the drying time.

Acrylic paints, unlike oil paints, do not necessarily need a gesso layer between the canvas and the paint, but most artists seal the canvas with acrylic gesso primer, which is made from the same emulsion as the paints themselves.[8] This is not the same as traditional gesso that is used for oil paintings, but many artists now use acrylic gesso primer as gesso for oil paint. Acrylic paint can also be applied to almost any surface as long as it has been properly prepared, and the finished work does not need a top layer such as varnish to protect it because the final paint layer is so durable.

Watercolor and Gouache

Watercolor paints are made by combining pigment with gum arabic as a binder. **Gum arabic** is a substance that comes from the acacia tree and is important for watercolor because it completely dissolves in water, but not in other substances like turpentine. Because watercolors are thinned with water, they need a support that can absorb water. Watercolor paintings are usually executed on special paper that the artist soaks in distilled water and tapes

to a board with special tape that is sticky when wet. Watercolors come in two forms, as a cake and in a tube. Cake watercolors are dry while tube watercolors are in a liquid form. The result of thinning the paint with water is a very transparent color which does not allow for the use of white. Instead, white is usually the white of the paper, which can be blocked out in those areas that are intended to remain white. Watercolor cannot be easily removed from the support once it has been laid down, and too much water can ruin the surface of the painting. Because the white areas have to be planned out and because watercolor cannot be corrected, the watercolor artist must carefully plan his or her composition.

There are two distinct watercolor painting approaches: wet into wet and wet into dry. Wet into wet involves wetting the surface of the paper before painting begins, and wet into dry is painting directly onto dry paper. One of the advantages of wet into wet is that the resulting color is softer than with wet into dry. These two methods can be used together in one painting to build up different parts of the watercolor composition.

Another type of water-soluble paint known as **gouache** is very similar to watercolor but is opaque because of the addition of a Chinese white chalk, and acts more like a paint than a stain like watercolor. Gouache is sometimes used in watercolor paintings.

Fresco

Fresco is unique in art because the painting surface is a wall and the pigment is not mixed with a true binder, but with **limewater,** a mixture of calcium hydroxide and distilled water. Fresco has been around for a very long time and was especially popular in Roman art for decorating the walls of homes. Masaccio's *Holy Trinity* is an example of a fresco painting. [Figure 9] There are two types of fresco, *buon fresco* and *fresco secco*. **Buon fresco,** meaning "true/good fresco" is a process by which pigment is applied to wet plaster. This type of fresco creates a very stable painted surface because the pigment becomes part of the plaster itself. For the process of *buon fresco*, different base layers of plaster are applied to the wall to prepare for the final layer on which the paint will be applied. The materials for the final layer are mixed and the resulting plaster is applied to the wall and its surface is smoothed out or roughed up depending on which type of surface the artist would like to paint on. When the fresh plaster has

had time to set up (dry out a bit) the surface is ready to accept paint and the artist begins.

The time that the artist has to paint for the day depends on the climate where he or she is painting. Humidity and temperature will affect the drying time of the plaster. Throughout the day, the plaster will change character as it dries, which in turn affects how well the plaster accepts the paint. Early in the day, when the plaster is fresher and wetter, it does not absorb the paint as easily. Later in the day, towards the end of the plaster's workability, there is a time known as the *ora d'orato*, which is Italian for "the golden hour." The *ora d'orato* is a small window of time when the painting is the easiest and the plaster readily accepts the pigment. During this time, all of a sudden the struggles of the previous hours of painting disappear and the painting process is much easier because the much drier plaster readily soaks up the water of the paint. If the plaster dries before an area is painted, then the dried plaster has to be removed, and the area re-plastered for painting the next day. A *giornata* is the term for the amount a fresco painter can paint in one day of work before the plaster dries.

The second, less stable approach to fresco painting is *fresco secco*, meaning "dry fresco." *Fresco secco* is a method where paint is applied to the wall after the plaster has dried, much like a mural. In both methods, the works can be made by either creating a full-scale charcoal drawing on the wall, or drawing a full-scale copy of the work on paper with indications of areas of light and shadow. These full-scale paper drawings are known as cartoons. To use a cartoon, small holes are made around the outlines of the scene and the paper placed against the wall. Next, a powder such as chalk is dusted over the pricked paper and when the paper is removed, an outline of the scene is left on the wall. The artist then proceeds to paint the scene according to the imprint of the cartoon.

Encaustic

Encaustic is a painting technique where the pigment is suspended in beeswax. One of the advantages of painting in encaustic is its durability, providing that the climate does not destroy the support. The most well-known encaustic works are a number of funerary portraits made in Roman-controlled Egypt between the second and third centuries AD. These portraits were painted on wood and placed over the face of the deceased to serve as a death mask. Encaustic was the preferred painting technique for

these works because of the way that the wax could simulate skin tone. Unfortunately, there are not as many other types of painting to compare these encaustic works to because works from this same time period from other parts of the Roman empire did not survive intact. The encaustic mummy portraits survived because Egypt's arid climate preserved their wood supports.

Although encaustic is a very durable painting medium and was commonly used for Roman portraiture, it is no longer widely used today. It is quite difficult to work in encaustic and even a little dangerous because the wax has to be hot in order to paint with it. The artist must keep the beeswax liquid in order to mix in the pigments and apply it to the painting surface. Almost immediately after application, the wax will begin to solidify as it cools. To rework areas a heat source, such as a heat gun, may be used on the surface of the painting and areas may even be scraped away with a palette knife. One of the limitations of using encaustic is that the wax can develop a cloudy residue on its surface if the correct storage and climate conditions are not met. One modern artist who successfully used encaustic is Jasper Johns (b. 1930) who is known for a number of encaustic works on canvas completed in the 1950s including *Three Flags,* painted in 1958. Jasper Johns is considered to be part of the Early American Pop Art movement and the encaustic technique gives his otherwise flat subjects, American flags and a target, depth and visual interest.

Paint Quality Comparison

This chart compares the qualities of each of the different types of paint we have learned about.

Paint	Binder	Support	Drying Time
Oil	linseed oil	canvas or board	slow
Acrylic	acrylic emulsion	almost anything	fast to medium*
Egg tempera	egg yolk	board	very fast
Watercolor	gum arabic	paper	fast
Fresco	————**	plaster	fast
Encaustic	wax (beeswax)	canvas, board	fast to medium***

*Drying time can be retarded with the addition of an acrylic retarding medium.
**Pigment is mixed with limewater for *buon fresco,* but seemingly any paint can be used for *fresco secco.*
***Set time can be extended with a heated painting surface.

NOTES

1. David Pyle. *What Every Artist Needs to Know About Paints & Colors.* (Iola, WI: Kraus Publications, 2000), 21 and 82.
2. Ray Smith. *The Artist's Handbook.* (London: DK Publishing, revised edition, 2003), 125.
3. One of the first illustrations of a maulstick is in Caterina van Hemessen's (1528–after 1587) *Self-Portrait* of 1548. The painting shows a young woman working on a painting while using a maulstick.
4. Rutherford J. Gettens and George L. Stout. *Painting Materials.* (New York: Dover Publications, 1966), 233.
5, 6. Ray Smith. *The Artist's Handbook.* (London: DK Publishing, revised edition, 2003), 161.
7. Ibid., 162.
8. Ibid., 205.

ART AND ARTISTS

Maulstick

Caterina Van Hemessen, *Self-Portrait*, 1548.

Oil

Willem de Kooning, *Woman 1*, 1950–52. The Museum of Modern Art, New York.
Lee Krasner, *Polar Stampede*, 1960.
Robert Motherwell, *Elegy to the Spanish Republic No. 34*, 1953–54. Albright-Knox Art Gallery, Buffalo, New York.
Bernett Newman, *Vir Heroicus Sublimis*, 1950–51. The Museum of Modern Art, New York.
Jackson Pollock, *Number 1, 1950 (Lavender Mist)*, 1950. Oil on canvas. National Gallery of Art, Washington, DC.

Acrylic

Helen Frankenthaler, *Interior Landscape*, 1964. San Francisco Museum of Modern Art.
David Hockney, *A Bigger Splash*, 1967. Tate Gallery, London.
Morris Louis, *Moving In*, 1961. André Emmerich Gallery, New York.
Kenneth Noland, *Golden Day*, 1964.

Tempera

Sandro Botticelli, *Primavera,* c. 1482. Galleria degli Uffizi, Florence.
Andrew Wyeth, *Braids,* 1979.

Watercolor and Gouache

Georgia O'Keeffe.

Fresco

Masaccio, *Holy Trinity,* Santa Maria Novella, Florence, Italy, ca. 1428.
Diego Rivera, *The Making of a Fresco,* 1931. The San Francisco Art
Institute, San Francisco, CA.

Encaustic

Fayum Mummy portraits.
Painted Portrait of a Young Man, from Fayum, 160–170 AD. Albright-
Knox Art Gallery, New York.
Jasper Johns, *Target with Plaster Casts,* 1955.
Jasper Johns, *Three Flags,* 1958.

Printmaking

WHILE PAINTING IS a direct method of creating art, meaning the finished work of art is the direct result of the act of painting, printmaking is a mediated form of expression involving the transfer of an image from a printed surface to a ground. Another crucial difference between painting and printmaking is the reproducibility of the printed image. The result of painting is one unique image while printmaking is a process which usually results in the production of multiple identical images, as long as the original plate is available. Due to the reproducible nature of printmaking, it has been a useful tool for art that functions as social protest because the copies can be distributed widely. Printmaking has also become invaluable for advertising and other mass media.

The basic premise of printmaking is that an image is created on a plate. A **plate** is the material, wood or metal or even plastic, on which an original art image is created, and which the final image will be made from. The plate is worked using a number of different techniques such as relief, intaglio, lithography (which uses a stone to hold the image), or serigraphy (which uses a screen to hold the image). The final result of printmaking is a **print,** the final image that is said to have been "pulled" from the plate when it is printed. Because it is very difficult to imagine how a finished print will look from a plate, artists pull prints as they work to see if the image on the plate is turning out as desired. Each test print is known as a **proof.**

When the plate is finally ready and final printing begins, the artist will print a limited quantity of identical

images from the same plate, known as an **edition.** The number of prints in an edition, as well as the number of the print itself, is designated on the print by two numbers separated by a slash mark. For example, if the print carries the designation 2/10, it designates that the print is number two out of a series of ten. Printmaking is a challenging art form and a lot of skill is required in order for an artist to pull identical prints because each time an image is pulled the plate must be inked and printed in the same manner.

As a cautionary note, great care must be taken when practicing any type of printmaking. For printmaking involving carving into a plate, care must be taken to avoid stabbing your hands as you carve because printing tools are ideally kept very sharp. The rule of thumb is to always keep your tools sharp and to push them away from the body as you work. A bench block or non-slip surface is often used to keep the plate in place as the printmaker works. Additionally, some printmaking techniques use acid to corrode metal plates and acid is very dangerous, but these will be discussed in detail with the intaglio process.

There are a number of main categories printmaking can be broken into based on working method, materials used, and how the plate is inked. The following section is broken into five categories; the four main printmaking categories (relief, intaglio, lithography, and serigraphy), and a final section for a unique method that does not fit neatly into any of the previous four categories.

Relief Printing: Raised Surface Prints

In the process of relief printing, an image is drawn or transferred onto a plate and all the areas that need to remain white are carved away, almost like a rubber stamp. The areas that need to be removed are referred to as non-printing areas. To print a relief work by hand, the plate is inked with a tool that rolls the ink over the surface of the plate to provide even coverage. Next, a sheet of paper is placed over the inked plate and the paper is burnished firmly to ensure that all the ink is picked up by the paper. Lastly, the paper is carefully pulled off of the plate to reveal the print. After the print is dry, it is signed and numbered by the artist. The following types of relief printing are all virtually the same in

terms of working method, but what sets them apart is the material of the plate.

Woodblock (Woodcut) Printing and Wood Engraving

Woodblock printing is a very old technique. In woodblock printing, the surface of a piece of wood is prepared and everything that is cut away will not print. One of the challenges with woodblock printing is the grain of the wood itself. If the right wood is chosen this is not a problem, but some artists have chosen to include the grain as part of their work of art because the grain of the wood will print from certain types of cut wood. The advantage of using the woodblock technique is the resulting sharpness of line and the general availability of wood. Woodblock prints are usually printed by hand in the method described above, but with careful preparation, some relief plates can be run through a printing press.

An example of woodblock printing is Katsushika Hokusai's *The Great Wave at Kanagawa* [Figure 3]. Prints such as Hokusai's were popular in the Edo period of Japan's history and the style is referred to as *Ukiyo-e*, which means "floating world." *The Great Wave at Kanagawa* is a complex print, requiring a separate plate for each printed color. When plates of different colors are used to make a single print, they have to line up exactly, and this alignment is known as *registration.* If the registration is off, the print is ruined and cannot be redone, as the colors will cause the image to appear blurred.

Wood engraving is similar to woodblock printing except that the final result resembles an engraving rather than a woodblock print. The lines that are produced are usually finer in wood engraving because engraving tools are used, rather than traditional woodblock printing tools. While woodcuts sometimes have a jagged appearance to their lines, wood engraving uses crisp lines to create form through hatching and cross-hatching. In addition, the plate for wood engraving is made from end-grain of boxwood, lemon, holly, or maple,[1] and because of the plate material, wood engravings tend to be smaller than woodblock prints. An example of a wood engraving is Charles W. Taylor's *Essex* [Figure 2]. It is difficult to understand from a photographic reproduction, but the entire composition is made up

of small, delicately engraved lines, especially in the areas depicting grass. Everywhere that is white in this print has been carved away from the plate. If you look at the water just below the bridge, you can see just how delicate the engraved lines in wood can be made.

Linoblock (Linoleum Block, Linocut) Printing

Although the first thought associated with linoleum is flooring, linoleum has been used as an artist material since the early twentieth century. **Linoleum printing,** often called lino printing or lino-block, is very similar in process to woodblock printing, but the plate material is very different. Lino printing is in many ways an easier form of printmaking because linoleum has no grain and is relatively soft. The only real drawback of lino printing is that linoleum quickly dulls cutting tools and, without sharp tools, the edges of the line can crumble—ruining the sharpness of the line. Because linoleum is rather thin, it is backed with burlap and commonly glued to a wood block, but can be purchased unbound and then attached to a block or rolled unattached through a printing press.

Intaglio: Depressed Surface Prints

Intaglio is an Italian word that comes from the verb *intagliare* which means "to cut into." Intaglio is a method of printmaking where lines are scratched or etched with acid into the surface of a metal plate. Historically, copper was the metal of choice, but zinc is now a very common plate material, although copper is said to hold up better over time with multiple printings. Intaglio printing is different from relief printing, not only because of the plate material, but because of the placement of the ink itself. In relief printing, the ink is rolled on the raised surface of the plate, while in intaglio the ink is forced into the etched or scratched grooves of the plate. To print intaglio, the ink is first applied to the whole plate, and then forced into the tiny lines on the surface with a piece of thick paper cardstock, or a squeegee. A soft cloth is then used to buff and remove all the ink on the surface of the plate, and to ensure it is clean.

Next, the plate is placed on the press and covered with a piece of paper that has been wetted. Finally, a special felt blanket

is placed over both plate and paper and the whole stack of plate, paper, and felt blanket is run through a printing press. The pressure of the press forces the damp paper into the grooves of the plate where the ink is. Each time the plate is run through the press it has to be re-inked because the paper removes the ink from the plate. Because the paper is forced in and around the plate, an impression of the plate is made in the paper, called a plate mark. For this reason, the edges of the plate must be filed at an angle before it goes through the press so that the paper and felt do not get damaged or cut by the plate edges. One way to distinguish a true intaglio print from a commercially produced copy is to look for the plate impression and to lightly touch a finger to the surface of the print to feel the texture of the lines. The following intaglio techniques are categorized based on whether or not they use acid, and although they are discussed as pure examples, several techniques are often combined in one work.

Acid-free Intaglio Techniques

Engraving

Engraving is an intaglio process where line is created with a tool, known as a burin. The burin is used to cut into the plate, and the resulting lines are filled with ink in order to make a print. Tone is created through the use of hatching and cross-hatching.

Drypoint

Drypoint is a technique where the printmaker uses a pointed stylus to scratch thin lines into the surface of the plate. Like engraving, the image relies on line and the building up of tone through hatching and cross-hatching. The difference between etching and drypoint is that drypoint creates a softer image than engraving, because the lines have more rough edges (burrs). These burrs hold the ink, and so only limited numbers of prints can be made before the burr is worn down and the image becomes corrupt. Drypoint intaglio often resembles drawing.

Mezzotint Engraving

Mezzotint literally means "middle tint" and is a printing technique in which the surface of the plate is scratched up with a

tool, known as a rocker. The rocker has a curved surface with small "teeth" on its sharp edge. The printmaker rocks the tool back and forth on the plate until the whole plate is covered with small marks. This process has to be done over and over on the plate so that the rocker marks overlap and give the plate an even covering. It takes a long time to create the proper surface on a plate for mezzotint. If left alone, these scratches would cause the resulting print to be quite dark because all of the little lines would hold ink. To achieve tones, the plate is worked from dark to light, using a tool known as a burin (see previous page) to burnish areas that are intended to print white. The burin smoothes out and flattens the burrs created by the rocker, causing those areas to not be able to hold ink, and so not print.

Acid-dependent Intaglio Techniques

The above acid-free techniques for intaglio can be used to create beautiful and detailed prints, but are not as useful for creating very soft areas of even tone and deep, clean lines. When acid is used for intaglio, areas of the plate are removed by immersion in an acid solution rather than by using hand tools. The plate is first coated with a greasy or waxy substance, called the **resist** or **ground,** which is usually dried under a lamp to form a coating that resists the corrosive action of the acid, referred to as **bite.** Depending on the technique, the resist is either applied to the whole plate and scratched through, painted on with a brush, or sprayed on. When the plate has been prepared according to technique and placed in acid bath to be corroded, printmakers say that the acid is "biting" into the plate. The term **open bite,** however, is a technique where large areas of the plate are allowed to be eaten away by the acid. When an area of open bite is prepared for printing, only the edges of the area hold the ink, producing an outline of the area made with the technique. Sometimes, open bite is used as an intentional technique, but other times it is the result of leaving the plate in the acid solution too long, or the acid undercutting the resist and causing the resist to come off the plate. This accidental use of open bite is sometimes referred to as **foul bite.**

The acids used for intaglio depend on the type of plate used and the technique. Ferric chloride, a safer acid that does not release toxic fumes, is useful for biting copper plates, while zinc requires dangerous nitric or hydrochloric acid.[2] Acids for printmaking are never used full strength, but are diluted with water. They must, however, be mixed correctly and the studio must also have a proper ventilation system. Just as it is cautioned in a chemistry lab, acid is always added to water, NOT water to acid (which can result in a violent chemical reaction). If used full strength, acid will bite too quickly and ruin the crispness of the lines. For copper plates, nitric acid may be mixed with water in a strong solution (1:1) or in a weaker solution (3:1), and for zinc plates, the solution is much weaker.

Acid is very dangerous to use and can pose a significant health hazard both from short and long term use. The danger of using acid lies with inhalation and skin contact. The acid solutions used in printmaking are diluted with water, and gloves and eye protection are always worn, but carelessness can still cause injury from the unintentional splashing of the solution which can cause acid burns. An acid burn on the skin is not always immediately apparent but may be indicated by the increased sensation of stinging and the development of a rash-like redness in the location of contact. This can be avoided by wearing elbow-length gloves and long sleeve shirts, taking care not to allow the acid solution to run down or into the gloves, and not leaning elbows or placing bare hands on any surface used for holding chemicals. Because of the serious health risks of traditional printmaking with acid, there have been some recent developments in printmaking in the area of acid-free etching solutions. These are not yet widely used; but they are gaining in popularity.

Before a plate is immersed in any acid solution it needs to be free of grease and oil, even oil from the skin. There are a number of materials that can be used to clean plates, but many of them include using some amount of ammonia. One popular, but very unpleasant, technique is to mix whiting (French chalk) with ammonia and water to rub on the surface of the plate. Grease and oil retard the corrosive action of the acid, so fingerprints would appear in the finished work if the plate is not properly cleaned. The following acid-dependent intaglio techniques rely on the

principle that greasy substances resist the bite of acid and so are also dependent on an acid-resist ground to block certain areas of the plate off from the corrosive action of the acid.

Etching

Etching is an intaglio process in which the plate is coated with a resist and the dry resist is scratched through with a stylus to expose the plate for biting. Although similar to drawing in its use of line, etching is unique because the darkness of the line depends on its thickness and the length of time the acid is allowed to bite. The longer the bite, the darker the line because the deeper lines hold more ink. Lighter areas of line can be retained by blocking them out with resist (called "stopping out") so that they are no longer exposed to the acid and cannot become darker. The three most common types of ground for this technique are beeswax, bitumen, and resin[3] and are referred to as hard grounds.

Aquatint

With the exception of mezzotint, the discussion of printmaking to this point has focused on methods for creating line. The technique of **aquatint** is different because it is used to create areas of tone. Traditionally, rosin or bitumen particles were blown onto the surface of the plate to give it an even coating and then the plate was heated to melt these particles to the surface. Another method is to use a wooden box with a movable paddle to achieve more even coverage of the particles on the plate. In this process, the rosin particles are ground up and placed in the box. A crank outside that controls a paddle inside the box is turned to make the particles airborne. Next, the plate is placed in the box for a set amount of time, and then removed. Lastly, the plate is heated from below with a torch to make the particles stick to the metal. An easier method of creating an aquatint is to use a can of spray paint. The spray paint can is used to give an even coating of tiny drops of paint.

With either of these methods, the coated plate is placed in an acid solution and the acid bites the areas around those tiny particles to create a soft texture. When the plate is printed, those areas between the particles are filled with ink and produce a dark tone.

A lighter tone can be created by stopping out certain areas of the aquatint early on in the acid biting process. Since aquatint leaves so many areas to bite, a weaker acid solution is usually used. If the acid is too strong, it will undercut the small particles and create an open bite area.

Lithography: Planographic Printing

Lithography is a **planographic** technique, meaning that the printing surface is flat. This is different from relief printing where the surface is raised, and intaglio printing where the printing surface (the place where the ink is held) is sunken. Lithography is a very direct approach to printmaking because a drawing is applied directly to the plate. Lithography is the printmaking technique that is closest to drawing, but can be a cumbersome printmaking technique involving using a large and heavy stone as the "plate." A less well-known fact is that lithography can also be done with zinc and aluminum plates.[4] Metal plates, however, are too slick and need to be given tooth (rough texture) to hold the lines of the drawing. For stone lithography, traditional lithographers use a special type of limestone from Bavaria, which is useful for lithography because it is very porous. The basic premise of lithographic printing is that water and grease do not mix, and so ink and special crayons are used to draw or paint on the surface of the stone. The lines drawn on the stone are the lines that will print, but in reverse.

An important part of the process of lithography is preparing the stone through cleaning and grinding, because the surface of the stone must be completely flat for the printing process to work correctly. The stone is ground flat with a special tool known as a **levigator,** a thick, disk-shaped tool with a handle that is rotated over a mixture of sand and water to abrade the surface of the litho stone, which is then polished to prepare the surface to receive the image. Next, a drawing is made directly onto the stone with a special lithographic crayon, and areas of tone are created by diluting the lithographic crayon. Fats in grease crayons combine with the stone, and can only be removed by grinding down the stone. Once the drawing is laid down, the stone is covered with gum arabic, preserving the blank areas of the composition from further marking

by preventing the absorption of further grease by the stone. The stone is then cleaned and prepared for printing. To print, ink is rolled evenly over the surface of the stone with a roller, and then the stone is covered with paper and run through a press. Lithography was favored by the nineteenth-century artist Henri de Toulouse-Lautrec (1864–1901), who used lithography to create posters of singers and dancers in the clubs of the Montmartre area of Paris. Lithography has a history of being used for commercial purposes, but Toulouse-Lautrec was able to bridge the gap between commercial printing and art.

Screenprinting/Serigraphy/ Silkscreen

Screenprinting is also known as serigraphy and silkscreening. Screenprinting is different from the other forms of printmaking we have discussed so far because instead of using a plate to print an image, screenprinting uses a screen through which ink is pressed to create an image. Screenprinting is often referred to as silkscreen because silk is a common material used for the screens, although now synthetic materials are often used. To create a screen, fabric is stretched taught in a frame, and the image is either painted directly onto the silk with a brush or transferred from a pre-designed stencil. When printing, the screen acts like a stencil, blocking off certain sections that are not intended to print. Instead of rolling ink onto the printing surface or carding ink into the printing surface and transferring the image to paper, a screen print is made as the ink is pushed across the surface of the screen with a squeegee.

Like relief printing and intaglio, a separate screen is used for each color and the colors are printed over each other, so registration is very important. One of the advantages of silkscreening is the ability to create broad, flat planes of color. In relief printing or intaglio, a broad plane of one color might not print evenly, but with silkscreening this is not an issue since the color will be even and full. Also, like the other printing processes, screenprinting can create multiple images as long as the screen is retained. This technique was favored by the twentieth-century artist Andy Warhol who used it to make multiple images on canvas.

A Printing Technique That Produces Singular Images

Monotype/Monoprint

Monotype is a printing technique that produces a singular unique image. The term mono refers to one, and a **monoprint** is the result of the monotype process. This is one of the few printing techniques in which only a singular image is made. Using any slow-drying medium such as printers' ink or oil paint, an image is drawn on a non-porous surface which is printed directly onto paper. Sometimes, a second fainter image may be produced from the same plate, but its quality will never match that of the first image. The ink or paint used in monotype printing can be applied in a number of different ways; it can be painted on with a brush to form lines, or the plate can be coated with ink and a stylus used to scratch lines in the medium. Sometimes, large areas of color can be placed on the plate to form a non-objective work of art. One of the advantages of monotype is that limitless numbers of colors can be used in a single printing, unlike relief printing and intaglio which require multiple plates for each color, although a monoprint may be run through a press with multiple plates if desired. The possibilities of monotype are limited only by the imagination and skill of the artist.

NOTES

1. Ray Smith. *The Artist's Handbook* (London: DK Publishing, revised edition, 2003), 234.
2, 3. Ibid., 241.
4. Ibid., 249.

ART AND ARTISTS

Woodcut/Woodblock

Albrecht Dürer.
Andō Hiroshige, series *One Hundred Views of Famous Places in Edo,* 1857.

Katsushika Hokusai, *The Great Wave at Kanagawa* (from a *Series of Thirty-Six Views of Mount Fuji*), ca. 1831–33. The Metropolitan Museum of Art, New York.

Etching

Lucian Freud, *Naked Man on a Bed*, 1987. Private collection.
Parmigianino, *Entombment*, ca. 124–1527. British Museum, London.

Aquatint

Francisco de Goya y Lucientes, *Los Caprichos*, Plate 32, from the *Por Que Fue Sensible* series, 1799.

Lithography

Henri de Toulouse-Lautrec, *Moulin Rouge-La Goulue*, 1891. Victoria and Albert Museum, London.
Käthe Kollwitz, *Death Seizing a Woman* (1934) from the series *Death*, 1934–36. The Museum of Modern Art, New York.

Silkscreen

Andy Warhol, *210 Coca-Cola Bottles*, 1962.

CHAPTER 11 Photography, Moving Pictures, and New Media Art

Photography

Photography has an interesting history. A very long time ago people observed that light coming into a dark room through a small opening, or aperture, created an inverted reflected image of the outside world in the interior of the room. This effect was soon replicated by building boxes with apertures and mirrors and these devices are both called a camera obscura, which means "dark room" in Italian. The concept of photography is generally traced back to the camera obscura while the actual invention of photography itself it traced back to the early half of the 1800s in both England and France, and it is believed by a number of art historians that the Dutch artist Jan Vermeer (1632–1675), and other artists of the time, made use of portable camera obscuras contraption to create detailed genre scenes, or scenes of everyday life, with correct perspective.

A common misconception we make when looking at older works of art is that the artists drew the scenes freehand when they actually commonly used mechanical devices for capturing the correct perspective or the correct shapes of objects. Some artists looked through specially constructed grids and transferred the images from each grid to paper, while other artists sat behind plates of glass onto which they traced the shapes of the objects before them. Although the *camera obscura* was originally both entertaining and useful, eventually, people wanted to try and capture the fleeting image of the *camera obscura* in a permanent

method. This became possible through scientific experimentation and advances in the early half of the 1800s.

Early Photography

The move toward photography progressed by scientific experimentation with light-sensitive chemicals in the 1700s. Photography was not invented at this time because the chemicals that were used resulted in images that faded quickly and disappeared. It wasn't until the early 1800s that a number of men working separately in both England and France developed permanent photography. In France, Joseph Nicéphore Niépce (1765–1833) created the world's first permanent photograph in 1826. He then went on to collaborate with Louis Jacques Mandé Daguerre (1789–1851) to develop a successful photographic process, but after Niépce's unexpected death in 1833, Daguerre went on to become famous for the method he and Niépce developed. This process consisted of a piece of metal treated with light-sensitive chemicals which was then exposed to light, fixing the image on a metal plate. The image produced by this technique was called a **daguerreotype,** after Daguerre, and debuted to the world in 1839. The hallmark of the daguerreotype was its irreproducibility and silvery, mirror-like surface, both of which were also its chief drawbacks. Only one daguerreotype could be made from taking a picture, and the shininess of the plate on which the image was fixed often made it difficult to see the image. Usually, you can see your own reflection better in a daguerreotype than the intended photographic image. The worst drawback for makers of daguerreotypes, however, was that it was a process which used toxic mercury fumes to develop images.

Meanwhile, at about the same time in England, William Henry Fox Talbot (1800–1877) developed a method he perfected in 1841, by which a piece of paper was substituted for the metal plate. By creating an image on treated paper, Talbot could then shine light through the paper to produce an image on another piece of paper, the result of which he called a **calotype.** The genius of Talbot's method, which is the forerunner to our modern negative photography, is that with Daguerre's method only one image was created while Talbot could create multiples. Daguerreotypes and other similar photographic methods, however, remained popular with the public until the late 1800s.

The earliest photographic cameras were wooden box-like structures with mirrors and ground glass lenses. As photography became cheaper and more convenient, it became very popular for portraiture. Before photography, if you wanted a likeness of your loved one, you would have to have a portrait painted or a drawing made, which was often beyond the means of most common people. For small-scale personal images, you could have had a portrait miniature of your loved one painted (if you had the money), but these small-scale painted portraits could vary greatly in quality and accurateness of representation of the subject. When photography became popular, the practice of having a portrait miniature made declined greatly until it was not commonly done anymore. Portraits were immediately popular, but because of the long amount of time it took for an exposure, people did not tend to smile, giving modern observers the false impression that everyone in the 1800s was boring and sour-faced in their black-and-white photos. Imagine trying to hold a smile or a pose for five to ten minutes. The desire for color was apparent from the earliest days of photography. Small personal photographs were often hand-tinted to give the appearance of color, but usually limited to gilding wedding rings and applying blush to cheeks.

These early images on metal plates were quite delicate and people kept them in specially made leather or plastic cases that could be closed like a book to keep the image from fading due to exposure to light. There were definite limitations both aesthetically and practically with the daguerreotype, and soon various other approaches to portrait photography were developed. The ambrotype and the tintype were two such developments in the later 1800s [Figure 12] using different plates and chemicals. New advances and techniques made photography even more popular with the masses, especially in the United States where the photographs were appreciated because of their perceived realism,[1] In both Europe and America, photography took on the air of an impartial medium, merely recording life as it appeared.

Meanwhile, while photography was popular among regular people for portraits, photographers and scientists continued with their experimentation to create new photographic forms. One such process resulted in the **cyanotype,** invented in England in 1842, and named for the blue (cyan) color of the finished work. When an object is placed on a sheet coated with a

certain combination of chemicals, and the sheet exposed to sunlight, the paper around the object turns blue while the shadow of the object stays white. Other artists experimented with combining photos, for example, juxtaposing a figure from one photo over the background of another. And still other photographers teamed with artists to conduct experiments in capturing images in motion used to make works of art.

These previous methods still had the limitation of producing only singular images, and so people began experimenting with methods to produce multiple copies of a singular image. One such method was **photogravure,** a complex photographic process invented in 1876 where multiple copies of an image could be produced in a technique combining photography with printmaking. The result was an engraved plate used to make multiple photographic prints. Other artists took a more hands-on approach to combining photographs by using photomontage. **Photomontage** is the process of cutting and pasting photos together to form one larger image. It is much like collage except that it is usually limited to the use of photos. The cut and pasted image could be considered the final work of art, or it could be photographed to form one large photo.

While the chemical nature of photography lends itself more to science than art, artists eventually succeeded in elevating photography from a mere record of reality, to an art form. Photography had many advantages for artists; a photograph could replace hiring a live model and could "freeze" reality for artists to study and use in their art. Most of the early examples of photography were documentary in nature, recording people and scenes of cities, but soon these impartial images started to change, and the public saw reality in a new sense—unvarnished images of death and suffering in their own world. Some very famous examples are images from photographers Mathew B. Brady and Timothy O'Sullivan, whose photographs of dead American soldiers are powerful reminders of the destruction of the Civil War, as well as documents of the aftermath of fighting in places such as Gettysburg. Other later photographers used the camera to document rural poverty, as in Dorothea Lange's *Migrant Mother, Nipomo* [Figure 1].

Modern Photography

As more and more advances occurred in photography, the process started to become standardized in methods as well as

materials. George Eastman developed film to replace cumbersome glass negatives and difficult to use paper negatives. The result was a photographic medium that could fit easily in a small box and take multiple pictures. Eastman called his camera the Kodak and it was put into mass production by the late 1800s.[2] This portable, refillable camera was the prototype for the modern film cameras. In a 35mm film camera (not digital) the camera itself holds a light-sensitive negative. The shutter behind the lens of the camera opens and shuts quickly to admit a small amount of light onto the negative. The image is recorded onto a film negative which is then developed in chemicals, resulting in a reusable and transparent image which can be exposed to light. The negative is then placed in an enlarger to make the image on the small negative big enough for a photograph. Light is shone through the negative onto a piece of paper treated with light-sensitive chemicals, and a photograph is created. Scientists and businessmen labored over making the newest advancements in photography, but the advancement everyone wanted was color. They finally got their wish when color photography was developed in the early twentieth century and became commercially available in the 1930s.

There are two main types of film cameras: SLR and point-and-shoot. **SLR** stands for "single lens reflex" and describes those cameras that rely on interchangeable, detachable lenses. A **point-and-shoot camera** is just a standard camera without a detachable lens. If you look at a regular point-and-shoot, you will notice that the viewfinder is not aligned with the lens, but usually up above it. This means that what you are shooting is not really what you are seeing, and that can interfere with the framing and composition of a shot. An SLR has an advantage over point-and-shoot because what you see in the viewfinder is what the camera sees through the lens, and the image that will be captured on the negative. This is why SLR cameras are used by professional photographers, and point-and-shoot cameras are for everyday use.

Single lens reflex cameras also have the advantage of being able to focus, and to change the length of time the camera shutter stays open. The longer the shutter stays open in the camera, the more light is admitted. In a dark room this can be beneficial because, since there is little light, the film needs a longer amount of time to collect light. In a bright room, having the lens open too long would admit too much light and give the photograph

a washed-out appearance. In terms of focus, a point-and-shoot camera focuses on whatever is the main object in the scene, but with an SLR camera, the photographer chooses the object that will be in view, and that can be something in the foreground or something in the background, leaving some areas in focus and others blurry.

Moving Pictures

Film

It seems only natural that motion photography would come after the invention of still photography. There were a number of people in art that are seen to have paved the way for moving pictures. Eadweard Muybridge is a well-known photographer who conducted experiments with capturing motion on film. Muybridge and his assistants set up a series of cameras that could be tripped by wires as a subject ran in front of the cameras. With the set-up, Muybridge and his assistants were able to photograph subjects leaping and hopping, as well as capture the movement of a running horse. The result was a series of still images recording motion at intervals, the basis of the moving picture. The next step in translating still photography to moving pictures was to move the pictures fast enough to give the impression of continual motion.

The use of photography to capture motion progressed beyond still photographs to moving pictures in the very late 1800s with the use of long strips of film. Film can be thought of as the running together at high speed of many still images that gives the impression of movement and is the next development in art based on photography. Images are captured on the film strip, which is then developed similarly to a still photograph. The film strip is then loaded onto a projector where it moves at twenty-four frames per second and is projected by a light shining through the film onto a screen. Movies primarily became a form of entertainment, and newer and newer advances mark the rest of the twentieth century, from the invention of sound in 1927, to the prominence of the use of color in the 1930s.

Some artists were able to team with filmmakers and created art films, but the high cost of film often meant that this medium

was generally off-limits to the majority of artists. This was soon to change, however, with the invention of the hand-held film cameras. One artist who used film as art was Pop artist Andy Warhol, who is known for the mid-1960s works he developed called *Screen Tests*. These screen tests consisted of inviting a person into his studio in New York, asking them to sit in front of a running camera, and then leaving the room while the film was rolling. The unfortunate sitter was not informed of what was going on, and the point of the works was to capture the expressions of people caught in this awkward situation—to see their true identities. Warhol considered his *Screen Tests* to be portraits.

Video

Although hand-held film cameras were available, they had their limitations. The film lasted only for a short amount of time and still had to be processed and projected on a screen to be viewed. The breakthrough for the incorporation of motion picture technology in fine art came with the invention of the hand-held video camera in the 1960s. The portable hand-held movie camera had an advantage over older hand-held film cameras because the image was recorded directly onto a tape that could be played immediately. Later, the VCR (video cassette recorder) was developed for consumer use in the 1970s and that meant that the video could go straight from recording to viewing. Video had the advantage of being more instant—record, rewind, and play—but it was also lower quality than film, and cheaper. Video cassettes could be used over and over again, but tended to wear out from too many plays and too much recording. The most popular format for video was VHS (video home system).

Digital Technology and New Media Art

The latest development in new technology to affect art is digital technology. Coupled with the popularity of the personal computer in the last couple decades, digital technology has revolutionized the transfer and creation of images. The DVD (Digital Versatile Disk) was developed in the late 1990s, and rendered

VHS obsolete. The most recent camera development is the digital camera which, instead of using film, relies on the visual imagery to be stored as pixels, small pieces of digital information. The digital camera is a product of the early 1990s, but as with any technology, there is a significant lag-time between invention and common use resulting from cost. It wasn't until the early 2000s that digital cameras became affordable for professional use, and then for private use.

Digital camera technology is rapidly changing not only the way we see information, but has contributed to a mindset where instant gratification in image viewing is expected. Even as late as the early 2000s, 35mm film cameras were still the most common consumer camera, but the film had to be taken somewhere to have it developed. With digital, the delay between capturing, viewing, and sharing images has been erased. The Polaroid camera was for a long time the only camera where the image could be developed right after the picture was taken, but digital photography allows for the image to be quickly used in a variety of other applications from web publishing, to video making, to instant sharing via online social media sites.

New Media Art

As computers and digital technology became pervasive in modern life, it only seemed natural that artists would seek to incorporate these new technologies in art. The term New Media Art is a term that has been coined to describe a genre of art where the art is made using new technologies including works of art that use computers or anything made with a computer, art that is internet-based or virtual, and any art using digital technology. One of the hallmarks of our use of modern technology is its social dimension, and so a lot of New Media Art mirrors that social component in the art, with artists creating works of art that require participants to interact in some way with each other or with the work of art. This genre is still in its infancy, and practitioners and art historians are still trying to develop a cohesive definition of what the genre includes and how far back to trace its history.

CASE IN POINT
Preserving Technology in Art

We will see in coming chapters how some newer forms of artistic expression rely on photography to serve as the only evidence a work of art ever existed. Photography is used in art not only to create art, but to document it. But what will happen to videos and films of art when their technology is abandoned or made obsolete by newer methods? What will also happen to video and film artworks themselves when the technologies are no longer available? These questions are some of the main concerns that museums and artists encounter when technology is incorporated into art production. How do museums and artists preserve technology so that works of art can always be appreciated, and what to do when technology becomes obsolete? For some museums, this means taking a movie or video and upgrading it to the newest technology—like recording a VHS tape onto a DVD. For other works of art, this is not practical, such as with the work of Nam June Paik (1932–2006), whose work often incorporates television sets. What happens when the traditional television set becomes obsolete and the parts to repair these works are no longer available? At present, there really is no one definite answer, and unfortunately the solutions will come as the situations arise. It is inevitable, however, that some works of art will be lost. How do you feel about losing works of art because their technology cannot be upgraded?

NOTES

1. Wayne, Craven. *American Art: History and Culture.* (New York: McGraw-Hill, 2nd ed., 2003), 239.
2. Craven 376.

ART AND ARTISTS

Photography

Mathew B. Brady, *On the Antietam Battlefield,* 1862. Library of Congress.

Louis Jacques Mandé Daguerre, *Le Boulevard du Temple*, 1839.
Bayerisches National Museum, Munich.
Eadweard Muybridge, *Annie G, Contering, Saddled, December 1887*.
Collotype print. Philadelphia Museum of Art.
Timothy O'Sullivan, *Harvest of Death, Gettysburg. Pa*, 1863. Collodion
print. Library of Congress.
William Henry Fox Talbot, *The Open Door*, 1843. Fox Talbot Collection,
National Museum of Photography, London.

Photomontage/Photographic Collage

Hannah Höch, *Cut with the Kitchen Knife Dada Through the Last Weimar
Beer Belly Cultural Epoch of Germany*, 1919–20. Staatliche Museen zu
Berlin, Preussischer Kulturbesitz, Nationalgalerie.
David Hockney, *Pearblossom Highway*, 1986.

Video Art

Bill Viola, *Stations*, 1994.

Sculpture

THERE ARE THREE APPROACHES to creating traditional three-dimensional sculpture:

1. the additive process
2. the subtractive process
3. casting

In addition, there are a number of characteristics of sculpture that set it apart from the other types of art based on the fact that sculpture takes a three-dimensional form. When a sculpture is carved on all sides and the viewer is able to walk around it, this is called **sculpture-in-the-round,** or free-standing sculpture. Sculpture-in-the-round is challenging to create because, since it will ultimately be viewed from many angles and perspectives, the sculptor must pay special attention that all sides look correct. Some sculpture, however, is only finished on the front because the back is meant to be placed against a wall or in a wall niche, or is part of a building. When sculpture is part of the façade of a building, it is referred to as architectural ornament, and is sometimes isolated and studied separate from the building itself.

The opposite of sculpture-in-the-round is sculpture that can be seen only from one perspective, and attached to a solid surface. This type of sculpture is known as relief sculpture; a sculptural form where a three-dimensional sculptural form is attached to a flat background and gives the impression of a two-dimensional representation. Relief sculpture can be carved or cast (we will explain this process later in the chapter), so the term refers only to the finished

item and does not refer to the process of creating the three-dimensional work of art. However, relief sculpture *is* described by the degree that its three-dimension elements project from the flat background surface. **High relief,** also known as *haut-relief,* describes relief sculpture where the sculptural elements project out from the flat surface, almost to the point of being sculpture-in-the-round. **Low relief,** also known as *bas relief,* describes relief sculpture where sculptural elements barely project from the flat surface. A simple test for determining whether an element represents high relief or low relief is to imagine you are trying to touch the three-dimensional element with your hand; if you could feel it only by running your hand over it, but not be able to wrap your fingers around it, then that is low relief. If you could grasp it in some manner with your hand, then it is an example of high relief. High relief and low relief are commonly found in the same work of art, and an artist will often use high relief for the foreground and low relief for the background.

Sometimes, the description of a sculpture will include the term "polychrome" in its description. This is a term to denote that the work of art has been painted or colored in some manner; poly means "many," while chrome means "color." Polychrome, then, literally means many colors. In ceramics, polychrome refers to the use of different colored glazes. Many types of sculptures can be polychromed, from wood to plaster and marble. One of the problems with painted sculpture is that the paint can completely come off a work of art due to a number of factors, ranging from exposure to the weather, to intentional removal of the paint during cleaning. For example, when most people think of ancient Greek sculpture, they think of beautiful white marble representations. What most people do not know is that many of these sculptures, and even buildings, were originally painted bright colors that have disappeared over the centuries, or been removed by art dealers eager to sell people the beautiful white sculptures they expect from classical art.

Besides sculpture-in-the-round and relief sculpture, there are two other terms related to sculpture that have to do with the location of a work of art: site-specific sculpture and public art. **Site-specific sculpture** is art that is made for a specific location. If the work is taken and installed in another location the work of art will effectively lose its meaning because it is not sited in its intended location. **Public art** is used to denote artworks created

for public spaces, usually funded by governmental entities. In addition, public art is usually site-specific because a public art project is usually conceived for a specific location.

Public art is not a new phenomenon; there are many examples of ancient civic monuments, but controversy often surrounds modern public art because of funding and perceived impact on the local area. In the United States, public art is often funded by tax monies and, because public art is a public interest, the public is allowed to voice their concerns over proposed art projects. In fact, there have been many cases where negative public response led to the cancellation of a proposed project. The art community never seems to forget (or forgive) when a work of art is blocked by the public; however, in a democratic society the public has a right to act in what it perceives as its own best interest. While a work of art might seem acceptable to an artist or art committee, the general public has every right to voice disapproval.

Subtractive Method of Sculpture

The first of the two methods of creating sculpture, the **subtractive process,** is a sculptural approach where the artist begins with a solid chunk of sculptural material and proceeds to remove, or subtract, material to create the sculpture. For example, a sculptor might take a large piece of marble and chisel away at the block until a sculpture is left. The subtractive method requires a lot of careful planning on the part of the artist to create a good quality work of art. The planning process usually begins with a concept that is sketched out on paper. Next, a small-scale sculpture of the work, a *maquette,* is made to serve as a guide for the sculptor to follow to create the finished work of art. This is the traditional approach to creating a sculpture, but there is now another, more spontaneous approach known as direct carving, which dates back to the early years of the twentieth century.

Direct carving is a more intuitive process in sculpture, the physical equivalent to *alla prima* in painting, where the artist allows the material itself to guide the execution of the work of art. The artist first chooses his or her specific piece of material and begins to carve in a manner that brings out the best qualities of the raw material, such as color or texture. The maquette is not needed for this approach because the sculpture develops as it is carved

or chiseled from the base material. Often, the finished result of direct carving is an abstract or non-objective object. The choice of method will depend on the desired form of the finished work of art and either subtractive method can be used with the most popular materials, wood and stone.

Wood

Wood is usually worked in fine art by carving with sharp metal tools to create form. The artist usually plans out the sculpture and chooses a piece of wood suitable for a finished work of art. Next, the wood block is marked with lines to indicate areas to be removed to reveal the general shapes of the sculpture. Then, using sharp metal tools, flat chisels, and gouge chisels, the wood is roughed out to the desired shape and the surface of the wood is worked with progressively finer hand tools to remove all the former chisel marks of the previous carving stages. The last part of the carving process is finishing the surface of the wood sculpture by scraping and sanding. Centuries ago, sanding wood was done with anything from sharkskin to sand, but today sandpaper is economical and efficient. Sandpaper is chosen based on grit, the roughness or smoothness of the abrasive substance on the surface of the sandpaper. The larger the sandpaper number, the finer the grit. For example, a woodworker usually starts at 60 or 80 grit sandpaper, and works his or her way up using progressively finer grits, often to 220.

One of the limitations of wood sculpture is working with the grain of the wood, which can sometimes make wood carving impossible. Grain is the direction that the wood grows and is often easy to see because it sometimes appears in bands of color. In addition, sometimes a piece of wood will have a grain of a strong, contrasting color that is not apparent until the sculpture is under way, which can mar the look of the work of art. For example, if a sculptor is working on a bust of a woman and discovers a strong, contrasting color grain that exists in the area of the face, the work on the sculpture would most likely be abandoned and another piece of wood chosen for the next attempt.

In addition to grain, hardness or softness of the wood needs to be considered in choosing wood for sculpture. Hard woods are very difficult to work and tend to dull tools quickly, while soft woods are easy to carve but have a tendency to dent. Also, hard and soft woods take finishes differently, so finishes have

to be chosen carefully. Finished wood sculpture can be sealed with a liquid sealant or polished with wax in order to protect the wood. Protection is important because wood is a material that is especially susceptible to the elements, and many wood sculptures have not survived from antiquity, except from arid climates like Egypt. When wood does deteriorate, it has a tendency to either dry and split, or develop rot, and is also susceptible to insect infestation. Termites have been found in wood artifacts, even in sealed tombs in ancient Egypt.

Stone

Another very common, but much more difficult, material used for the subtractive sculptural process is stone. Like wood, stone comes in varying degrees of hardness, from very hard granite, to soft limestone. Other popular types of stone for carving include marble, sandstone, soapstone, and alabaster. In art, stone can have significance for class status such as the Roman use of **porphyry,** a dark reddish-purple stone used exclusively for imperial sculpture during Roman times. Regardless of the stone type, however, certain precautions must be taken when engaging in stone sculpture, including wearing a respirator for certain kinds of stone (especially granite), wearing eye protection to keep eyes safe from flying stone chips, earplugs to protect from the constant bang of the hammer on chisel, and special padded safety gloves to cushion the hand against the constant shock of the hammer striking metal to stone.

Stone is worked in much the same way as wood, where metal tools are used to remove material from a large block of stone. The difference between wood and stone, however, involves the logistics of dealing with such a heavy material. The stone must be worked on a table or stand strong enough to support the piece, and supported by sandbags both to prop the work up, and prevent it from falling off and causing severe bodily injury. To begin, the artist first draws the composition on the stone and then uses chisels to remove large areas of stone. There are three main types of chisels for carving stone: point, tooth, and flat. The **point chisel** is used initially in the carving process to remove large areas of stone and rough out the major forms of the sculpture. The **tooth chisel,** also known as a claw, has teeth to shape the sculptural forms, but leaves parallel gouges on the surface of the stone. Lastly, the **flat chisel** is used to remove the

marks left by the tooth chisel and is the final tool used before finishing is begun. Since just over the last one hundred years, several advances in tool technology have changed the practice of stone carving. The introduction of pneumatic, or air-driven, hammers has allowed for artists to work quicker and not have to use quite so much arm muscle to remove stone material. The same types of hand chisels are used with pneumatic hammers, but have special ends meant to be fit into the hammer.

The finishing process for stone sculpture involves scraping the surface of the stone with a **rasp,** a metal hand tool with a rough side, to remove all the marks left by the flat chisel. The final step in finishing a stone sculpture is to sand the surface of the stone with wet/dry sandpaper because wet sanding ensures that the stone surface is polished while it is sanded. Like wood finishing, the artist works his or her way up from larger grit sandpaper (such as 60 or 80 grit), using progressively finer grits until the stone is polished (from between 600 to 3000 grit). The final grit of the sandpaper depends on the hardness of the stone and can vary widely depending on the stone. For example, granite needs a much higher grit to achieve a polish than marble. Finally, the stone sculpture can be waxed to a fine shine or left untreated.

Additive Method of Sculpture

The second approach to creating sculpture is to use the **additive process,** a working method where the artist builds up the form of the sculpture with material to create a final work of art. The most common material for the additive process is clay, although newer movements in art have resulted in a technique known as assemblage, which often uses found objects.

Clay

Clay is a material that is dug out of the ground and refined in order to create sculpture. The term for the manipulation and forming of sculptural materials such as clay is **modeling.** The clay techniques used in sculpture differ from those used in creating craft objects such as pottery, so this section will only describe modeling used for sculpture. This section will, however, cover firing and finishing methods since these are similar for both clay sculpture and pottery. Since clay is not a strong material, artists

use an **armature,** a wire skeleton, to support the clay. An armature is usually made out of twisted wire and the clay added onto it to build up a form that can be refined by alternately modeling and carving. Sometimes in clay sculpture, the armature is packed with perishable materials such as newsprint and covered with clay so that less of the material has to be used in the final sculpture. In this approach, the sculpture must be cast since these materials cause problems for firing clay, and because since clay shrinks as it dries, it tends to crack and fall off metal and other non-shrinking materials.

There are several different types of clay that can be used for sculpture, but one of the more specific types of clay is *terracotta*. In Latin, *terra* means "earth," and *cotta* means "baked" or "cooked." *Terracotta* is distinct in art because of its reddish-brown appearance and, although in this context it is considered an art material, *terracotta* is common in many cultures as a utilitarian construction material used for roofing tiles, planters, and water pipes. *Terracotta* is widespread and has a long history, used in ancient China as well as in ancient Italy by the Etruscans. One of the best known works of art are the thousands of *terracotta* sculptures discovered in 1974 in the tomb of Emperor Shi Huangdi in China. These sculptures are lifelike, full-scale soldiers and horses.

Another important use for *terracotta* was in the Baroque period in Europe when the material was used by artists, such as Gianlorenzo Bernini, to create small-scale sculptural models, known as *bozetti*. Since clay is cheaper and easier to model than marble is to carve, detailed miniatures of the planned marble sculpture were made of clay and served as a model for final sculptures. *Bozetti,* then, can be thought of as the sculptural equivalent of a sketch, but because they were not finished works of art, many were not preserved. The few that have survived are now displayed in museums and are invaluable for art historians who want to learn about the artist's working methods. Some *bozetti* even bear the actual fingerprints of the artists who made them, and when you see those fingerprints caught in clay, you can imagine the artist carefully sculpting the tiny model plan of their work of art.

All forms of clay need to be treated before they can be used for sculpture. This treatment is very important and involves beating and folding the clay to rid it of air bubbles. If these air bubbles are not removed, the piece can deform when it is fired. Besides using their hands, artists use a variety of hand tools

made of wood, metal, or plastic to manipulate clay. These hand tools range from scraping tools, flat sheets of metal, to tools with a sharp edges and points for gouging and removing sculptural material. One of the peculiarities of using clay as a sculpting material is that it must always be kept moist, and this can become a challenge, especially if the sculptor needs to work over a period of days, or weeks. These days, the clay is kept moist and workable by covering it with a plastic sheet to keep it in a wet environment. While the sculptor works, he or she must keep wetting the clay, but too much water can ruin the surface of the sculpture and turn the clay back into a slippery paste. If too much water is accidentally added, the sculptor has to wait for some of it to evaporate before he or she can resume work. In addition, a slurry of water and clay, known as **slip,** is used to add pieces of clay onto the form. Both the surface of the sculpture where the addition is planned, as well as the addition, need to be scraped and coated with slip in order for them to adhere to one another. If this is not done correctly, these pieces can later fall off.

The final step that turns soft, malleable clay into hard sculpture is the firing process. After the sculpture is completely finished, it is allowed to dry thoroughly. This is important because if the clay does not dry thoroughly, it can explode in the kiln. The pieces are placed in a large **kiln,** a special type of oven that can withstand very high temperatures, and baked at high temperatures, and the desired baking temperature depends on the type of clay. Sometimes, clay is coated with **glaze,** a colored finish, and this is applied either when the clay is dry, or in between firings. Glazing ceramics is tricky because the firing temperature and environment can affect the resulting glaze color, and the color that is painted on the ceramic piece is not always the finished color. Using glazes requires a lot of faith and imagination to achieve the artist's desired effect. Once all of the possible glazing and firing has been completed, the result is a durable and attractive sculptural form.

Assemblage and Found Objects

Assemblage can be seen as the parallel development to collage in sculpture that resulted from explorations in art in the twentieth century. An **assemblage** is a sculptural technique where the sculpture is composed of the arrangement of three-dimensional objects, which may also include found objects. **Found objects** are objects that were not intended to be used as art, but that the artist

has appropriated for art-making purposes. Assemblage both refers to the process of assembling these objects and to the finished object itself, and can incorporate a variety of materials and approaches; the range of possibilities for this type of sculpture is boundless. In addition, welded metal sculpture is often considered assemblage because it involves joining a variety of three-dimensional forms.

Casting Materials and Methods

Casting is a sculptural process relying on the use of positive and negative space. Generally, the process involves using a three-dimensional object, often a sculpture, as the initial positive and copying it by covering it in another material. The original three-dimensional object is then removed, leaving behind a negative space, the mold, that is next filled with a liquid material that sets up to form an identical solid copy of the original object. This results in the creation of a second positive, identical to the first. Often, the additive process is used to create the initial positive and, although clay may be a final material in itself, it is often used in casting as the original positive, especially in the lost-wax casting process for bronze sculpture.

Bronze Sculpture and Lost-wax Casting

One of the oldest and most respected sculptural casting materials is bronze, an alloy of copper and tin. The base of most traditional bronze sculpture is the additive sculpture process using clay and wax, even though the sculpture must be cast to achieve its final form. Bronze is a very sophisticated sculptural process because of the number of steps and the complexity of achieving a finished sculpture. The following list outlines the steps involved in **lost-wax casting.**

The lost-wax *(cire perdue)* **casting process:**
1. A positive is made with a base of clay covered with wax, and the details of the sculpture are modeled by adding and carving away wax.
2. The surface of the work is finished, and wax rods (called sprues) are added that stick out from the surface of the sculpture.

3. The entire structure is covered in clay and allowed to dry. This completes the mold-making process.

4. The entire mold with the encapsulated positive is heated until the interior wax becomes liquid and is poured out. When the wax is gone (lost), a negative space is formed that can be filled with liquid metal.

5. Next, liquid metal is poured into the cavity and allowed to cool, forming another positive the same as the original.

6. The mold is broken away, sprues cut off, and the surface finished.

Using this casting method results in the creation of a single original work of art, but recent developments in casting now allow for multiple copies of the original to be made. This can allow for an artist to create a limited series of a work.

Plaster Sculpture and Plaster Casting

Plaster is a substance made by combining water and a special type of powdered gypsum. The initial result of mixing these materials is a thick liquid (the consistency of cake batter) that can be poured into a mold to make a sculpture, used as a sculptural mold, or (less commonly) carved in the subtractive method. In a short amount of time, the liquid begins to set and changes to a solid that will dry out over time. Plaster has been used for quite a long time to create sculpture, but is much more delicate than wood or stone, and highly susceptible to breakage and gouging. Plaster casting, however, is an inexpensive method for casting sculpture that is commonly used in schools to teach about mold making and casting, and is also quite versatile because a variety of materials can be cast in plaster molds that are sometimes reusable. Plaster is so versatile that it can even be used to cast parts of the human body as well as inanimate objects. Care must be taken, however, when casting the human body in plaster to cover all body hair in Vaseline, because the plaster will bond to the hair and remove it when the plaster cast is removed. Every art student has heard painful, yet entertaining, stories about casting incidents and unintentional hair loss.[1] In addition, artists need to take care to insert something into the nostrils when casting faces so that the model can breathe while the plaster sets.

There are a number of approaches to plaster casting, but one method is to create a positive in clay and to insert metal flanges (squares of thin metal) while the clay is still wet. These flanges are placed in such a way that the sculpture is divided into at least two quadrants, but more complex sculptures may be divided into many more areas. The mold and flanges are both covered in plaster, which is allowed to cure. One of the most entertaining ways to cover the positive in plaster is to literally throw it at the clay sculpture, so that it covers it completely. One of the negative side effects of this method is that the artist invariably becomes covered in plaster, but throwing the plaster ensures that no air bubbles become trapped between the positive and the plaster. Similarly, care must be taken when casting with plaster to rid the plaster of trapped air bubbles, and this is often done by lightly striking the side of the container or mold so that the air bubbles rise to the surface.

When the plaster mold has set, it is removed by separating it along the flanges, creating a two-part (or more) mold that can be fit back together. The mold is cleaned out of any residual clay and strapped back together to form a negative space to accept the chosen casting material. If plaster is used as the casting material in a plaster mold, the mold must be treated with a separator, such as oil soap, and tinted to make it easier to distinguish between mold and sculpture. When plaster is used as both mold and casting material, a chisel is usually used to remove the mold, destroying the mold in the process. If the release agent is used correctly, one hit of the chisel will cause large areas of plaster to easily fall away. Once the mold is removed, the plaster positive can be finished with an application of paste wax, similar to the kind used on hardwood floors, and buffed to a high gloss with a soft rag.

Newer Mold-making Materials

One of the better innovations in recent years is the use of latex and other synthetic casting materials. Some of these are non-toxic and can be used to cast directly from the human body easier than using plaster. Plaster is not very comfortable for casting body parts because the curing process is a chemical reaction and one of the byproducts of hardening plaster is heat. The other limitation of a plaster mold is that it is inflexible and care has to be taken with delicate surface projections, and so flexible synthetic

molds allow for great detail and easier removal. These molds can usually be used repeatedly until the model degrades, with the first casting of a new mold always producing the crispest details. Many types of synthetic molds have to be treated with a mold release so that positive and mold do not stick together permanently, but others do not require any treatment. These casting methods allow contemporary sculptors to easily model directly from the human body and mass manufactured objects, and incorporate them into sculptures.

NOTES

1. When I was learning plaster casting in school, a student in my class was casting his own face and got the plaster stuck in his hair. When the cast set, it stuck to his head and he had to use a razor blade to remove his hair in order to free the cast. Needless to say, he slipped and cut himself. Another such story involved an artist who was making a full-body cast of a woman and forgot to have her shave or Vaseline all of her body hair. This resulted in an extremely painful hair loss as the cast pulled out all her arm hair as well as leg hair, etc. A painful lesson was learned in both cases; always treat body hair before casting from the human body.

ART AND ARTISTS

Stone

Menkaure and His Queen, ca. 2490–2472 BC.
Nike of Samothrace, ca. 190 BC.
Praxiteles, *Hermes and Dionysos,* ca. 340 BC.
Venus of Willendorf, ca. 25,000–20,000 BC, Naturhistorisches Museum, Vienna.

Bronze

Jean Arp, *Head with Three Annoying Objects,* 1930 (cast 1950).
Alberto Giacometti, *Man Pointing,* 1947. The Museum of Modern Art, New York.
August Rodin, *The Burghers of Calais,* 1886 (cast later). Hirshhorn Museum and Sculpture Garden, Smithsonian Institution, Washington, D.C.
Riace Warrior, ca. 460–450 BC, Archeological Museum, Reggio Calabria.

Mixed-Media

Joseph Cornell, *Untitled (The Hotel Eden)*, c. 1945. National Gallery of Canada, Ottawa.

Assemblage

Deborah Butterfield, *Vermillion*, 1989. The Metropolitan Museum of Art.

Marcel Duchamp, *Bicycle Wheel*, New York, 1951 (third version after lost original of 1913). The Museum of Modern Art, New York.

Joan Miró, *Object*, 1936. Assemblage: stuffed parrot on wood perch, stuffed silk stocking with velvet garter and doll's paper shoe suspended in hollow wood frame, derby hat, hanging cork ball, celluloid fish, and engraved map. The Museum of Modern Art, New York.

Louise Nevelson, *Mrs. N's Palace*, 1964–77. The Metropolitan Museum of Art.

David Smith, *Becca*, 1965. The Metropolitan Museum of Art.

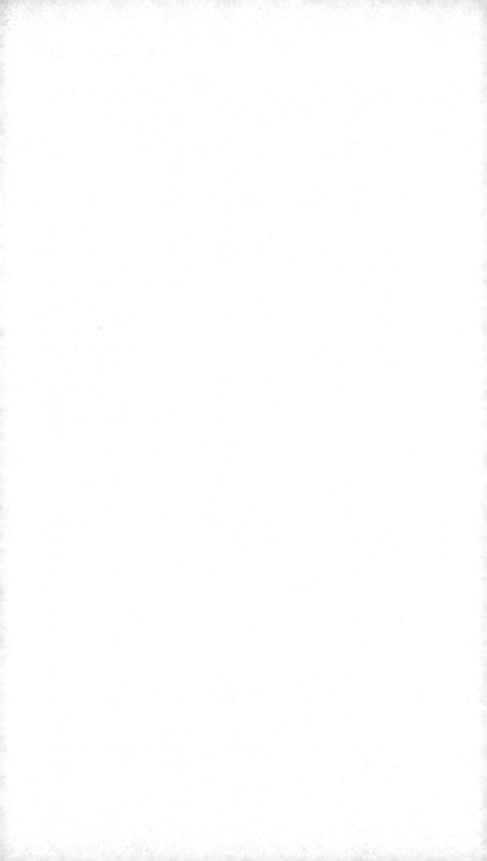

CHAPTER 13 Craft as Fine Art

IN CHAPTER ONE, craft was previously discussed as a category of artistic production. In this section, craft methods will be looked at in more depth, and we will also see how craft can be incorporated into fine art, and as fine art. The previous discussion of craft as a category of art stated that craft objects tend to have three things in common: process, material, and utility. Not only will we look at these three categories in this section, but how craftworks additionally have to negotiate intention, context, and quantity when they are made and shown as fine art objects.

Process

Process refers to the working methods of the artist used to bring the piece from conception to fruition. Craft production is a skills-centered process that relies on the knowledge of a specific skill set to create an object, and each craft type requires a different set of skills. For example, if a person wants to learn how to use a lathe to turn wood, she or he would have to learn about woodworking, how to use chisels, how to sharpen chisels, and how to finish wood. Because of the focus on process, objects in the category of craft tend to be evaluated on the artist's techniques and skills as a craftsman, and better skills often produce better craft objects. In craft as fine art, these skills are still very important to the completion of an object, but they are not of supreme importance and the work of art should not rely solely on technique or skill to the detriment of artistic conception. If the work, however, is about process, then

process is of supreme importance. If the work is not about process, but instead is about some other underlying theme or idea, then the finished work and the ideas behind it are as important, or even more important, than the skills of the craftsman.

We previously looked at the work of Native American Indian potter Maria Martinez, and her work is again a good example of an artist who has transitioned from craftsperson to fine artist, although she never considered herself a fine artist. One of the issues that clouds Maria Martinez's reception in the fine art community is the collaborative nature of her work which, although it is a reflection of her culture, does not fit with modern artistic emphasis on the individuality of the artist. Maria did not make all of her pottery by herself (although there was a short period when she did); she had many helpers from her family such as her husband Julian, her daughter-in-law Santana, and her son Popovi Da. Maria usually formed and polished the vessels while another person executed the painted designs. Maria Martinez also taught her pottery skills to other women in her culture, and they and other members of her family went on to create pottery in their own styles. Some of Maria's well-known potter kin include Maria's grandson, Tony Da, and the collaboration of Santana and Adam (Maria's son).[1] Process, then, and the number of people who participate in process, are important when craft is considered fine art.

Three conditions tend to exist for the importance of process in craft elevated to fine art, process as performance, process subordinate to the finished product, and technical skill as evidence of beauty. For example, if an artist sits in a gallery and knits as performance art, then process takes precedence over the final form of the object because the artwork itself is the process of knitting. However, if another artwork is a knitted object hanging in a gallery, then the skills needed to make the piece may be irrelevant so long as they are good enough to complete the work; process is subordinate to form. However, a third situation may exist if a craft object is of supreme technical skill, then the work may be exhibited as art because of the skill of the process, regardless if the object was intentionally created as art. Process, then, can determine the artistic value of the object. This is the case with many works of ancient art shown in museums as fine art; these objects were probably considered attractive by the people who used them, but not considered art objects in our contemporary sense by the people who made them.

Material

Material is a defining parameter of craft because craft objects tend not be paintings and sculptures, but objects made out of materials such as clay, glass, fiber, or wood, to name a few. Material is important for a discussion of craft because craft production centers on the creation of material objects to be visually appreciated, and the material of the craft object is usually readily apparent. For example, a vessel made of wood will look like wood, and be appreciated for the ability of the crafter to work the wood. Craftworks have their own styles based on the history and working methods of the material, and each material has its limitations and proper working methods. These material limitations mean that not everything imaginable is possible to create. For example, thin pieces of wood are easily broken, so creating a functional chair out of thin strips of wood would not constitute sound chair design. The thin wood chair could theoretically be built, but it would probably be broken by the first person to sit in it.

When craft enters the realm of fine art, all rules about material become irrelevant because the object no longer has to be functional. If function is no longer a constraint, then more chances can be taken with the materials, and the quality of the materials can vary depending on the work of art. For example, a craftsperson might make a blanket using crochet and a high-quality yarn such as angora or alpaca, while an artist might want to make a comment on commercialism and mass-production by crocheting a blanket out of strips of plastic grocery bags. The basic process of crocheting is the same for both objects, but the materials differ greatly depending on the purpose of the item and whether or not it is made as craft or fine art. This ability to experiment in new materials is a hallmark of newer forms of art expression and is indebted to the artists who began working in non-traditional materials in the beginning of the twentieth century.

Utility

Another distinguishing characteristic of craft is its utilitarian, or functional nature. Craftworks are often made to be functional, even if they are placed on display like a work of fine art. A master woodworker, to revisit this example, can produce a beautifully crafted chair or cabinet and collectors may even

prize the works, collecting examples and displaying them without ever using them, but integral to the object is its usability. In fact, some craft practitioners may not even think of their work in anything but utilitarian terms, and may not be aware of the artistic beauty of their functional items until someone else sees them as such.

Setting is very important in terms of the utility. When craft is displayed in a museum, it loses all ability to be utilitarian in the conventional sense because the craft object is set apart from the viewer and the focus is on its uniqueness as an art object. In addition, craft as art is often produced to imitate the forms of functional craft, but not intended to be used in the same manner. For example, a work of art may be created in the form of a chair using all the same building methods and materials a master woodcarver would use for a craftwork, but the chair may never be intended to be used because the artist considers his or her creation to be a fine art object. In these cases, the object is usually altered in such a way as to make it distinguishable from an ordinary craft object, such as reducing the scale of the art object. In this way, utility might be negated as part of its artistic design.

Craft as Fine Art

The distinction between craft and craft as fine art is reflected by the following statement, which was actually made in reference to fiber arts, yet expresses the basic attempt to distinguish mere craft from fine art craft by the practitioners themselves:

> Within the range of aesthetic creations falls everything in this world that isn't purely functional, as a machine. Aesthetic creations range from potholders and doilies to liturgical hangings to the abstract and sculptural art of contemporary fiber artists. How do we encompass such varied things? We don't. Instead, we narrow the field and don't include potholders or works that merely follow patterns without doing anything more. Such works may be "good" for their class, but we judge them not appropriate for serious consideration as art.[2]

Some people might ask why artists who work with craft need, or want, to distinguish themselves from regular craftworks. The answer is bound up in the history of the public's reception

of craftwork, and the even the reception of craftwork today. Historically, the production of craft articles was practiced by all segments of society, from upper to lower classes. The upper classes, however, could afford to engage in craft as a leisurely pastime, while the lower classes usually engaged in craft production as a means of supporting themselves and their families. After the hand production of many craft objects was replaced by mechanized industrialization, craft production became more of a pastime and was thereafter considered to be a hobby. In fact, in old art history texts, craft production was categorized as a "minor art."[3]

It is essential to understand that our modern access to mass-produced commercial objects has distorted our perception of the importance of craftwork. For example, items such as undergarments, bed linens, and doilies used to be made by hand and would be preserved and repurposed until the materials literally fell apart. Imagine taking an old T-shirt today and making a pair of underwear out of it to recycle the T-shirt! People today would laugh at the very notion, but not those who did just that over one hundred years ago when it was common to repurpose old fabric. For example, in the late 1800s, a handmade sheet set with a crocheted edging might wear out and be taken apart and sewn to make a woman's camisole, using the better part of the sheet fabric and parts of the crochet edging. When the camisole wore out, the edging might be removed and incorporated into another article of clothing, and so on until the edging was no longer usable. People were very thrifty because, at that time, not everyone had the luxury of being able to go to a local store and pay for new items when the old ones wore out.

Later, as household and personal objects became readily available and cost-efficient, the time and care involved in making these items by hand became regarded as a frivolity. So now, in a time when handmade items do not seem to be prized over mass-produced items, our attitudes towards craft and craft production are different. This is why artists are concerned about setting a standard of quality for craft as fine art—to distinguish it from hobby craft and to ensure that it has meaning and is not entirely decorative.

In addition to process, material, and utility, craft as fine art bears more of burden than regular craft objects because craft as fine art must also deal with intention, context, and quantity.

Intention refers to any intentions associated with the work of art or artist in regards to the work of art. What this means is that craft made to be evaluated as fine art is created with that intention in mind, while craftworks are usually intended to be craftworks. The intention to make craft as art carries the burden of the necessary incorporation of content, so that the work is not merely decorative.

Context for craft as art is similar to the idea of context for fine art, except that context also has to take into account craft as a component of the artwork and how that reception can be clouded by craft's history. Secondarily, the craft as art object will be viewed in the context of the fine art museum or fine art gallery space, which is not always a space receptive to craft as art. This also relates to the muted utility of the object, because placing the art craft object in a museum implies that the object will not fulfill a utilitarian purpose; the utility of the object is negated. For example, if an artist creates a chair as an artistic expression, the chair will not be used when it is shown as fine art in a museum.

Lastly, craft as fine art objects are also usually different from regular craft objects because of quantity. Even though much earlier in this text we learned that many of the great Renaissance works of art we know were produced by artists running art studios who trained apprentices in their own signature style, contemporary fine art appreciation places great emphasis on the uniqueness of material objects or the irreproducibility of an individual object. Craftworks are often made from mass-produced patterns, so reproducibility is limitless. Fine art objects are usually made in singles or in limited quantities, called editions, and even if the artist developed a pattern for the project, that pattern would not be made available to the public. The following are a sampling of the different categories into which craft as fine art may be divided. The methods for these categories are so diverse that only the most common have been described, in no particular order. The techniques used to create craft as fine art overlap those for regular craft production, and even the different craft areas often overlap when artists create fine art. In some ways, craft as fine art has something in common with conceptual art in that material may be secondary to idea, but sometimes ideas guide the choice of materials, while other times the limitations of the material guide the production of the object.

Categories of Craft as Fine Art

Ceramics

Craft ceramics are made in much the same way as clay sculpture involving forming, finishing, and firing processes. In this section, however, we will discuss pottery because it is a very common form of craft, and because it is not sculptural in the traditional sense as we previously discussed. One of the main differences we will encounter later in this section, however, that signifies a marked difference between sculpture and pottery is the firing process. There are four main approaches for hand-building ceramic vessels: slab-built, coil method, pinch-pot, and wheel-thrown. **Slab-built** vessels are made by rolling out a slab of clay to uniform thickness, cutting out clay shapes, and joining them together to form a vessel. This would be an approach that would be used for making a box-like structure, or any structure with angles.

The other three techniques are used to make rounded, hollow vessels such as pots. **Coil method** pots are formed by rolling out long, snakelike pieces of coil between the hands and wrapping the coils around on themselves until a form is achieved. **Pinch-pots** are made by balling up a large piece of clay between the hands, making a depression in the center of the ball, and pinching the sides until they form walls of uniform thickness in the shape of a vessel. The last technique, **throwing clay on a wheel,** is a method where the clay is spun on a pottery wheel and the clay is formed by the artist's hands into a vessel as it spins.

There are a few stages the clay goes through on its journey to finished pottery. The clay starts out as plastic and malleable, able to be formed by hand with the addition of water. When the form is finished, the clay is allowed to dry and prepared for the next stage, firing. The first kiln firing is known as the bisque firing, and this is done before the pottery is glazed so that the vessel is hard enough to decorate, yet porous enough to hold the glaze. After the bisque firing, the pottery is decorated with glaze and allowed to dry. The second firing is known as the glaze firing because it is the higher temperature firing that that fuses the glaze to the vessel. Pottery made through any of the aforementioned methods can be fired in a kiln, like the kind used for clay sculpture, or they can be fired through a traditional ancient method known as pit firing.

Pit firing does not use a kiln, but is where a pit is dug into the ground and filled with combustible material, such as wood or animal dung. The pottery is set on the material, covered in pieces of broken pottery and more of the combustible material, and then the whole thing is set on fire. The fire burns a long time and the pit must be tended throughout the process. When the fire dies down and the pile cools enough, the pottery is removed by sifting around in the pit for the individual ceramic pieces. This is the same method used by Maria Martinez and her family to fire their pottery.

There are two main approaches to firing ceramics during the glaze firing; oxidation and reduction. An oxidation firing is best done in an electric kiln, where no substance is burned, and is the firing typical of most ceramics. This type of firing produces colors that would commonly be expected from ceramic glazes. A reduction firing is usually done in a kiln that burns a combustible substance to achieve the correct temperature, or through pit firing, and refers to a firing where the amount of oxygen is limited during the firing process. This is the technique used by Maria Martinez achieve her characteristic black-on-black ware [Figure 7], and the colors of the original glaze are entirely different from the final result, "the process for black-on-black ware was actually a simple one. The design was painted with red clay slip on a polished vessel before firing."[4] The original red glaze was turned black in the reduction firing. Another method that is related to reduction firing is *raku*, where the pottery is fired and brought out of the kiln while it is still hot, and then covered with ash or wood to create a colorful, metallic surface.

Some ceramic artists have easily spanned the gap between craft and fine art, while others have not been as successful. One such artist who has been successful at negotiating both the art and craft worlds is Kenneth Price, whose sculptural ceramic works are collected and shown in museums of fine art, as a well as craft museums. Price's works involve process-oriented surface decoration that is applied and sanded to create colorful, textural surfaces. In his 2000 work, *Yang* [Figure 10], Price creates a form that is not only beautiful but also symbolic of the male component of yin and yang in a graceful, curving form.

Jewelry and Metalsmithing

Fine art jewelry is very different from production jewelry, the kind for sale in retail stores. Fine art jewelry may be made out of the same materials as regular jewelry, such as silver and gold, or it may incorporate unique items such as found objects or even fibers. Sometimes, fine art jewelry seems impossible to wear, e.g., rings that are ten inches long or necklaces that stick out like Elizabethan collars. Fine art jewelry, however, is usually designed to be able to be worn, but not actually worn on a regular basis. In many ways, fine art jewelry is like small-scale precious sculpture, and the possibilities of fine art jewelry forms are limitless.

There are many methods used to work with metal and are broken down into whether or not the metal must be heated. These two approaches are cold construction/connection and soldering and heat forming. In **cold construction,** or cold connection, metal is attached to metal using rivets, or even by employing textile techniques such as weaving and knitting to create a form out of metal. **Soldering** and heat forming work off of the principle that metal changes on a molecular level with the addition of heat. The process through which metal is heated is known as **annealing,** and is done with a torch running an ignited mixture of gas and air, such as acetylene and oxygen. The flame of the torch is used to bring the metal up to a specific temperature based on the type of metal used, and often the correct temperature can be judged based on the color the metal turns when the flame is applied. Heating metal softens it so that it can be formed with steel tools, which cause the metal to again harden.

Soldering is a process whereby metal is permanently adhered to other metal through the use of heat. Unfortunately, metal that has been heated under a flame gets a coating that must be removed by submersion in a weak acid solution, known as **pickle,** which can be heated up to hasten the process. Casting can also be used in making jewelry in a process similar to the bronze lost-wax casting, but on a much smaller scale, and the original is made entirely out of carved or molded wax that comes in varying degrees of hardness. The wax is carved with small metal tools similar to the ones used by dentists for cleaning teeth.

Fiber Arts

Fiber art is a category that includes any artwork made with fabric or fiber, including weaving, embroidery, felting, knitting, crocheting, basketry, lacemaking, sewing, quilting, and spinning. There are far too many different techniques and possibilities to mention them in this short space, and the list is growing seemingly every day. The fiber arts community is well-organized; each area usually has a guild dedicated to education and instruction in their own field. Membership in the guild is not a requirement of practicing or showing fiber art, but many people join the guilds in order to advance their knowledge of their area through contact with others in the field. For example, there are many regional weaving groups that offer members access to pattern libraries, rent looms, and hold workshops. Through membership, members advance their knowledge of their craft and pass it on to others. Fiber arts is one of the most diverse groupings in craft as art, but it is still cohesive enough to have a strong web presence, magazines, and galleries devoted solely to fiber arts. The range of fiber art forms is varied, ranging from wearable, one-of-a-kind garments to abstract, three-dimensional sculptural forms and large gallery installations.

Book Art/Artists' Books/Bookworks

Artists' books are as hard to define as they are to describe, but book art is not for the bookshelf, but for display and appreciation. There is even an argument against their inclusion in a text on art, because they can also be associated with writing and literature and are often collected and displayed by libraries. What book art practitioners have in common is that they are exploring the medium of book-making as a way to create works of art and to express something meaningful. Many of these artists make their own paper and so are also incorporating traditional craft methods and materials to create a work of art. The books can be produced in limited editions, can include original works of art made in the form of a bound text, or can be in the form of altered books—mixed-media works that take an already-published book and turn it into a work of art.

Glass

Glass has been used for a long time in architecture, especially stained glass, but oven-formed (slumping) and blown glass have become useful for making fine art, especially glass blowing. Glass blowing has been elevated to an art form in part by the sculptural installations of Dale Chihuly, who also produces functional objects like bowls and glass chandeliers similar to the ceiling he designed and constructed for the Bellagio Casino in Las Vegas. In the foyer of the Bellagio, Chihuly covered the entire ceiling in circular, fan-shaped swirls of glass. Unfortunately, glass can only be worked when it is in a molten form, making the material both dangerous and malleable, able to be manipulated. For kiln forming, a glass sheet or rod is placed over a ceramic form and the kiln is run through a series of heating cycles until the glass melts to the shape of the form. If the glass is not heated and cooled correctly, it tends to shatter easily. **Glass blowing** involves heating a lump of glass in an open kiln on a long, hollow tube. The artist blows through the tube to form the glass and uses metal tools to pinch and push the glass into the desired shape. **Studio glass** is the term for artistic glass produced by hand.

NOTES

1. Richard Spivey. *María* (Flagstaff, AZ: Northland Press, 1979).
2. Janet Koplos, "When is Fiber Art 'Art'?" *Fiberarts Magazine,* March/April (1986), http://fiberarts.com/article_archive/critiquefiberart_art.asp (accessed June 24, 2007).
3. This is the case in the first few editions of the very well-known art history survey text, *Art Through the Ages* by Helen Gardner that date from the 1920s and 1930s.
4. Richard Spivey. *María* (Flagstaff, AZ: Northland Press, 1979), 48.

ART AND ARTISTS

Ceramics

Maria Martinez and Popovi Da, *Black-on-Black Ware Plate, Feather and Kiva-Step Design,* Signed Maria/Popovi 670. Undated (late 1960s to early 1970s). Collection of Charles and Georgie Blalock.

Kenneth Price, *Yang,* 2000. Museum of Contemporary Art, San Diego.

Jewelry and Metalsmithing

Arlene M. Fisch, *Copper Cascade.*

Helen Shirk.

Fiber Arts

Joan Austin, *Untitled,* from *Skin Series.*

Yinka Shonibare, *Mr. and Mrs. Andrew Without Their Heads,* 1998 (National Gallery of Canada, Ottawa, Canada).

Gunta Stölzl, *Gobelin Tapestry,* 1926–1927.

Book Arts/Artists' Books/Bookworks

Ed Ruscha, *Every Building on the Sunset Strip,* 1966.

Glass

Dale Chihuly.

CHAPTER 14 Architecture

WHILE ART AND ARCHITECTURE are often discussed in tandem, they do have some fundamental differences related to their form. The main differences between architecture and art are that:

1. Architecture is usually functional, serving a definable purpose, such as to shelter a home or business.
2. Architecture can be judged by how well it serves its intended purpose; some architecture looks good from the outside, but is difficult to live or work in, or the layout may be confusing.
3. Architecture must be able to withstand the elements and natural disasters. Architectural mistakes can cost lives.
4. Architecture is not usually under the sole creative control of one person, but rather of a team of people both in the design phase and the construction phase. Often, architectural plans have to be altered during construction.
5. Architectural creativity must conform to limitations such as building codes, availability of materials, etc. Anything can be designed, but not everything can be built.
6. Architecture tends to be more visually prominent than art; buildings are large structures and can enhance or detract from those structures around them.

7. Architecture is often altered with the tastes of the changing time period or repurposed; many buildings are remodeled to suit the needs of new occupants.

8. Architecture is less likely to be moved, and even more likely to be destroyed over time. Buildings are subject to myriad forms of deterioration, but if they are kept in good condition, they can last indefinitely. Buildings are also often the casualties of warfare and natural disasters, and many important structures have already been lost.

The following is a discussion of style and site followed by the different categories of building methods including ancient and modern.

Style and Site

One of the primary considerations for architecture is **site,** or where it is located. Architecture is constrained by its location, and a building sited on a city lot will have limitations of height, width, and length, as well as local ordinances and setbacks. Meanwhile, a structure situated on acreage can be placed in almost any suitable location on the land. For example, Frank Lloyd Wright's structure, *Fallingwater (The Kaufmann House)* [Figure 11] in Bear Run, Pennsylvania, is sited over a waterfall on the property for maximum visual effect. The style of architecture, however, tends to be determined by the materials available, the climate, personal choice, and local or cultural style. In California, for example, many residential homes are framed with wood and sheathed in some form of wood or composite siding. Structures made entirely of brick are not as common in California because they do not tend to withstand powerful earthquakes, so geographic location influences the type of materials used in construction. In many arid third-world countries, residential homes are constructed of heavy mud bricks, a material both readily available and cheap, as well as a good insulator. In this case, economy and availability influences the use of materials.

Architectural style is also influenced by location. For example, in the state of Louisiana, many old Creole plantation homes near the Mississippi River were built on stone piers or wood stilts with the first story traditionally used as a storage area, and living

space on the second level. This planning and construction served two purposes; before the levees were built along the Mississippi River, low-lying areas were subject to periodic flooding and this meant that a raised home could potentially withstand a flood of up to eight feet in height without the main part of the home sustaining damage. Secondarily, the raised structure allowed for air to circulate under the home and to provide not only a cooler storage area for foodstuffs, but a cooler home temperature. The architecture in this case adapted both to the climate and geography of the location. Lastly, choice of architectural style can be purely a matter of taste. For example, even though there are regional differences in traditional architecture in the United States between the west coast and the east coast, a person building a home in California may still opt for an historical east coast style of house, such as a traditional colonial New England saltbox home, based purely on personal preference.

Structural Systems

Load-bearing Construction

One of the most straightforward and earliest building techniques in the world is **load-bearing construction,** where the weight of the building is carried by solid walls themselves. Common materials for load-bearing construction are mud brick and cut stone. Because the weight of the structure is carried in the walls, the limitation of this type of construction is that it does not allow for many windows and doors. If there are windows and doors, they have to be small in size or supported by a cross piece of wood or stone to support the weight of the structure above. Roofs have to be lightweight and tend to be made of perishable materials such as wood. Load-bearing construction is most useful in warm climates because the thick building material acts as an insulator for the living space, keeping the interior cool even in the hottest temperatures.

Post-and-Lintel Construction and Cantilever Construction

Post-and-lintel construction is one of the greatest innovations in architecture. In **post-and-lintel construction** two vertical posts

carry the weight of a horizontal lintel [Diagram 10]. This system of building allows for larger openings in the walls of buildings for windows and doorways. If the posts and lintels of a structure are large enough, the building does not necessarily have to even have solid walls. The limitation of traditional post-and-lintel construction is that when using materials such as wood and stone, the span between posts cannot be too great or the lintel will collapse under its own weight.

Early examples of post-and-lintel construction date back to ancient prehistoric passage graves, but a well-known example of sophisticated post-and-lintel construction is the use of columns in Greek architecture. Using three main styles of columns, the Greeks built large temples to their gods. These Greek column types are known as orders, and the three Greek orders are Doric, Ionic, and Corinthian. [Diagram 11] The **Doric** order is the simplest order, having a plain capital, or uppermost part of the column, and no base, the bottommost part of the column. While the Doric order is considered masculine, the **Ionic** order is considered the feminine order with curving elements, known as volutes, in the capital. The Ionic order also has a base, as does the **Corinthian** order, a style of column developed by the Greeks but heavily used by the Romans. The Corinthian order

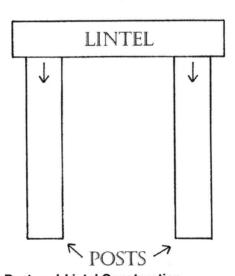

Diagram 10 Post-and-Lintel Construction
In post-and-lintel construction, the lintel is supported horizontally by two vertical posts. The downward-pointing arrows on the posts indicate the direction of thrust.

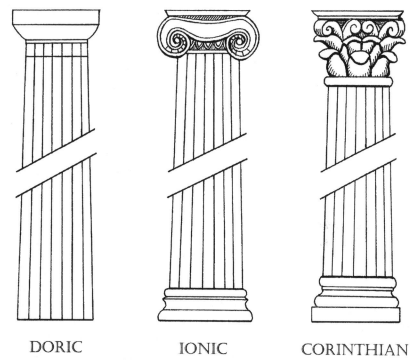

DORIC IONIC CORINTHIAN

Diagram 11 Greek Column Orders
The three Greek column orders are (from left to right) Doric, Ionic,
and Corinthian. The Doric order can be distinguished from Ionic
and Corinthian because of its simple capital (uppermost part of the
column) and lack of a base (bottommost part of the column). The
Ionic order is distinguished by the curving volutes in the capital, and
the Corinthian order is distinguished by the vegetal motif capital,
resembling the leaves of the acanthus plant.

is characterized by the presence of a vegetal motif in the capital,
a plant-like design, and in this case the foliage in the capital of
a Corinthian column is modeled after the leaves of the acanthus
plant. In Greek temples, columns were used around the perim-
eter to support the roof of the structure and this line of columns
is referred to as a **colonnade.**

When we look at post-and-lintel construction we see a beam
where its weight is evenly supported by two spaced posts, but
what happens if you do not want to have two evenly spaced sup-
port posts? The answer is to use cantilever construction. Have
you ever seen a second-story deck that jutted out from the side of
a home without any supports? That is **cantilever construction,** a

useful building method that uses the structure itself for support rather than posts or piers. In cantilever construction, one of those posts is moved over to allow for the significant overhang of the horizontal beam, and the result is that cantilever construction allows for unsupported elements such as balconies and decks, because the support is integrated into the structure of the building. The architect Frank Lloyd Wright (1867–1959) is well-known for his use of cantilever construction in his building *Fallingwater (The Kaufmann House)* [Figure 11]. Wright used cantilever construction for the exterior decks to make it appear as if the decks are floating in space.

Arches, Vaulting, and Domes

Although ancient architects were adept at creating fascinating buildings with columns, the limitation of that type of architecture was that columns do not allow for great areas of interior open space in a structure. An innovative development in architecture to follow post-and-lintel construction was the use of arches, vaults, and domes. The basic unit is the **arch** [Diagram 12a], which is made up of wedge-shaped stones known as *voussoirs*. Arches are often used for openings such as windows and doors, and also as supports for other structures since the arch is a very solid building technique. The topmost *voussoir* is the keystone and its pressure is responsible for keeping the whole arch together. When the basic arch is elongated and used as the ceiling of a building, this is known as a vault.

There are two main types of vaults, barrel vaults and groin vaults. A **barrel vault** [Diagram 12b] is essentially an elongated arch where the weight of the vault is carried on thick side walls. The main limitation of this type of architecture is that the addition of windows to the side wall compromises the ability of the walls to carry the **thrust,** or downward and outward gravitational force, of the vault. A **groin vault** [Diagram 12c] is formed by the intersection of two barrel vaults at right angles. The advantage of a groin vault is that the weight of the roof is now carried on the four corners of the structure instead of on thick side walls. This opens up the possibility for the structure to have many more windows and much more light incorporated into the interior space. Groin vaults can be placed next to each other in sequence to form what is known as a **fenestrated sequence of groin vaults.** Fenestrated refers to windows, and this structure

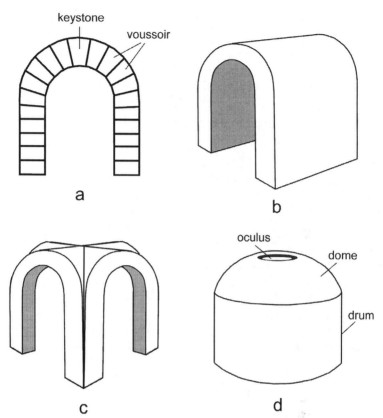

Diagram 12a: arch diagram showing voussoirs and keystone; **12b:** barrel vault; **12c:** groin vault; **12d:** dome diagram showing drum and oculus.

can be used to span large spaces. A dome is a bit different from either a barrel vault or a groin vault. A **dome** is a semi-circular covering over a space [Diagram 12d] that is usually supported by a drum, a circular foundation wall. Domes have the advantage of being able to span large open interior spaces, but they can be very heavy. Recessed spaces on the inside of the dome, known as coffers, are sometimes used both to lighten the load of the dome and as a decorative feature.

Steel Frame, Truss, and Geodesic Construction

Steel frame construction, along with the invention of the elevator, is the architectural innovation of the modern period that allowed for the development of the modern skyscraper.

Steel frame construction relies on a skeleton of steel beams and reinforced concrete floors to support the structure. This skeleton can then be covered by a variety of materials from masonry to glass, while the inside can be configured in any manner desired because the majority of the interior space is not structural. The reason steel and not some other material like wood is used is because steel has tensile strength, or strength over an unsupported span. A long beam of wood will sag over an unsupported span, but steel holds its shape and is very strong.

The only way wood can be used unsupported over a span is to use trussing. **Trussing** is a building system based on the base unit of the triangle, which is a very sturdy shape [Diagram 13a]. Trusses are made out of triangular shapes and the most common place we find trussing is in the attics of homes with pitched roofs. Truss construction is usually used as a skeleton for a building, to later be covered with sheathing, but in the middle of the twentieth century R. Buckminster Fuller (1895–1983) developed a structure that showed its skeleton. Fuller's triangle-inspired structures were called geodesic domes, also called geo-domes [Diagram 13b]. The spherical skeleton of a geodesic dome is made out of triangles, and it is very sturdy by itself without any sheathing. The real

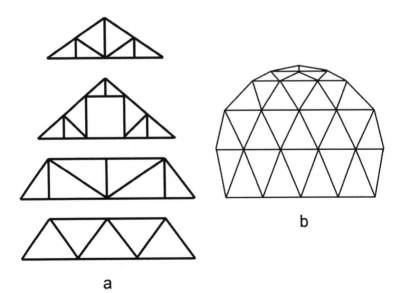

b

a

Diagram 13a: four different types of common trusses; **13b:** geodesic dome.

innovation of the geodesic dome was that the triangular elements could be prefabricated and assembled on-site, which cut costs, and because geo-domes do not need internal support they allow for the maximum use of internal space. Unfortunately, there are many limitations to living and working in spherical structures, and geodesic domes are not overly common today, although there are a few home building companies that specialize in pre-manufactured geodesic homes. One of the most well-known examples of a geodesic structure is the one in Epcot Center at Walt Disney World in Florida, which is actually a geodesic globe.

Reinforced Concrete or Ferroconcrete

The Romans are usually credited with the invention of concrete, but concrete as a building material really got a boost in the late 1800s with the development of reinforced concrete, a material that allowed for new heights of experimentation and expression in architecture. Reinforced concrete, also known as ferroconcrete, differs from original concrete in that reinforced concrete benefits from the addition of steel reinforcement to provide tensile strength. Steel is the chosen material both for its strength and because it expands and contracts at the same ratio as concrete, ensuring that the concrete will not crack off of the steel. Un-reinforced concrete is prone to cracking as temperature fluctuations cause the material to expand and contract. Over time, this can cause the material, and the structures themselves, to fail. Concrete is a substance that results from a chemical reaction when cement is mixed with water and an aggregate, such as rock. A form, or mold, is fabricated from wood and then steel rods are placed in the form. Next, the concrete mixture is poured in and when the mixture sets, or cures, the result is a stable, solid material. Flrank Lloyd Wright's *Fallingwater* [Figure 11] is made from reinforced concrete, although because not enough reinforcement was used during construction, parts of the building were sagging and in danger of collapse. This highlights the importance of properly reinforcing a structure, but that is not as much of a problem today because tables have been developed for builders and engineers to use to determine the correct proportion of steel for a structure.

ART AND ARTISTS

Post-and-Lintel Construction

The Parthenon, Athens, Greece, 447–438 BC.

Arches, Vaults, and Domes

The Pantheon, Rome, Italy, 118–125.

Modern Buildings and Materials

Le Corbusier, *Villa Savoye*, Poissy, France, 1928–30.
Frank O. Gehry, *Guggenheim Bilbao*, Spain, 1991–97.
Walter Gropius, *Workshop Wing*, Bauhas, Dessau, Germany, 1925–26.

Reinforced Concrete

Frank Lloyd Wright, *Fallingwater (The Kaufmann House)*, Bear Run,
 Pennsylvania, 1936–1939.

Geodesic Structures

Buckminster Fuller.
Spaceship Earth, Epcot Center, Walt Disney World, Florida.

New Genres

THERE HAVE BEEN phenomenal advancements in art since the beginning of the twentieth century, a time when artists began embracing new developments in technology in an attempt to break away from traditional art representations. A natural development to result from this desire to abandon traditional art was the movement towards idea as art, large-scale works of art using the landscape, sound as art, and even theatrical performance as art. The exact source of this development in art is difficult to trace, some art historians claim it goes back to the early years of the Twentieth Century and the artist Marcel Duchamp, but what is generally recognized is that there are art practices that are challenging to classify in the traditional manner using categories such as drawing, painting, and sculpture, to name a few. To further confuse the issue, the artists themselves are not defined by their chosen medium, letting the idea for a work of art dictate the appropriate medium rather than spending a career working in one chosen medium. What all of the following non-medium-specific practices have in common is a focus on idea over material creation.

This area of artistic practice is still so relatively new and controversial that not all scholars and practitioners even agree that it should be its own category of artistic practice; many texts categorize these practices as sculpture, even including sound art. As a field of study for art historians, New Genres as a category of artistic production is in its infancy, and at the writing of this text few graduate programs in the United States have a dedicated New Genres emphasis.

In the future, the field of New Genres may be reabsorbed into the field of sculpture, or it may continue as a separate discipline, offering freedom from the history and constraints of traditional disciplines. In the following sections we will look at conceptual art, performance art, sound art, land/earth art, installation art, and mixed-media. These are but a few of the myriad expressions that may be categorized as New Genres.

Conceptual Art: Idea as Art

Conceptual art is very different from all the other types of art that have been discussed because artworks that fall into the category of conceptual are more concerned with ideas than with images. Sometimes, these works create a physical object that is left behind to be collected or displayed, and other times the work may not even involve a physical artifact at all. Early forms of **conceptual art** were practiced in the early twentieth century, but really took off in the 1970s as an approach to making art that places emphasis on the idea, or concept, over the form of the art itself. One of the hallmarks of conceptual art is that the concept determines the form and medium of the art. Since conceptual art is not confined to one medium, this frees up the artist to experiment with new materials, and even use materials not traditionally associated with art. Sometimes, the work itself is just a concept, meaning that the only physical production of the artist is the documentation of an idea. Since the 1970s, the result of this approach to art is a new envisioning of the nature of art, and the tendency of artists to work in more than one medium.

Another important component of conceptual art is that it relies heavily on art theory, and so art theory has become an important part of making art. Conceptual art appeals to the intellect, rather than following the traditional notion of creating an art object to be appreciated based on its visual characteristics. Conceptual art as an art movement came about as a response to the culture of the United States in the 1960s that was becoming progressively commercialized. This art approach, then, was also developed as a way to resist the idea that artists produce an object for public consumption. In order for us to learn about many

conceptual artworks, they must be documented either through writing or through photographic or videographic means, and learning about these works of art is challenging because they are usually meant to be experienced firsthand. In addition, if the only contact with the work of art is mediated by a camera, writer, or video, the experience will never be the same as if it had been witnessed firsthand. In art history, this is referred to as a **mediated experience;** the work of art is experienced through a filter, another medium.

An example of a conceptual art piece that involves a physical object is Joseph Kosuth's *One and Three Hammers (English Version)* of 1965. This work of art consists of a photograph of a hammer, the actual hammer, and a printed definition of the term, hammer. The purpose of this work of art is to highlight the distinction in art between representation and reality, but is not a novel concept. In 1928–29, the Belgian artist René Magritte painted a realistic painting of a pipe and wrote at the bottom of the painting "this is not a pipe."[1] What Kosuth is getting at is that a photograph of a hammer is not a hammer, nor does a definition of a hammer present the complete idea of what a hammer is. Only the presence of the actual hammer is fully representational of the nature of a hammer, but the real purpose of the hammer has been negated by being displayed in a museum as art. It will (it is hoped) never be taken off the museum wall and used. This is a work of art that, like Magritte's, challenges the viewer to think about art in a whole new way.

Performance Art: A Theatrical Approach to Art

What sets performance art apart from traditional arts is that the medium of performance art is intimately tied the body of the artist, so much so that it has even been referred to as body art. In **performance art,** the human body is used in the art as its subject, as well as to create the art. Performance art, as a distinct subset of fine art, can be traced back to the *Happenings* of Allan Kaprow in the 1960s but it was more widely popular in the 1970s. Kaprow's *Happenings* are not easy to categorize, but the description of one

performance, *18 Happenings in 6 Parts* of 1959, sums up what they were typically like:

> [Alan Kaprow] produced a version of this work [18 Happenings in 6 Parts] in a New York gallery, which he outfitted with plastic partitions, Christmas lights, slide projectors, tape recorders, and assemblages of junk. "Performers" spoke doubletalk, read poetry, played musical instruments, painted on the walls, squeezed orange juice, and executed other similar acts. The gallery patrons had to be given instructions on how to move through this potpourri, becoming in a sense performers themselves.[2]

The point of this work, and other performance art pieces, is to break down the traditional separation between theater and audience, and viewer and artwork—blending the two separate realms into a work of art. Necessarily, then, performance art involves elements of theater as well as traditional fine art, but the difference between theatre and performance art is the setting. A theatrical performance is confined to the stage, usually with little audience interaction, applause aside. A performance work of art can theoretically be performed anywhere, from a museum to the streets of a city. The location of the work will follow the concept of the work.

Like conceptual artists, early practitioners of performance art felt constrained by art as a process through which a material object is produced, such as a painting or a sculpture. Performance art allowed modern artists to create art without having to create an object, as well as allowing the artist to have direct interaction with their audience, instead of creating an art object to be viewed in a museum from a distance. One well-known performance artist is Chris Burden (b. 1946) who is best known for having been shot in the arm during the enacting of a performance art piece in 1971. Still photos of Burden document the event and provide an art object for collection and discussion. Many artists document their works because, without documentation, there is no record of the work. Performance art is quite varied, and the following works are just two of the many well-known performance art projects.

CASE IN POINT
Yoko Ono, *Cut Piece*, 1964

The general response to the subject of Yoko Ono (b. 1933) is that she "broke up the Beatles," but Yoko Ono actually was an artist and a member of the international art collective Fluxus before her association with John Lennon. In terms of art, she is best known for *Cut Piece*, first performed in 1964. In *Cut Piece*, Ono appeared onstage and sat down on the floor. She placed a pair of scissors in front of her and invited the audience to come up on stage and cut away pieces of her clothing until she was left bare. The purpose of this work of art was to explore the notion of control. Ono was in control of the situation because this was her performance, but she gave that control over to the audience when she relinquished her scissors to them, placing herself in a state of vulnerability. When we talk about performance art, we have to describe it and because of the mediation of performance art, it is necessary to understand the motives of the work in order to appreciate it. In this particular performance piece, there was very little performing by the artist herself—the majority of the performance centered on the actions of the audience.

CASE IN POINT
James Luna, *The Artifact Piece*, 1987

Another example of a performance piece (and installation art) in which the artist is stationary is James Luna's *The Artifact Piece*. This work of art is a little more unusual because it was staged in San Diego's Museum of Man, not in an art museum. Luna, a Native American, placed himself in a mock display case, dressed in only a loincloth, in the Museum of Man, a museum that at that time had displays about the evolution of humans as well as Native American artifacts. He set up the performance in the area reserved for showing art from the Kumeyaay Indian tribe, a tribe once prominent in the San Diego area. During the performance, museum patrons were

(Continued)

> **CASE IN POINT** (*Continued*)
>
> able to approach this "display" and read cards that described Luna as an artifact. For example, one of the cards pointed out a scar that Luna had received after a night of heavy drinking, using humor to challenge the stereotype of the "drunk Indian." Luna describes his work as:
>
> > a performance/installation that questioned American Indian presentation in museums—presentation that furthered stereotypes, denied contemporary society and one that did not enable an Indian viewpoint.[3]
>
> The whole performance was intended to highlight the prejudices that museums have against displaying art of living cultures. Luna observed that museums only tend to show art from cultures that are considered dead, like the ancient Egyptians, or art from older ages of a culture. Luna's point is that Native Americans are still alive, but the works they currently produce are not represented, even in a museum dedicated to showcasing their culture.

Sound Art: Art That Is Heard, But Not Seen

Another form of art that some artists have been experimenting with is **sound art,** where the work of art is composed of sound instead of creating a material art object. One of the debates surrounding sound art is whether it is actually art, or just a form of experimental music whose roots go back to the early part of the twentieth century. The difficulty in learning about sound art is experiencing the art itself. Without being able to actually hear the work of art, we have to rely on descriptions of the sounds, photos of sound installations, and video (often taken surreptitiously). For example, the Canadian artist Janet Cardiff (b. 1957) is known for sound art installations, as well as her "walks," tours of areas accompanied by sounds heard through headphones. Cardiff's 2001 sound installation, *40-Part Motet,* includes the use of forty speakers set on stands at head level, arranged in a circular configuration in eight groupings of five speakers each.

Using the musical composition *Spem in Alium nunquam habui,* by Thomas Tallis, as the base:

> Using this piece of secular music as a starting point and working with four male voices (bass, baritone, alto and tenor) and child soprano, Cardiff has replaced each voice with an audio speaker. The speakers are set at an average head height and spaced in such a way that viewers can listen to different voices and experience different combinations and harmonies as they progress through the work.[4]

The result is amazing because, as the music progresses, the voices rise and fall, and the work sounds different from different areas within and around the circle of speakers. In this case, sound art is merged with installation art, but other times, sound art is merged with performance art.

Land/Earth Art: Art That Transforms the Landscape

In the latter half of the twentieth-century a common theme in art production was the desire to create art that was not traditional in the sense that works were either too large to move, or the works did not fall into a traditional art object format. One such type of art that got its start in the 1970s is land art, otherwise known as **earth art.** Although there were a number of earth art practitioners, their common thread was that they used the land itself to create works of conceptual art in the museum, or that the works played off the landscape. These early works tended to be large in scale and were documented photographically because many of them were difficult to access due to their remote locations. Due to the scale of the works, these artists did not work alone but had to often employ construction crews with heavy equipment.

One such artist was Robert Smithson who created the work *Spiral Jetty* [Figure 14] in the Great Salt Lake, Utah, between 1969–70. Smithson's work is basically a large jetty that spirals out into the Great Salt Lake. Smithson created this work with the help of a construction company, and the following passage describes the importance of this shape to this site, and the necessity of photographic documentation for earthworks:

> At this particular point on the shore of the Great Salt Lake, Smithson found not only industrial ruin, in the form of

wreckage left behind by oil prospectors, but also a land-scape wasted and corroded by its own inner dynamism. As Smithson wrote, the gyre does not expand into a widening circle but winds inward; it is "matter collapsing into the lake mirrored in the shape of a spiral." Prophetic words, for in the ensuing years *Spiral Jetty* has disappeared—and reappeared—periodically amidst the changing water levels of the Great Salt Lake. The films and photographs that document the piece now provide the only reliable access to it.[5]

Spiral Jetty exemplifies the tendency of earthworks to interact with the environment around them. In this case, the high salt content of the water has deposited a mineral deposit on the rocks that has turned the work white. Also, in years where there is more rain, the work is submerged under water. When the area goes into a period of drought, the work again reemerges, so it is not static but always changing. In addition, the time of the day and part of the year also affect the way the work looks.

Land Art in the Museum Space

Eventually, land/earth artists realized the limitations of creating remote works of art viewed by only a few, and as a response they began to prepare earth works that could be displayed in the museum setting. These works ranged from boxes of rocks and maps to rooms filled with earth. This approach fulfilled a need for artists to work within the well-established confines of the museum system and for museums to be able to collect and display physical works of art. For example, Christo (b. 1935) and Jeanne-Claude (1935–2009) are a husband and wife team of artists who create large site-specific projects. Their works often take many years because they have to gain the approval and the permission of various state and local governments and private citizens. In addition, their works are large in scale and often require the use of construction companies and volunteers. While Christo and Jeanne-Claude never solicit money for their projects, they raise money through the sale of Christo's drawings of the proposed projects, and even some of his early works of art. They believe that by raising their own money they retain artistic control over the work of art and that local governments will also be more inclined to help them, since they do not

require their monetary support. For the project *Valley Curtain,* in Rifle, Colorado [Figure 14], Christo created a collage of the proposed project to be sold to finance the construction of the actual project. The finished work was erected on August 10, 1972 and had to be taken down the next day due to unexpected high winds. The work was constructed of saffron-colored fabric strung on cables across the valley. The actual artwork, then, is the constructed project made by Christo and Jeanne-Claude, but the drawing are what were sold to museums and collectors, and those are only made by Christo. This fulfills Christo's need to produce works of art, and the museum's need to display and collect.

Installation Art: Transforming the Museum Space

Installation art is a type of art that came out of the twentieth century desire to create a work of art that was not like standard works of art in museums, but a work of art that could be intimately experienced because installation art transforms the gallery space. Installation artists consider painting and sculpture to be objects that are passively viewed and want artwork that engages the senses of the viewer beyond mere viewing. Ronald J. Onorato writes about installation art:

> Fundamental aspects of installation artwork are its habitation of a physical site, its connection to real conditions—be they visual, historical, or social—and often, its bridging of traditional art boundaries: public and private, individual and communal, high style and vernacular. The aesthetic power of installation does not reside in the singular, commodified object but in an ability to become, rather than merely represent, the continuum of real experience by responding to specific situations. . . . There are several arenas within which most installation artists work: light and audio, performance and process, constructed architectural environments, narrative or political work, and video.[6]

The output of installation artists can be quite varied, ranging from creating whole environments to smaller installations highlighting the space of the museum. These whole environments

may include transforming the museum space by covering walls and floors, or may only involve creating a work of art in the space of the museum instead of in a studio. The resulting work of the second possibility creates pieces that are site-specific and de-installation sometimes ruins the work of art, limiting its duration. Photography aids in the documentation of these temporary installation works of art. Another possibility for installation art is that some works can be shown in more than one location, but each installation creates a new variation on the work of art, which is usually noted in captions accompanying photographs of the installed work.

For example, the artist Tara Donovan uses everyday materials to create art installations. In 2003, Donovan installed the work *Haze* in a gallery at the Museum of Contemporary Art, San Diego. The work comprised covering the four walls of the gallery, from floor to ceiling, with thousands of plastic drinking straws, set with their ends touching the wall that undulated in and out away from the wall. The effect was astounding to witness in person, but the work does not seem as interesting in photographs because installation art is meant to be experienced, not read about. The reason the work was so astounding was because the hollowness of the straws caused all the sounds in the gallery to be muted, and the straws themselves took on a yellowish cast in the dim light of the gallery. What Donovan did was to transform the museum space through the repetitive use of a common mass-produced product.

Mixed-Media: The New Art Hybrid

Mixed-media is a term that can be used to refer to any work of art whose final form is a combination of more than one type of medium, and refers both to a category of art as well as the material of the object itself. A mixed-media work can be a combination of two distinct types of sculptural material, or even a combination of two entirely different types of media such as sculpture and photography. In the section on sculpture, we previously looked at assemblage as a type of sculpture, but assemblage can also include mixed-media constructions. The following are two common types of mixed-media; collage and combine.

Collage

The literal meaning of the term collage comes from the French verb *coller,* which means "to glue." **Collage** is an art method where mass media objects, such as newspaper or magazine clippings, are pasted onto another flat medium or solid base, such as paper. Although collage works do not have to be mixed-media, a work may be composed of only paper materials *(papier collé),* often collage does involve the addition of non-paper materials. Collage was made famous by the Cubist artists Pablo Picasso and Georges Braque in the very early years of the twentieth century in Europe. The beginnings of collage are said to have begun with the Picasso work *Still Life with Chair Caning,* which is a small work of art made from collaged oilcloth on canvas with a rope frame. Up to Picasso's time in art history, fine art consisted mainly of painting and sculpture, and by using magazine and newspaper clippings to make fine art, Picasso was challenging the very notion of what constituted fine art. A second rationale for using collage in Cubist works was to incorporate the material world into art compositions, to merge real life and art. Newspapers and photos are actual objects used in the works, instead of painted interpretations of the real world.

Combine

The term **combine** is a term invented in the mid-twentieth century by the early American pop artist Robert Rauschenberg at a time when large, expressive paintings were the most popular form of art. A combine is a hybrid of the two traditional mediums of painting and sculpture, and can take the form of either a free-standing sculpture, or a painting-like wall hanging. The definition of a combine as a hybrid of painting and sculpture is the traditional application of the term, but today some artists confuse the term combine with mixed-media. Technically, a combine is a mixed-media work of art, but a combine is traditionally limited to the combination of painting and sculpture, while mixed-media is not confined to any specific medium or materials.

NOTES

1. René Magritte, *The Treachery (Or Perfidy) of Images,* 1928–29. Los Angeles County Museum of Art.

2. Jack A. Hobbs. *Art in Context* (New York: Harcourt Brace Jovanovich, Inc., 2nd edition, 1980) 71.

3. James Luna, statement on *The Artifact Piece*, www.james luna.com

4. Janet Cardiff. Untitled statement in *Elusive Paradise: The Millennium Prize* at the National Gallery of Canada, Ontario, 2001 (brochure), reproduced in *Tate Liverpool Past Exhibitions: Janet Cardiff* at http://www.tate.org.uk/liverpool/exhibitions/janetcardiff/ (accessed June 22, 2007).

5. H. H. Arnason. *History of Modern Art: Painting, Sculpture, Architecture, Photography* (New Jersey: Prentice Hall, Revised by Peter Kalb, 5th edition, 2004), 614.

6. Ronald J. Onorato. "Blurring the Boundaries: Installation Art," in *Blurring the Boundaries: Installation Art 1969–1996* (New York: the Museum of Contemporary Art, San Diego and Distributed Art Publishers, 1999), 13.

ART AND ARTISTS

Mixed-Media

Joseph Cornell, *Untitled (The Hotel Eden)*, c. 1945. National Gallery of Canada, Ottawa.

Collage

Richard Hamilton, *Just what is it that makes today's homes so different, so appealing?* 1956. Kunsthalle Tübingen, Sammlung Zundel.
Pablo Picasso, *Still Life with Chair Caning*, 1912. Musée Picasso, Paris.
Pablo Picasso, *Guitar, Sheet Music, and Wine Glass*, Fall 1912. McNay Art Museum, San Antonio, Texas.

Combine

Robert Rauschenberg, *Bed*, 1955. The Museum of Modern Art, New York.
Robert Rauschenberg, *Canyon*, 1959. Sonnabend Collection.

Ready-mades

Marcel Duchamp, *Fountain (second version)*, 1950. Philadelphia Museum of Art.

Conceptual Art

John Baldessari, *Heel*, 1986. Los Angeles County Museum of Art.
Joseph Kosuth, *One and Three Hammers (English Version)*, 1965.
Sol LeWitt.

Land Art/Earth Art/Site-specific Art

Christo and Jeanne-Claude, *Wrapped Reichstag, Berlin*, 1971–95 (now removed).
Christo and Jeanne-Claude, *Running Fence, Sonoma and Marin Counties, California*, 1972–76 (now removed).
Andy Goldsworthy, *Three Cairns*, 2002. Museum of Contemporary Art, San Diego.
Robert Smithson, *Spiral Jetty*, 1969–70, Great Salt Lake, Utah.

Installation Art

Chris Burden, *The Reason for the Neutron Bomb*, 1979.
Chris Burden, *All the Submarines of the United States of America*, 1987. Installation with 625 miniature cardboard submarines, vinyl thread, typeface. Dallas Museum of Art.
Tara Donovan, *Haze*, 2003. Museum of Contemporary Art, San Diego.
Robert Irwin, *Untitled*, 1969.
Anish Kapoor, *The Earth*, 1991.
Jean Lowe, *Ladies' Room*, 1990.
Bruce Nauman, *Green Light Corridor*, 1970–71.
Nancy Rubins, *Airplane Parts and Building, A Large Growth for San Diego*, 23 September 1994–1 May 1995.
Robert Smithson, *Mono Lake Non-Site (Cinders Near Black Point)*, 1968.
Sarah Sze, *Drawn*, 2000. Museum of Contemporary Art, San Diego.
Bill Viola, *Heaven and Earth*, 1992.

Performance Art

Vanessa Beecroft, *VB 39, U.S. Navy Seals, Museum of Contemporary Art, San Diego, 1999*, 1999. Museum of Contemporary Art, San Diego.
James Luna, *The Artifact Piece*, 1987. First performed at the Museum of Man, San Diego.
Yoko Ono performing *Cut Piece* at Carnegie Recital Hall, NYC, March 21, 1965.

Sound Art

Janet Cardiff, *40-Part Motet*, 2001.
Ryoji Ikeda, *Matrix*, 2000.
Carsten Nicolai, *Telefunken*, 2000.

Appendix

PROJECT #1
Categories of Visual Art

PURPOSE OF PROJECT: The project is intended to test the visual recognition skills of the student in understanding the difference between various categories and genres of art. Through the process of viewing and evaluating images, the student will put to practical use the knowledge gained from lecture and text.

Directions

First, search through print media, such as magazines or books, to collect images that represent each of the three main categories of art (fine art, popular culture, craft) and three of the five genres of art (figurative, landscape, still life, abstract, or non-objective). Do not use images from your textbook or Internet images since it is far too easy to rely on an Internet search engine to identify the type of image you are viewing.

Next, cut out or make copies of images that are representative of these six categories and glue each image on its (following) corresponding page. Please attach the actual images, not scanned copies. You will have one image per worksheet page. Remember that quality of presentation is important.

Finally, evaluate each image and formulate a paragraph to accompany each picture providing a rationale for each of your image choices. Write out your rationale on the

worksheet under the corresponding picture. In this paragraph you should address how each particular image is representative of its category. Your responses should demonstrate your knowledge of each category based on the text and examples shown in class.

IMAGE 1: FINE ART

IMAGE 2: POPULAR CULTURE

IMAGE 3: CRAFT

IMAGE 4: GENRE OF ART

IMAGE 5: GENRE OF ART

IMAGE 6: GENRE OF ART

PROJECT #2
The Museum In-person and Online

LENGTH OF PROJECT: The finished length of the project will be five to six pages including worksheets and typed pages.

PURPOSE OF PROJECT: This project is intended to introduce the student to the space of the museum. Through a structured visit both online and in-person, the student will be able to evaluate the most effective means of viewing art.

Directions

To complete this project, you must visit two museums: one in person and one on the Internet. For the physical museum, you may visit a large museum or a college art gallery, but **not** a commercial gallery or natural history museum. For the online museum, please conduct a web search for a museum website. Please do not visit a virtual museum; you need to view the website of a museum that actually exists, and the museum should be well-respected and well-known. If you are in doubt about your museum choice, check to see if the museum has a physical location listed on its contact information page. You may also choose to visit the website of the museum you visited in person.

In addition, your project should address the following points:

1. When you conduct your in-person and web visits, use the worksheet provided to make a sketch of each artwork, as well as recording the title of the artwork and any relevant information.
2. On a separate typed page for each artwork, describe in detail the work of art using at least 3 of the formal elements of art for each description. Attach each description to its sketch page.
3. Address the following questions in the form of a short essay of at least one full page in length:

 Which museum visit do you think is more beneficial for the viewer, in person or online?

How was your experience of the artworks different in person from online? Explain your response in detail.

4. Attach proof of attending a museum (ticket stub), and visiting an online site (print the first web page).

Name and location of physical museum: _____

Title of Artwork #1: _____

Notes: _____

Title of Artwork #2: _____

Notes: _____

Name and website of online museum: _____

Title of Artwork #1: _____

| |
| |
| |
| |
| |
| |
| |
| |
| |
|_____|

Notes: _____

Title of Artwork #2: _____

Notes: _____

PROJECT #3
A Visit to the Museum

LENGTH OF PROJECT: Length—<u>minimum</u> one full page typed, and one sketch.

PURPOSE OF PROJECT
Directions

1. Please visit an art museum.
2. Choose a work of art that catches your attention, positively or negatively.
3. Record the title of the work and make a sketch of it. Do not substitute or include a photo of the artwork (You will not be graded on the quality of your sketch, just the completion of it).
4. Answer these questions:

 Who is the work <u>attributed</u> to? Where did you find this information?

 Is the work <u>representational</u>, <u>abstract</u>, or <u>non-objective</u>? Explain your choice with reference to specific elements in the work. (one paragraph)

 Please describe in detail the <u>content</u> of the work and your reaction to it. (one paragraph)
5. Lastly, Attach proof that you have visited the museum—a ticket stub or museum brochure.

PROJECT #4
Formal Analysis of a Found Object[1]

PURPOSE OF PROJECT: This is a structured exercise for the student to apply the formal elements and principles of design to the description of an ordinary object.

Directions

Please find an object that has artistic, aesthetic qualities, but was *not* intended to be art of any kind. Do not look for a beautiful object, but something that has been discarded. In addition, do not alter the object in any way or make it into art—the object must remain in the state in which it was found.

Next, take a photograph of your object and affix it to the worksheet page. Please respond to the questions on the worksheet in the space provided.

Lastly, please bring the object to class on the assigned day along with the completed worksheet to turn in.

NOTES

1. Special thanks to the previous teachers of art appreciation at California State University San Bernardino who provided the foundation for my development of this project.

PROJECT #4: FORMAL ANALYSIS OF A FOUND OBJECT

Place image of found object here.

What is your object? _____

Where did you find this object? _____

Why did you choose this object? _____

Describe your object using at least three of the formal elements
and two of the principles of design.

Glossary

A

abstract Artwork with an object as its subject, recognizable or not, that has been distorted or simplified. Abstraction is not a poor attempt at illusion, but an attempt to create a new representation of reality.

actual line Line that actually exists having real length and width.

actual motion A term to refer to motion that is actually present in a work of art. The opposite of actual motion is implied motion.

actual space A term to refer to real, tangible space. The opposite is implied space.

actual texture The physical three-dimensional texture of an object, such as smooth or rough.

additive color system The system of color for light-emitting media such as computer screens, LCD projectors, and televisions.

alla prima **("at once")** An Italian phrase which refers to a style of direct painting in which all areas of the composition are worked at the same time in one layer, instead of working the painting up in multiple layers (indirect painting). *Alla prima* is now a common method in oil painting and is sometimes called wet-on-wet or *premier coup.*

ambient light Reflected light from natural or artificial sources.

analogous colors Colors that have a color in common but have different proportions of that color. For example, orange contains red, so orange and red are analogous colors.

aperture A small hole that allows in light. Usually used in reference to photography.

arbitrary color Non-representational color chosen for effect or expressive purposes.

arch A rounded architectural element made up of wedge-shaped stones used for openings such as windows and doors.

armature A wire skeleton used to support a clay sculpture.

art appreciation An approach to studying art in which the student studies art through subjects such as themes in art and formal content.

art brut **("raw art")** A French term coined by the mid-twentieth-century artist Jean Dubuffet to describe works of art made by outsiders to the art establishment, but especially art produced by the mentally ill.

art history A formal academic discipline involving learning about the historical or social context of a work of art and viewing it in light of this information.

artificial light Light from artificial sources such as light bulbs, computer screens, or candles.

assemblage A sculpture composed of the arrangement of three-dimensional objects, which may also include found objects.

asymmetrical balance Balance that is not equally visually weighted, but still gives the appearance of visual harmony.

attribution The process of assigning a work of art to an artist. Attribution of a work of art may change with scholarship.

B

balance A term used to describe the arrangement of negative and positive space used to create the feeling that elements in the work of art are evenly distributed.

barrel vault A rounded architectural element used for covering large interior spaces and resting on thick side walls. Resembles a barrel.

binder or vehicle A binder is the substance a pure powdered pigment is mixed with that allows for the adhesion of the pure powdered pigment to a ground. The binder determines what type of paint it is.

bite In printmaking, a term used to refer to the corrosive action of acid on a plate. Biting refers to the removal of material from the plate.

buon fresco (**"true fresco"**) A fresco method where pigment is applied to wet plaster, thus bonding permanently with the plaster. The opposite of *fresco secco.*

bust A sculpture of the head, shoulders, and upper torso of a person.

C

calotype An early photographic process developed by Henry Fox Talbot, whereby a photographic image is created on a piece of paper (instead of a metal plate) to create a paper negative, and then the paper negative is used to produce a photograph.

camera obscura (**"dark room"**) A device used to correctly render the perspective in a work of art. The portable form of this device is usually a small box with a hole and a mirror that reflects the scene onto a piece of paper. A larger form of the *camera obscura* is a darkened room with a single hole to the outside. The light coming into the hole creates an image of the outside world.

canon of proportion A system for depicting the ideal proportions of a human body based on a base unit of measure, such as a head or fist. The base unit of measure is different for different cultures.

"Canon" of art history The "Canon" of art history includes all the works of art considered great and worth studying. Works included in the "Canon" are those considered to be of high artistic achievement and which have relevance to people across generations and cultures.

canvas Refers to both the fabric on which a painting is executed as well as a term for any painting support made of fabric stretched over a wooden frame, whether made out of canvas or not.

charcoal A drawing medium made from burnt wood and comes in a variety of thicknesses of either hard or soft consistency.

chiaroscuro (**"light/dark"**) An Italian term that refers to the use of light and shadow to create the illusion of modeled forms in two-dimensional works of art, especially a painting.

Classical Art The art of ancient Greece and Rome.

CMYK The base colors of printers' inks are cyan, magenta, yellow, and black, referred to as **CMYK**. The color black is referred to as K because the K stands for "Key."

collage An art method where mass media objects, such as newspaper or magazine clippings, are pasted on to another flat medium or solid base, such as paper.

combine A term invented by the mid-twentieth century American artist Robert Rauschenberg to describe his works, which are a hybrid of painting and sculpture.

complementary colors Pairings of colors across from each other on the color wheel that are considered to be the most contrasting colors on the wheel.

composition The total arrangement of visual elements in a finished work of art.

connoisseurship In reference to a category for understanding art, connoisseurship is the evaluation of works of art for the purposes of attribution and inclusion in the Canon of art.

conservation Both a professional field dedicated to preserving and repairing works of art, and an approach to art conservation which stresses halting the deterioration of a cultural artifact, and includes cleaning the work as well as treating it to stop further deterioration.

context Context refers to the situation that surrounds the creation and reception of a work of art. This includes the social and political situation at the time of the art, the place the art was made, the events of the artist's life included in their biography, the date the work was made, and how and where the work was received by viewers.

contour line A line that traces the outer shape of an object, or contained interior spaces, without providing detail.

cool colors Blues, purples, and greens are considered cool colors.

cross-hatching A method of creating tone in a drawing or linear composition using overlapping lines.

cyanotype A cyan-colored photographic method where a piece of paper is coated with ferric ammonium citrate and potassium ferricyanide. When an object is placed on the sheet and the sheet exposed to sunlight the paper around the object turns blue while the shadow of the object stays white.

D

daguerreotype A photographic technique invented by Louis Jacques Mandé Daguerre where a piece of metal is treated with light-sensitive chemicals and then exposed to light, fixing the image on the metal plate itself.

diluent The substance used to thin paint to provide for more fluid handling, such as turpentine for oil paint.

direct light Light that comes straight from a light source, such as the sun or a lamp.

direct painting See *alla prima*.

E

egg tempera A type of paint that is made by mixing ground pigments with egg yolk and water. Egg tempera is fast-drying, and was commonly used for fine art paintings in the early Renaissance in Europe.

emphasis The focus of an artistic composition. Emphasis is used to convey importance to the viewer through the creation of focal points.

encaustic A painting method where the pigment is mixed with wax.

F

fenestrated sequence of groin vaults A series of groin vaults placed next to each other. This architectural arrangement allows for groin vaulting to cover a larger open interior space than a regular groin vault.

figurative art Art that depicts the human body; may be used for study as well as for a finished work of art such as a portrait.

figure drawing Art studies of human anatomy for the purpose of instruction and practice, often using a live model.

fine art A category of artistic production usually referred to as "high" art to denote that these works of art are of exceptional quality and held in high esteem by the art establishment. Traditionally, fine art works tended to be defined by medium and included painting, sculpture, and architecture, but that has changed in the last century.

focal points Points of interest in a composition.

folk art A type of art produced by informally trained artists in which the perpetuation of traditional design is emphasized over innovation. Folk art often incorporates craft techniques, but is not always considered craft.

formal artist training A type of art training that consists of completing a formal course of study with set requirements and a specified goal, such as would be provided at a local college or university, or even a course at an art academy or learning about art from an established artist in a structured course.

formalism An approach to interpreting art that uses the formal elements to construct understanding of a work of art.

found objects Objects are not intended to be used as art, but that an artist has appropriated for fine art purposes.

fresco secco **("dry fresco")** A method of fresco painting where paint is applied over dry plaster.

G

genre/genre painting/genre scene A genre scene or genre painting refers to works of art which depict scenes of everyday life. A genre refers to the category of the subject of a work of art, such as landscape, portrait, or abstract.

geometric Forms and shapes with regular, hard edges.

gestural The term "gestural" describes lines that are frenetic and seem to express visual energy.

giornata The amount that a fresco artist can paint in one day of work.

glaze A coating applied to ceramic objects. After firing, ceramic glazes are often glassy in appearance and character, but may also take on a matte finish depending on the firing process.

glazing In oil painting, the layering of transparent oil paints to create color and form. Also used to refer to a class of transparent oil paint colors especially suited for use in glazing, called glazing colors.

groin vault A groin vault is formed by the intersection of two barrel vaults at right angles. A groin vault has an advantage over a regular barrel vault because the vault is supported on four piers instead of thick side walls.

ground The surface, or material, on which a work of art is executed. The ground refers to the coating used to prepare a surface to accept paint, not to be confused with the support.

gum arabic A substance from the acacia tree used as a binder for watercolor paints because it completely dissolves in water.

H

hatching The arrangement of parallel lines to imply tone in a two-dimensional work of art. The darkness or lightness of the tone is determined by the proximity of these lines to one another.

hieratic scaling A device for showing the importance of an object in a composition by depicting the most important figure as the largest figure.

hue The pure state of the color itself that is referred to by the name we give it.

I

illusionistic space The illusion of three-dimensional space created in a two-dimensional work of art through the use of linear perspective.

impasto The very thick application of paint resulting in prominent peaks and valleys.

implied lines Lines that do not actually exist, but are created by the eye, such as a dotted line.

implied motion A term used to describe the effect when a group of elements are used in a work of art to create the illusion of movement.

indirect painting A technique where a painting is built up layer by layer. The opposite of *alla prima*. Traditionally, indirect painting begins with a monochromatic underpainting and builds up the color slowly through glazing.

informal artist training Any art instruction not learned as part of a formal educational program. The opposite of formal artist training.

installation art An approach to making art that transforms the museum space in order to create a whole sensory experience for the viewer.

intensity The brightness or dullness of the color.

interpretation A process through which art historians come to understand a work of art using both content and context to determine meaning and subtext.

K

key(s) Refers both to the color black in the CMYK printing process, as well as the small wooden triangles forced into slots in the corners of the stretcher bars of a painting in order to take up slack in an already-stretched canvas.

L

landscape A work of art that uses the land as its subject. Landscapes can be purely representational, or even metaphorical.

layered painting See *alla prima*.

levigator A thick, disk-shaped tool with a handle that is rotated over a mixture of sand and water to abrade the surface of a lithography stone. Used as part of the lithographic printing process to prepare the stone surface to receive an image.

limewater A mixture of calcium hydroxide and distilled water that is mixed with dry pigment in the *buon fresco* technique.

linear perspective A mathematical system used in drawing to create the illusion of depth on a flat surface. Linear perspective makes use of vanishing points, and imaginary lines known as orthogonals.

local color The actual, true color of an object.

M

material The substance a work of art is made out of, such as wood, stone, metal, or paint. Choice of material can contribute to the meaning of a work of art.

medium (pl. media) The physical material of the work of art, such as paper or paint.

metalpoint A drawing technique where a piece of metal is used as the drawing medium. Metalpoint includes copper, silver, lead, and gold.

methodology A formal structure used by art historians to research and explain a work of art.

mission statement A formal statement outlining the purpose of the museum.

mixed-media A work of art composed of more than one medium.

N

natural light Light from the sun. Natural light is considered to have the least amount of effect on color perception.

new genres A term referring to a category of non-medium-specific art based on ideas and new artistic practices, especially those that are technology-based or difficult to categorize in traditional terms. New genres may include performance, sound, and installation.

new media art A genre of art where the art is made using new technologies including works of art that use computers or anything made with a computer, art that is internet-based or virtual, and any art using digital technology.

non-objective Artwork that has no physical object as its subject.

O

ora d'orato An Italian term meaning "the golden hour," which is used to describe a time towards the end of a day of fresco painting when the plaster readily accepts the paint.

organic Shapes that are soft-edged and rounded; they curve and bend like objects in nature.

orthogonals In linear perspective, the orthogonals are the imaginary/implied lines that extend from the actual lines and converge at the vanishing point.

outsider art Technically refers to the production of art by anyone outside of the mainstream "art world," can also be a term used to describe artwork made by incarcerated individuals as part of criminal rehabilitation programs (or as a jail time pastime), and artwork made by people with diminished mental capacity or the mentally ill.

P

patron A person who financially supports an artist or provides money in exchange for a work of art to be created. Patrons may commission works of art.

performance art A relatively new approach to art where the human body is used in the art, as well as to create the art. Performance art is theatrical and involves the audience in the artwork more so than traditional art or theater.

photogravure A complex photographic process invented in 1876 where multiple copies of an image could be produced. This technique combines photography with printmaking by creating an engraved plate.

photomontage The process of cutting and pasting photos together to form one larger image.

pigments Pigments are the powdered form of colors traditionally made from substances such as minerals, plants, or even ground up semi-precious stones. Pigments are mixed with binders to make different types of paints.

planographic A printmaking process where the printing surface is flat.

plein air A painting completed entirely out-of-doors and of a natural subject such as a landscape.

popular art Refers to mass-produced objects and images meant for mass consumption.

porphyry A purple-red stone once used exclusively for Roman imperial sculpture.

primary colors The base colors from which other colors are mixed.

process A term that refers to the working methods of the artist used to bring the piece from conception to fruition.

proportion The size of things in relation to one another in a composition. Proportion can be an expression of the comparison of an element in relation to the whole, or two elements compared to one another.

provenance Provenance is the pedigree, or lineage, of a work of art. A complete provenance documents every owner of a work of art from creation to the present. A complete and well-documented provenance can aid in the authentication of a work of art.

public art Art intended for public spaces, often funded by government agencies.

R

radial balance When the elements of a composition radiate out from, or are arranged in an array around, a central point of reference.

restoration The process by which a work of art is returned to what is believed to be its original condition, usually through the readdition of missing pieces for sculpture or inpainting missing sections for painting.

rhythm The repetition of elements in a composition to create a pattern, with the repeating elements occurring at least three times. Rhythm in art can be regular or irregular, but still give the feeling of balance.

S

scale A comparison of the size of an object to what it would really be like in person.

secondary color Results from the mixing of two primary colors.

shade In color mixing, adding black to a color.

silverpoint A drawing method popular during the Renaissance where the artist uses a silver wire to execute a drawing.

site-specific sculpture Sculpture that is made for a specific location. Moving the artwork will significantly affect its reception.

sound art A type of artistic expression where the work of art is composed of sound instead of creating a material art object. Sound art is often coupled with performance or installation art.

still life An arranged array of objects, usually inanimate, used as the subject of a work of art.

stippling The process of creating tone in a drawing through the use of dots. The proximity of these dots to one another determines the quality of the tone.

subtractive color system refers to the mixing of pigment-based colors such as artists' paints and printers' inks.

subtext The underlying, secondary meaning of a work of art whose understanding can be arrived at through interpretation.

support In drawing, the surface, such as paper, on which a drawing is executed. In painting, the support is the canvas.

symmetrical balance The condition achieved when each side of a composition has equal visual weight. An imaginary line is drawn to bisect the composition to test for symmetrical balance.

T

tenebrism Considered an extreme form of chiaroscuro characterized by strong contrasts of light and dark often creating a spotlight effect.

tertiary color Sometimes referred to as intermediate color, tertiary colors result from the mixing of one primary color with its neighboring secondary color.

thrust The downward and outward gravitational force of a vault.

tint In color mixing, adding white to a color.

tooth The relative roughness of a paper's surface. Tooth helps the paper to hold the material of drawn lines.

tone In color mixing, adding gray to a color.

U

unity The overall sameness in a work of art. Opposite of **variety.**

V

vanishing point The vanishing point is the place where the orthogonals converge in a work using linear perspective.

value The lightness or darkness of a color.

vanitas still life A type of still life painting that uses transitory objects, such as flowers, as symbols for the brevity of life and inevitability of death. Especially popular in the Netherlands in the seventeenth century.

variety The overall difference in a work of art. Opposite of **unity.**

vehicle See *binder.*

visual texture The illusionary texture of an object; texture that is seen but is not three-dimensional.

visual weight In a composition, visual weight refers to the way some elements appear visually heavy while others appear visually light.

voussoir The individual blocks that make up an arch.

W

warm colors Yellows, oranges, and reds are considered warm colors.

Bibliography and Further Reading

Chapter 1

Langmuir, Erika, and Norbert Lynton. *The Yale Dictionary of Art & Artists.* New Haven, CT: Yale University Press, 2000.

Pataday Corporation, "Art Gallery" TV Ad. www.pataday.com/about-pataday/artgallery.asp.

Tate Modern Glossary. www.tate.co.uk/collections/glossary.

Chapter 2

Adams, Laurie Schneider. *The Methodologies of Art: An Introduction.* Boulder, CO: Westview Press, 1996.

Arnason, H. H. *History of Modern Art: Painting, Sculpture, Architecture, Photography.* 5th ed. Revised by Peter Kalb. Englewood Cliffs, NJ: Prentice Hall, 2004.

Ashton, Dore. *Picasso on Art: A Selection of Views.* England: Penguin Books, 1972.

Barnet, Sylvan. *A Short Guide to Writing About Art.* 6th ed. New York: Longman, 2000.

Biers, William R. *The Archaeology of Ancient Greece. 2nd ed.* Ithaca, NY: Cornell University Press, 1996.

Boone, Danièle. *Picasso.* New York: Portland House, 1989.

Cartwright, Lisa, and Marita Sturken. *Practices of Looking: An Introduction to Visual Culture.* Oxford: Oxford University Press, 2001.

Chadwick, Whitney. *Woman, Art, and Society.* London: Thames & Hudson, 1990.

Feldman, Edmund Burke. *The Artist.* Englewood Cliffs, NJ: Prentice Hall, 1982.

Huffington, Arianna Stassinopoulos. *Picasso: Creator and Destroyer.* New York: Simon & Schuster, 1988.

Jaffé, Hans L. C. *Pablo Picasso.* Rev. ed. New York: Abradale Press/Harry N. Abrams, 1982.

Langmuir, Erika, and Norbert Lynton. *The Yale Dictionary of Art & Artists*. New Haven, CT: Yale University Press, 2000.

Metropolitan Museum of Art. *www.metmuseum.org.*

Venn, Beth, and Adam D. Weinberg. *Frames of Reference; Looking at American Art, 1900–1950.* Berkeley: Whitney Museum of Art in association with University of California Press, 1999.

Venturi, Lionello. *History of Art Criticism.* Rev. ed. New York: E. P. Dutton, 1964.

Chapter 3

American Folk Art Museum. www.folkartmuseum.org.

Craft and Folk Art Museum. www.cafam.org.

Craven, Wayne. *American Art: History and Culture.* 2nd ed. New York: McGraw-Hill, 2003.

Ebert, John, and Katherine. *American Folk Painters.* New York: Charles Scribner's Sons, 1975.

Efland, Arthur D. *A History of Art Education.* New York: Teachers College Press, 1990.

Feldman, Edmund Burke. *The Artist.* Englewood Cliffs, NJ: Prentice Hall, 1982.

Gregg, Gail. "What are they teaching art students these days?" *ARTnews,* April 2003. Accessed May 31, 2007. http://www.artnews.com.

Langmuir, Erika, and Norbert Lynton. *The Yale Dictionary of Art & Artists.* New Haven, CT: Yale University Press, 2000.

Mingei International Museum. www.mingei.org.

Museum of Craft and Folk Art. www.mocfa.org.

Phoenix Zoo. www.phoenixzoo.org.

"Sad End for Phoenix's Celebrated Painting Pachyderm." CNN.com, November 6, 1998. Accessed May 28, 2007, http://www.cnn.com./US/9811/06/dead.elephant/.

Soussloff, Catherine M. *The Absolute Artist: The Historiography of a Concept.* Minneapolis, MN: University of Minnesota Press, 1997.

Spivey, Richard. *María.* Flagstaff, AZ: Northland Press, 1979.

Chapter 4

American Association of Museums. www.aam-us.org.

American Institute for the Conservation of Historic & Artistic Works. http://aic.stanford.edu.

Art Conservation at the University of Delaware. www.artcons.udel.edu.

Art Museum Network. www.amn.org.

Association of Art Museum Curators. www.artcurators.org.

Association of Art Museum Directors. www.aamd.org.

Balboa Art Conservation Center. www.bacc.org.

Bennett, Tony. *The Birth of the Museum.* New York: Routledge, 1995.

Hurwitz, Laurie. "Is She Smiling for Two?" *ARTnews,* January 2007. Accessed May 31, 2007. http://www.artnews.com.

Koeppe, Wolfram. "Collecting for the Kunstkammer." In *Timeline of Art History.* New York: The Metropolitan Museum of Art, 2000. Accessed October 2002. http://www.metmuseum.org/toah/hd/kuns/hd/kuns.htm.

Lovgren, Stefan. "Warping Mona Lisa Nothing to Smile About, Experts Say." *National Geographic News,* April 30, 2004. Accessed June 20, 2007. http://news.nationalgeographic.com/news/2004/04/0430_040430-monalisa.html.

McShine, Kynaston. *The Museum as Muse: Artists Reflect.* New York: The Museum of Modern Art, 1999.

Museum Trustee Association. www.mta-hq.org.

"Scream Stolen from Norway Museum." *BBC News,* August 22, 2004. http://news.bbc.co.uk/1/hi/world/europe/3588282.stm. Accessed June 22, 2007.

Sitwell, Christine, and Sarah Staniforth, ed. *Studies in the History of Painting Restoration.* London: Archetype Publications in association with The National Trust, 1998.

Sturken, Marita, and Lisa Cartwright. *Practices of Looking: An Introduction to Visual Culture.* Oxford: Oxford University Press, 2001.

Zimmerman, J. E. *Dictionary of Classical Mythology.* New York: Bantam Books, 1971.

Chapter 5

Gilbert, Rita. *Living with Art.* 4th ed. New York: McGraw-Hill, 1992.

Hobbs, Jack A. *Art in Context.* 2nd ed. New York: Harcourt Brace Jovanovich, 1980.

Lazzari, Margaret, and Dona Schlesier. *Exploring Art.* 2nd ed. Belmont, CA: Thomson/Wadsworth, 2005.

Chapter 6

Albers, Joseph. Interaction of Color. New Haven, CT: Yale University Press, 2013. First published 1963.

Finlay, Victoria. Color: A Natural History of the Palette. New York: Random House, 2002.

Gage, John. Color in Art. World of Art. New York: Thames & Hudson, 2006.

Hobbs, Jack A. *Art in Context,* 2nd ed. New York: Harcourt Brace Jovanovich, 1980.

Chapter 7

Gilbert, Rita. *Living with Art.* 4th ed. New York: McGraw-Hill, 1992.
Hobbs, Jack A. *Art in Context.* 2nd ed. New York: Harcourt Brace Jovanovich, 1980.
Itten, Johannes. *Design and Form.* Rev. ed. New York: John Wiley & Sons, 1975.

Chapter 8

Chilver, Ian. *Oxford Dictionary of Art.* 3rd ed. Oxford: Oxford University Press, 2004.
Contrance, Diana. *Complete Life Drawing Course.* New York: Sterling, 2001.
Gettens, Rutherford J., and George L. Stout. *Painting Materials.* New York: Dover, 1966.
"Raw Materials for Drawing in Ink, Charcoal, and Silver." *American Artist: Drawing Magazine* 2, no. 2 (Fall 2004): 128.
Smith, Ray. *The Artist's Handbook.* Rev. ed. London: DK, 2003.
Stanyer, Peter. *The Complete Book of Drawing Techniques: A Professional Guide for the Artist.* New York: Barnes & Noble, 2003.

Chapter 9

Chilver, Ian. *Oxford Dictionary of Art.* 3rd ed. Oxford: Oxford University Press, 2004.
Gettens, Rutherford J., and George L. Stout. *Painting Materials.* New York: Dover, 1966.

Chapter 10

Gettens, Rutherford J., and George L. Stout. *Painting Materials.* New York: Dover, 1966.
Hobbs, Jack A. *Art in Context.* 2nd ed. New York: Harcourt Brace Jovanovich, 1980.
Smith, Ray. *The Artist's Handbook.* Rev. ed. London: DK, 2003.
Vicary, Richard. *Manual of Lithography.* New York: Charles Scribner's Sons, 1976.

Chapter 11

Craven, Wayne. *American Art: History and Culture.* 2nd ed. New York: McGraw-Hill, 2003.
Freeman, Michael. *The 35mm Handbook.* Philadelphia: Running Press, 1980.
Gettens, Rutherford J., and George L. Stout. *Painting Materials.* New York: Dover, 1966.

Giannetti, Louis. *Understanding Movies*. 8th ed. Englewood Cliffs, NJ: Prentice Hall, 1999.

Smith, Ray. *The Artist's Handbook*. Rev. ed. London: DK, 2003.

Stenger, Erich. *The History of Photography*. New York: Arno Press, 1979.

Yablonsky, Linda. "Slides and Prejudice." *Artnews*, April 2006. Accessed May 31, 2007. http://artnews.com/issues/article.asp?art_id=2020.

Chapter 12

Fuga, Antonella. Artists' Techniques and Materials. Los Angeles: The J. Paul Getty Trust, 2006.

Johnson, Lillian. *Sculpture: The Basic Methods and Materials*. New York: David McKay, 1960.

Pictorial stone sculpture tutorial. www.thesculpturestudio.com/carving_stone.htm.

Chapter 13

Cornell, Daniell. *The Sculpture of Ruth Asawa: Contours in the Air.* Berkeley: University of California Press, 2006.

Gardner, Helen. *Art Through the Ages.* Rev. ed. New York: Harcourt Brace, 1936.

Kessler, Jane. "Content." *Art Papers*, November/December, 1992.

Koplos, Janet. "When is Fiber Art 'Art?'" *Fiberarts Magazine*, March/April 1986. Accessed June 24, 2007. http://fiberarts.com/Article_archive/critiquefiberart.asp.*Lateral Thinking: Art of the 1990s,* exhibition catalogue for the Museum of Contemporary Art, San Diego. Seattle: Marquand Books, 2002.

McCreight, Tim. *Jewelry: Fundamentals of Metalsmithing.* Rockport, MA: Hand Books Press, 1997.

Spivey, Richard. *María.* Flagstaff, AZ: Northland Press, 1979.

Chapter 14

Fallingwater. Homepage, sponsored by the Western Pennsylvania Conservancy. www.paconserve.org/index-fw1.asp.

Kostof, Spiro. *A History of Architecture: Settings and Rituals.* 2nd ed. New York: Oxford University Press, 1995.

Chapter 15

Arnason, H. H. *History of Modern Art: Painting, Sculpture, Architecture, Photography.* 5th ed. Revised by Peter Kalb. Englewood Cliffs, NJ: Prentice Hall, 2004.

Cardiff, Janet. Untitled statement in *Elusive Paradise: The Millennium Prize* at the National Gallery of Canada, Ontario, 2001 (brochure),

reproduced at *Tate Liverpool Past Exhibitions: Janet Cardiff.* Accessed June 22, 2007. http://www.tate.org.uk/liverpool/exhibitions/janetcardiff/.

Christo, and Jeanne-Claude. www.christoandjeanneclaude.net.

Cox, Christoph, "Return to form: Christoph Cox on neo-modernist sound art." *Artforum,* November 2003. Accessed May 28, 2007. http://www.findarticles.com.

D'Souza, Aruna. "A world of sound: high-tech effects, B-movie suspense and urban alienation all take a turn in an internationally touring exhibition that surveys Janet Cardiff's installation and audio walks." *Art in America,* April 2003.

Fineberg, Jonathan. *Art Since 1940: Strategies of Being.* New Jersey: Prentice Hall, 1995.

Hobbs, Jack A. *Art in Context.* 2nd. ed. New York: Harcourt Brace Jovanovich, 1980.

James Luna. www.jamesluna.com.

Mailach, Dona Z., and Elvie Ten Hoor. *Collage and Assemblage: Trends and Techniques.* New York: Crown, 1973.

Marzona, Daniel. *Conceptual Art.* Köln: Taschen, 2005.

Onorato, Ronald J. "Blurring the Boundaries: Installation Art," in *Blurring the Boundaries: Installation Art 1969–1996* (by the Museum of Contemporary Art, San Diego). New York: Distributed Art Publishers, 1999.

List of Figures/Credits

1. Dorothea Lange, *Migrant Mother, Nipomo Valley*, 1936. Photograph. The Dorothea Lange Collection, The Oakland Museum of California, City of Oakland.
2. Charles W. Taylor, *Essex*, early twentieth century. Wood engraving. Collection of the author.
3. Katsushika Hokusai, *The Great Wave at Kanagawa* (from *Series of Thirty-Six Views of Mount Fuji*), ca. 1831–33. The Metropolitan Museum of Art, New York.
4. Pablo Picasso, *Les Demoiselles d'Avignon*, 1907. Oil on canvas. The Museum of Modern Art, New York.
5. Jackson Pollock, *Autumn Rhythm (Number 30)*, 1950. Oil on canvas. The Metropolitan Museum of Art, New York.
6. Leonardo da Vinci, *Mona Lisa*, ca. 1503–05. Oil on wood panel. Museé du Louvre, Paris.
7. Maria Martinez and Popovi Da, *Black-on-Black Ware Plate, Feather and Kiva-Step Design*, Signed Maria/Popovi 670. Courtesy of Charles and Georgie Blalock.
8. Jacques-Louis David, *Oath of the Horatii*, 1784. Oil on canvas. Museé du Louvre, Paris.
9. Masaccio, *Holy Trinity*, Santa Maria Novella, Florence, Italy, ca. 1428.
10. Ken Price, *Yang*, 2000. Acrylic on fired ceramic; 27 × 22½ × 17½ in. (68.6 × 57.2 × 44.5 cm); Collection Museum of Contemporary Art, San Diego. Museum purchase, International and Contemporary Collector Funds. Photographer: Pablo Mason © Ken Price 2000.

11. Frank Lloyd Wright, *"Fallingwater,"* the *Kaufmann House,* Bear Run, Pennsylvania, 1936–1939.

12. *Ambrotype of a Woman,* ca. 1860, *Tintype of a Man,* date unknown, and *Man and Woman,* date unknown. All collection of the author.

13. Christo and Jeanne-Claude, *Valley Curtain,* Rifle, Colorado, 1970–72. Wolfgang Volz/laif/Redux.

14. Robert Smithson, *Spiral Jetty,* 1970. Great Salt Lake, Utah. Collection of DIA Center for the Arts, New York.

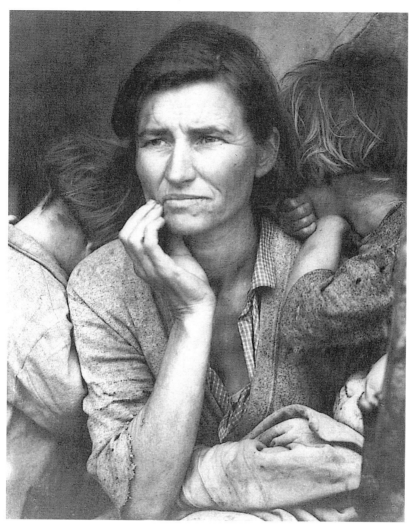

Figure 1 Dorothea Lange, *Migrant Mother, Nipomo Valley,* 1936.
Photograph. The Dorothea Lange Collection, The Oakland Museum
of California, City of Oakland.

Library of Congress, Prints and Photographs, LC-USF346-009058-C.

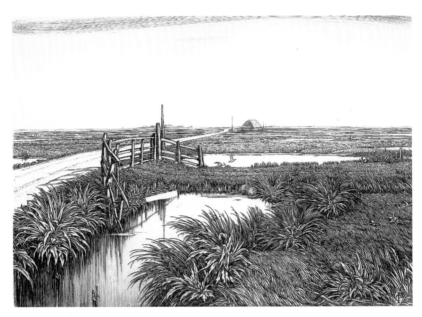

Figure 2 Charles W. Taylor, *Essex,* early 20th century. Wood engraving. Collection of the author.

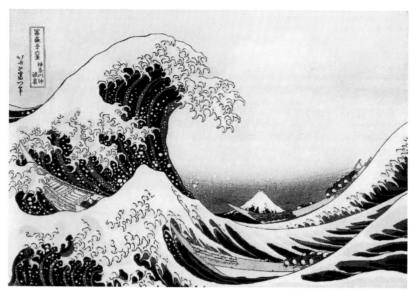

Figure 3 Katsushika Hokusai, *The Great Wave at Kanagawa*
(from *Series of Thirty-Six Views of Mount Fuji*), ca. 1831–33.
The Metropolitan Museum of Art, New York. Color woodblock print,
private collection.

Art Resource, NY.

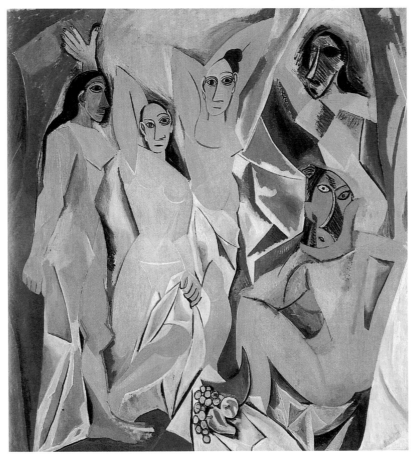

Figure 4 Pablo Picasso, *Les Demoiselles d'Avignon,* 1907. Oil on canvas. The Museum of Modern Art, New York.

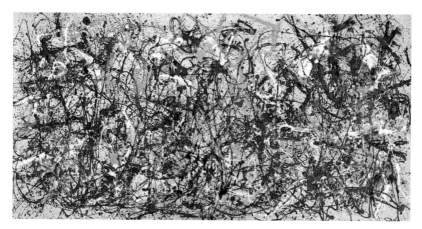

Figure 5 Jackson Pollock, *Autumn Rhythm (Number 30),* 1950. Oil on canvas. The Metropolitan Museum of Art, New York. George A. Hearn Fund.

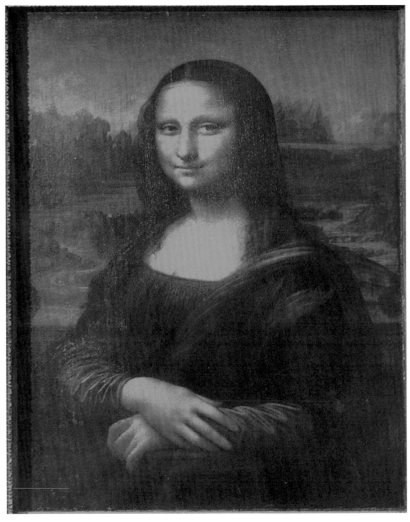

Figure 6 Leonardo da Vinci, *Mona Lisa,* ca. 1503–05. Oil on wood panel. Museé du Louvre, Paris.

Scala/Art Resource, NY.

Figure 7 Maria Martinez and Popovi Da, *Black-on-Black Ware Plate, Feather and Kiva-Step Design,* Signed Maria/Popovi 670.

Photo courtesy of Charles and Georgie Blalock. Artwork copyright Joyce Odell. Pottery copyright Barbara Gonzales. Used by permission.

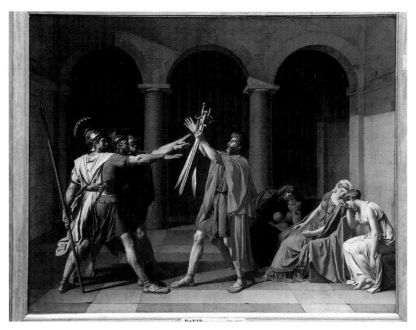

Figure 8 Jacques-Louis David, *Oath of the Horatii,* 1784. Oil on canvas. Museé du Louvre, Paris.

Figure 9 Masaccio, *Holy Trinity,* Santa Maria Novella, Florence, Italy, ca. 1428.

Erich Lessing/Art Resource, NY.

Figure 10 Ken Price, Yang, 2000. Acrylic on fired ceramic; 27 × 22½ × 17½ in. (68.6 × 57.2 × 44.5 cm); Collection Museum of Contemporary Art, San Diego. Museum purchase, International and Contemporary Collector Funds.

Photographer: Pablo Mason © Ken Price 2000.

Figure 11 Frank Lloyd Wright, *"Fallingwater," the Kaufmann House,* Bear Run, Pennsylvania, 1936–1939.

Frank Lloyd Wright, "Fallingwater." Robert P. Ruschak, courtesy of Western Pennsylvania Conservancy. Used by permission.

Figure 12 (From left to right) *Ambrotype of a Woman,* ca. 1860, *Tintype of a Man,* date unknown, and *Man and Woman,* date unknown. All collection of the author.

Figure 13 Christo and Jeanne-Claude, *Valley Curtain, Rifle, Colorado,* 1970–72.

Wolfgang Volz/laif/Redux.

Figure 14 Robert Smithson, *Spiral Jetty,* 1970. Great Salt Lake, Utah.

Collection of DIA Center for the Arts, NY. Art © Estate of Robert Smithson/Licensed by VAGA, New York, NY.

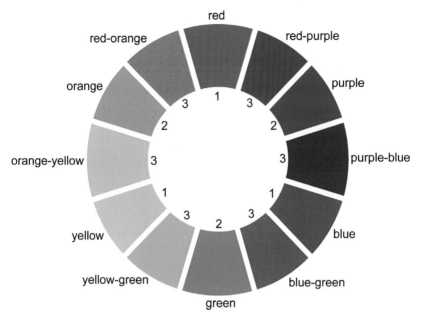

Diagram 7 The Color Wheel
The standard color wheel shows the primary (1), secondary (2), and tertiary colors (3).

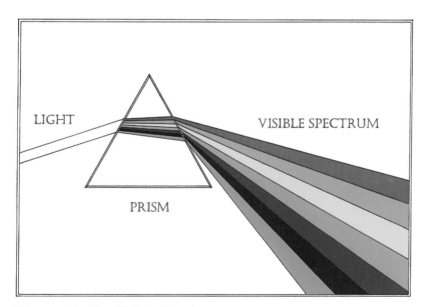

Diagram 8 The Visible Spectrum
White light enters the prism and is broken into the visible spectrum.

Subtractive Color System (non-CMYK) Additive Color System

Diagram 9 Subtractive and Additive Color Systems
Diagram showing the additive and subtractive color systems. Note
that the inclusion of all color in the subtractive system results in black
while the inclusion of all color in the additive system results in white.
A modified color wheel showing the relation between primary and
secondary colors. The black surrounding the additive color chart
indicates that the absence of all color/light is black.